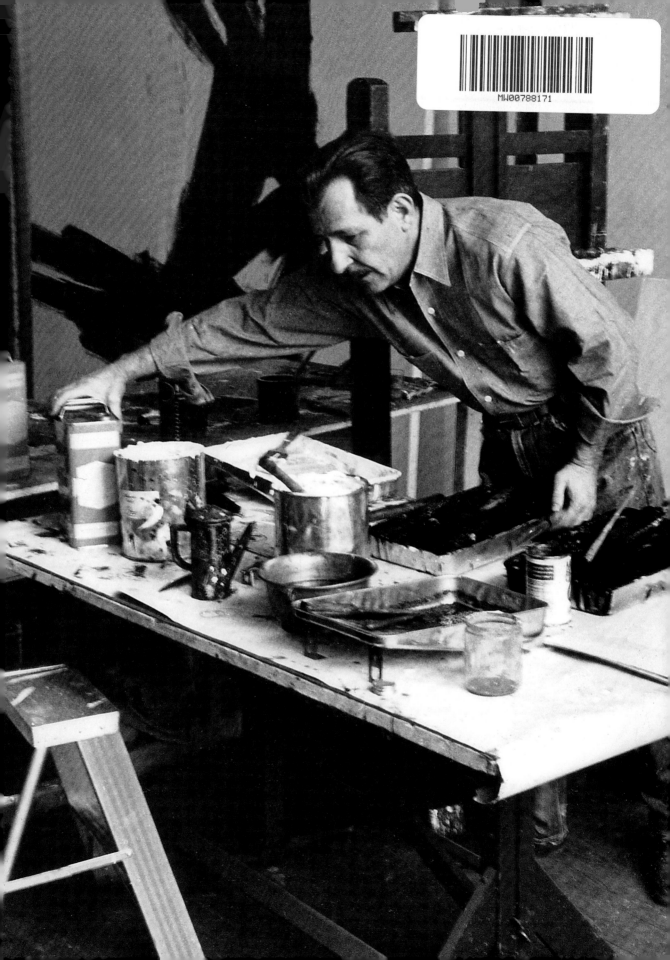

Other titles in the
Artist's Materials series

Willem de Kooning

Lucio Fontana

Sam Francis

Hans Hofmann

Sidney Nolan

Jean Paul Riopelle

Clyfford Still

Corina E. Rogge

THE ARTIST'S MATERIALS

Franz Kline

with contributions by
Zahira Véliz Bomford
and
Julie Arslanoglu
Silvia A. Centeno
Isabelle Duvernois
Maite Martinez Leal

Getty Conservation Institute
Los Angeles

Getty Conservation Institute

Timothy P. Whalen, *John E. and Louise Bryson Director*
Jeanne Marie Teutonico, *Associate Director, Strategic Initiatives and Publications*

The Getty Conservation Institute (GCI) works internationally to advance conservation practice in the visual arts—broadly interpreted to include objects, collections, architecture, and sites. The Institute serves the conservation community through scientific research, education and training, field projects, and the dissemination of information. In all its endeavors, the GCI creates and delivers knowledge that contributes to the conservation of the world's cultural heritage.

Published by the Getty Conservation Institute, Los Angeles
Getty Publications
1200 Getty Center Drive, Suite 500
Los Angeles, California 90049-1682
getty.edu/publications

Rachel Barth, *Project Editor*
Sheila Berg, *Manuscript Editor*
Jeffrey Cohen, *Designer*
Molly McGeehan, *Production*
Kelly Peyton, *Image and Rights Acquisition*

Distributed in the United States and Canada by the University of Chicago Press
Distributed outside the United States and Canada by Yale University Press, London

Printed in China

Library of Congress Cataloging-in-Publication Data
Names: Rogge, Corina E., author. | Véliz, Zahira, contributor. | Getty Conservation Institute, issuing body.
Title: Franz Kline : the artist's materials / Corina E. Rogge ; with contributions by Zahira Véliz Bomford and Julie Arslanoglu, Silvia A. Centeno, Isabelle Duvernois, Maite Martinez Leal.
Other titles: Artist's materials.
Description: Los Angeles : Getty Conservation Institute, [2022] | Series: The artist's materials | Includes bibliographical references and index. | Summary: "The first comprehensive study of Franz Kline's methods and techniques and the eighth book in the Artist's Materials series, which explores the unique and unconventional materials used by contemporary artists and the challenges encountered by professionals tasked with conserving their works"—Provided by publisher.
Identifiers: LCCN 2021038988 (print) | LCCN 2021038989 (ebook) | ISBN 9781606067642 (paperback) | ISBN 9781606067659 (epub) | ISBN 9781606067666 (pdf)
Subjects: LCSH: Kline, Franz, 1910–1962. | Painting, Modern—20th century—Technique. | Paint materials—Analysis. | Artists' materials—Analysis.
Classification: LCC ND237.K56 R64 2022 (print) | LCC ND237.K56 (ebook) | DDC 759.13—dc23
LC record available at https://lccn.loc.gov/2021038988
LC ebook record available at https://lccn.loc.gov/2021038989

Contents

Foreword

Franz Kline (1910–1962) is one of the seminal figures in the American Abstract Expressionist movement of the 1950s and 1960s and his work can be found in museums around the world. His expressive, dramatic brushstrokes (mostly black on white, although he never renounced color and increasingly incorporated it in his later work) has led some to categorize him an "action painter" like his friends and contemporaries Jackson Pollock and Willem de Kooning. But we now know that unlike the truly spontaneous action painters, Kline often carefully planned and sketched his seemingly spontaneous paintings before he applied paint to canvas.

Until recently, Kline's work had not been studied extensively. That changed in 2012, when the examination of an unstable Kline painting (*Wotan*, 1950) at the Museum of Fine Arts, Houston (MFAH), prompted a more careful study and technical analysis of several Kline paintings. This research project was led by paintings conservator Zahira (Soni) Véliz Bomford and conservation scientist Corina (Cory) Rogge at the MFAH, in collaboration with several colleagues at nine different museums and institutions, including scientists at the Getty Conservation Institute (GCI). With a full range of Kline's paintings at their disposal, and using a host of non-destructive and micro-destructive methods, their goal was to gain a more complete understanding of the artist's working methods and materials.

This book presents the results of their collaboration: the first major analytical study of Franz Kline's materials and methods. By sharing the results of their archival research, visual examinations, and extensive pigment and binding media analysis, the authors trace the evolution of Kline's technique and contextualize analytical findings about his materials.

Since 2007, the GCI's Modern and Contemporary Art Research Initiative has sought to address the challenges of conserving art of the twentieth and twenty-first centuries. This involves the scientific study of materials, the effects of conservation treatments on those materials, and the dissemination of research. One means of sharing that information is the GCI's Artist's Materials book series, which aims to make available in-depth studies of the materials and techniques adopted by modern artists and the implications for the long-term care and conservation of their works.

This volume, *Franz Kline: The Artist's Materials*, is the eighth in the series, which was launched in 2010 with the publication of *Willem de Kooning: The Artist's Materials*. Since Kline and de Kooning were friends and colleagues, it seems particularly fitting that the work of both artists has now been studied and published in this important series.

Our thanks to Cory Rogge and Soni Véliz Bomford and their co-authors, Maite Martinez Leal, Julie Arslanoglu, Silvia Centeno, and Isabelle Duvernois, for being generous colleagues, for their excellent research, and for entrusting us with their work. We are also grateful to all those who contributed to this volume, including colleagues at the MFAH, the Museum of Modern Art, the Solomon R. Guggenheim Museum, the Whitney Museum, the Metropolitan Museum of Art, the Harvard Art Museums, the Art Institute of Chicago, the Smithsonian American Art Museum, and the National Gallery of Art, Washington, DC.

We are confident that this volume will significantly deepen our understanding of the evolution of Franz Kline's paintings, methods, and materials, which will enable us to appreciate these works within the broader art historical discourse on Abstract Expressionism and to better preserve them for future generations.

Timothy P. Whalen
John E. and Louise Bryson Director
Getty Conservation Institute

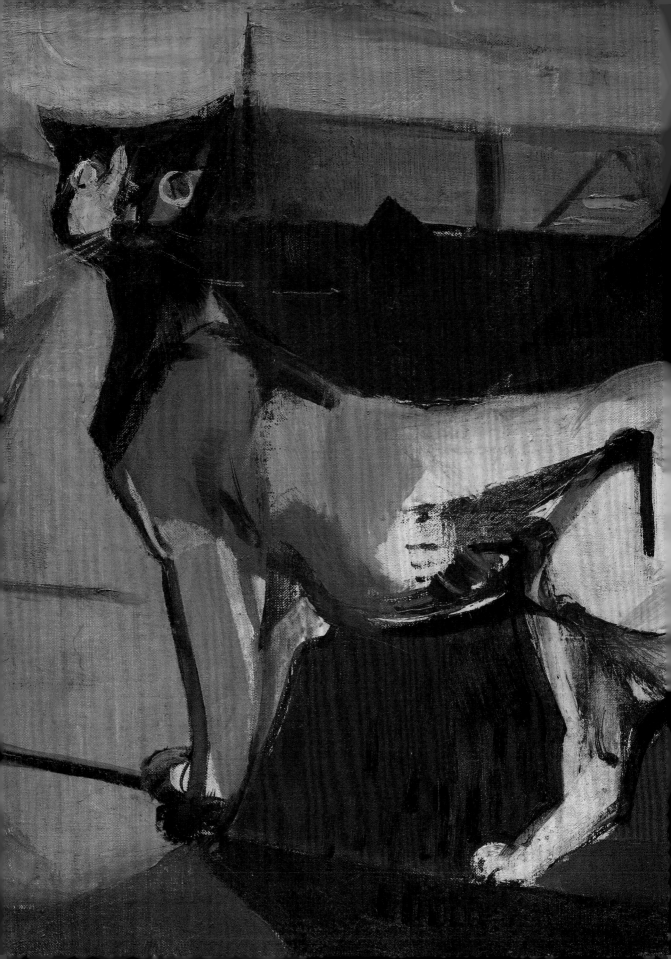

Introduction

Corina E. Rogge and Zahira Véliz Bomford

You don't paint the way someone, by observing your life, thinks you *have* to paint, you paint the way you have to in order to *give*, that's life itself, and someone will look and say it is the product of knowing, but it has nothing to do with knowing, it has to do with giving. The question about knowing will naturally be wrong. When you've finished giving, the look surprises you as well as anyone else.

—FRANZ KLINE, in Frank O'Hara, "Franz Kline Talking"

A masterpiece like *Wanamaker Block*, one of his most characteristic black and white paintings, seems the direct and inevitable result of a natural gift, but for Kline it was a hard-won battle, and he distrusted easy victories.

—FRANK O'HARA, *Franz Kline: A Retrospective Exhibition*

Franz Kline (1910–1962) is a central yet understudied figure in the Abstract Expressionist movement who created iconic works in an immediately recognizable mature style. Kline immersed himself in the Lower Manhattan art world, where he was known as a generous personality who was quick, effusive, and always authentic. His bonhomie was legendary—he was a master of the shaggy dog story, a fan of the funnies, and a player of practical jokes—but beneath his gregarious manner lay a serious commitment to his art. It took many years for Kline to find his distinctive "voice," and in the decades before he achieved critical and financial success he experienced real hardship. His commitment to a creative life was sustained by the generosity of two insightful patrons and by a supportive community of fellow artists. Kline counted Jackson Pollock, Joan Mitchell, Philip Guston, and Elaine and Willem de Kooning among his friends, and he interacted extensively with the Downtown cadre of New York artists. He created figurative works in color for many years, but his first major critical success came in a solo show at the Charles Egan Gallery in 1950, with a series of mostly black and white abstract paintings that essentially established his mature style. Although the Museum of Modern Art acquired one of his paintings in 1952 and the Solomon R. Guggenheim Museum purchased another in 1954, financial success came only with his first show at the Sidney Janis Gallery in 1956. Kline continued to explore abstraction with a varied palette and at ever larger scales, but he would die of heart failure just six years later. As April Kingsley wrote, "Abstract Expressionism as a movement died with him" (1986, 41).

The origins of this book can be traced to late 2012, when a routine examination of *Wotan* (see fig. 4.4), one of Kline's seminal paintings from 1950, revealed a stark dichot-

omy between the strong visual presence of the painting and the fragility of its paint layers. The unstable condition of the painting prompted a search of the technical literature to see whether conservators had reported comparable findings for other Kline works and whether the underlying causes for the condition issues were known. We discovered that references to Kline's methods and materials could be counted on one hand. The absence of rigorous technical investigation of Kline's paintings seemed a serious disservice to an artist whose place in the Abstract Expressionist movement is undisputed and whose works can be found in the permanent collections of major art institutions throughout the world. Such investigations might of course help explain the condition issues we and others had identified, but technical analysis can often also inform the art historical assessment of an artist's oeuvre, and we believed that such analyses might be especially significant in the case of Kline.

Much of the critical writing about Franz Kline invokes inapt generalizations about the Abstract Expressionist movement, among them the importance of spontaneity in abstract painting, the idea of the artistic breakthrough as a singular historic event, and the trope of the abstract painter as a solitary, heroic individual. Critical analyses are usually constrained to some degree by what the artist has said about their own work, but unlike many of his fellow New York artists, Kline did not write about his art or enjoy talking about it. As Elaine de Kooning (1962, 68) said, "[His] ideas were all locked in the image and could not be released by words." Given the dearth of Kline's own words regarding his art, one role of technical analysis might be to help resolve questions about or identify as yet unknown aspects of his process. Technical analysis might also help address a long-standing oversight: many assessments of Kline's oeuvre have focused on the successful decade of the 1950s, when much of what he painted was at monumental scale in black and white, but early training and habits can often provide insight into the mature procedures of an artist. A more complete understanding of Kline's working method might emerge from examining the full range of his work, from early figural and semiabstract works to his magnificent black and white and color abstractions.

When Corina Rogge joined the Museum of Fine Arts, Houston (MFAH), Conservation Department in 2013 as the Andrew W. Mellon Research Scientist, in-depth investigations into the materials and methods of the MFAH-held Kline works became feasible. The more we learned of Kline's paintings, the more distinct each was revealed to be; the four paintings held by the MFAH were as individual as four people, and it became apparent that to truly understand his oeuvre, more Kline works had to be analyzed. With this goal in mind, we contacted colleagues at other institutions with substantial holdings of paintings and drawings by Kline, and the response was universally one of generous collaboration. Without it, this book could not have been written. Each additional painting we were able to examine and each contribution of pigment and media analysis deepened our understanding of and appreciation for Kline's works. The collaborations with the Museum of Modern Art (MoMA), Solomon R. Guggenheim Museum (SRG), Whitney Museum, Metropolitan Museum of Art (MMA), Harvard Art Museums, Art Institute of Chicago (ARTIC), Smithsonian American Art Museum (SAAM), and National Gallery of Art, Washington, DC (NGA), have been invaluable, and we were honored to work with colleagues pursuing a shared interest in the techniques of this neglected luminary of Abstract Expressionism.

The analytical methods we brought to bear on Kline's works were both nondestructive and microdestructive. Nondestructive techniques included close visual inspection, technical imaging (X-radiography, infrared reflectography, ultraviolet induced visible fluorescence imaging), and elemental analysis (X-ray fluorescence [XRF] spectroscopy, both point and macroscopic mapping) to identify pigmenting materials. When war-

ranted and permitted by the holding institutions, microscopic paint samples were taken from areas of extant damage. These tiny samples were subjected to a variety of techniques, including scanning electron microscopy with energy dispersive X-ray spectroscopy (SEM-EDS) and optical microscopy to document paint layering and inorganic materials; Raman and Fourier transform infrared (FTIR) spectroscopy to identify media, pigments, and fillers; and gas chromatography–mass spectrometry (GC-MS) to refine media identification. The findings reveal that Kline used traditional techniques and approaches to create his innovative works, likely due to the influence of his early academic training, and establish that Kline often edited and sometimes completely reworked compositions.

Although Kline largely followed traditional painting practices, he introduced his own adaptations or nuances. He preferred canvases sized with glue and prepared with a double oil ground, but he stretched these only after the paintings were completed, preferring to staple the canvases to a vertical support to work on them. His use of sketches and the care with which the lines and shapes in his paintings were planned, edited, and reinforced until the composition was perfectly choreographed also connect his practice to tradition. Kline's brushstrokes, whether with a wide house painter's brush or a fine artist's sable rigger, are expressive and never automatic or haphazard. His affinity for the graphic line, which he developed in his confident cartooning of the 1930s and then in immensely sensitive pencil or ink sketches of everyday surroundings, expressed itself in the typical brush drawings of his artistic maturity, which were often executed on newsprint or pages torn from a telephone directory. Kline's power as a draftsman makes "the line" central to his art—intimate on a sketchbook page, operatic on a wall-sized canvas—and aspects of his practice reflect the challenge of transferring the vitality of a sketch to a monumental canvas. Contemporaneous accounts and technical analyses of his works show that his paintings were thoughtfully executed, sometimes quickly but often over an extended period, and the evidence available today establishes that his distinctive visual idiom arose from a creative process rooted firmly in a painterly tradition.

Though a traditionalist in some respects, Kline was also part of the community of abstract artists who sought to create new modes of expression divorced from historical association with representative art. One commonality that linked artists as different in style as Jackson Pollock, Mark Rothko, and Willem de Kooning was disengagement with received wisdom about materials and procedures. These artists retained the physical elements of western painting—a canvas support and applied paint—but they might use inexpensive house paint rather than high-quality artists' paint. Whether Abstract Expressionist artists like Kline and de Kooning chose materials because of financial constraints or as a conscious philosophical statement, the characteristics of those materials affected both the initial outward expression of their vision and the stability of their creations. In using inexpensive retail trade paints, Kline discovered working properties that differed markedly from those of traditional artists' tube paints, and the change in handling had an effect on the look of his brushwork and painted surfaces. Kline deliberately selected and manipulated his paints to control the tone of his whites and the glossiness of his blacks, but the materials he used soon began to yellow, crack, and undergo changes in surface gloss, altering his original expression.

This book presents the first major analytical study of Franz Kline's materials and methods, traces the evolution of his technique, and contextualizes analytical findings about his materials to decipher the quiet evidence of process hidden in the structure of his paintings. By integrating the results of the technical study and analytical examination with current scholarly research on Franz Kline, this book significantly deepens our understanding of how his mature working method evolved and certain compositions

developed during their creation and enables us to integrate issues of the materiality of these works into the broader art historical discourse on Abstract Expressionism.

The chapters that follow are arranged chronologically, structured by Kline's biography. We combine conclusions from our scientific analyses of his paintings with historical analysis and other scholarship in each chapter; the analytical data that support our conclusions are presented in the appendixes. Chapters 1 and 2 outline Kline's early years in eastern Pennsylvania, his formal training in Boston and London, and the start of his life as an artist in New York City. Technical analyses of his painted works from the 1940s provide evidence of Kline's early working method and his struggle to move from figurative works to abstraction. Chapter 3 situates Kline in the context of his New York contemporaries and addresses and refutes several generalizations about the Abstract Expressionist movement that have been inappropriately applied to Kline. Chapter 4 focuses on Kline's first solo show at the Charles Egan Gallery in 1950, which marked his coming-of-age in the New York art scene. Material evidence from four of these seminal paintings and comparison with preparatory sketches reveal the various means by which Kline first translated the immediacy of his sketches into monumental paintings on canvas. Chapter 5 provides a detailed description of Kline's artistic process in the early 1950s by first integrating our analysis of *Painting* (1952; see fig. 5.1) with Robert Goodnough's contemporaneous account of its creation in the *ARTnews* feature, "Kline Paints a Picture" (1952), and then using the technical results from other works to identify commonalities with that process or variations from it. Chapter 6 examines and compares paintings from Kline's final years, during which his evolving and diverse compositions in color and in black and white met with commercial and critical success. The final chapter addresses the implications of Kline's materials and methods for the conservation care of his paintings and provides a synthesis of the condition issues seen to date in his works and descriptions of the conservation procedures undertaken on three Kline paintings both before and after they entered the collections of the Museum of Fine Arts, Houston, and the Metropolitan Museum of Art.

Our close examination of over thirty paintings and comprehensive material analysis of more than 160 samples and 1,300 spectra provide a broad but far short of exhaustive study of Kline's oeuvre, and it is hoped that the work presented here will encourage further investigation. The conservator, art historian, and curator are equally challenged now by the imperatives of responsible care of paintings by Kline and his contemporaries. By presenting technical analyses of Franz Kline's materials, relating these to the current condition of his paintings, and illuminating in detail his actual painting practice, we hope this work will lead to a deeper understanding and appreciation of this iconic artist for specialists and nonspecialists alike.

1 Artistic Beginnings

Corina E. Rogge

The second child of Anthony Carlton Kline and Anne Evita Kline (née Rowe), baptized Franz Josef, was born in 1910 in Wilkes-Barre, Pennsylvania, in the northeastern area of the state renowned for anthracite coal mining (Gaugh 1985b). Later in life, Anne would relate memories of the young Kline using rhubarb stems to "paint" the sidewalk. Whatever significance one might assign to the creativity shown by a child at play, there is no doubt that Franz Kline figured prominently in his mother's thoughts throughout her life and that he was very close to her.

Kline's early childhood was stable and secure: his father ran the family-owned hotel, and his mother stayed at home raising the couple's four children. The family's financial circumstances changed dramatically, however, leading Anthony Kline to take his own life when Franz was just seven years old. To support her family, Anne enrolled in St. Luke's Hospital School of Nursing in Bethlehem, Pennsylvania (Mattison 2012, 14; Finsel and Finsel 2019, 32). The program required the nursing students to stay in residence, so Anne was forced to make arrangements for her children to live elsewhere. Initially, Kline, his older brother Frederick, and sister Louise were sent to live in a foundling home run by the Episcopal church in Jonestown, Pennsylvania, and the youngest of the siblings, Jacques, went to live with an uncle. After Kline had spent two years at the home, Anne enrolled him in Girard College, a free boarding school for fatherless boys in Philadelphia. Located on a sixty-four-acre campus, Girard College housed fifteen hundred students and emphasized self-sufficiency and discipline. Although the curriculum offered both traditional academic courses (e.g., chemistry, French) and vocational training, the education was intended to prepare students for jobs once they graduated at the age of eighteen, not for further academic study; graduates did not receive a high school diploma. It was not all hard work: there was a swimming pool, time for games, and an elective drawing class in which Kline participated, although he evidently displayed no unusual skill. A classmate recalled, "I do not remember Kline's works being outstandingly better than anyone else. I'm quite sure he did not win any of the annual prizes" (quoted in Finsel and Finsel 2019, 28). Anne remarried in 1920, to Ambrose D. Snyder, a widower with three children, who lived in Lehighton and worked for the Lehigh Valley Railroad (Finsel and Finsel 2019, 32). In 1925, when Kline was fifteen, Anne (now Mrs. Kline-Snyder) managed, through a persistent and dedicated writing campaign, to have him released early from Girard College, citing his poor academic performance and her concern that the lack of a diploma would adversely affect his future (44).[1]

Kline had visited his family after their move to Lehighton, so he was not thrust into an entirely strange environment, and he had siblings who were already part of the

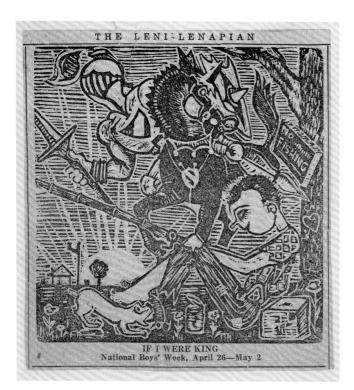

community to help him adjust (Finsel and Finsel 2019, 37–42). One of the points that Anne had used to argue for the early release of her son from Girard was that she had obtained employment for him, and that summer Kline worked at a local dairy bringing in milk from outlying farms. He began his commercial artistic career, at least at a modest level, painting signs for Fairyland Farms, the Graver's swimming pool, and other local businesses (45). In the fall of 1926, Anne enrolled him in eighth grade at Lehighton Junior High School, holding him back two grades to make up for the perceived lack of rigor in the education he had received at Girard College (48). In high school Kline began to devote a great deal of time to the graphic arts, contributing cartoons and woodblock prints for the junior high newspaper, *Junior Whispers*, the high school newspaper, *Leni-Lenapian*, and the high school yearbook, *Gatchin Bambil* (Gaugh 1985b, 27; Finsel and Finsel 2019) (fig. 1.1). His cartoon characters are stylized, often with large round heads and thin bodies, likely modeled after those of John Held Jr., a cartoonist whose work was featured in high-profile magazines such as *LIFE*, *Vanity Fair*, and *Harper's Bazaar* (Gaugh 1972, 9–10) (fig. 1.2). Kline's evocation of Held's work indicates that he had an innate skill at drawing and the ability to absorb and then creatively reinterpret a style. Despite his interest and ability in sports, Kline spent a great deal of time exploring the creative process: he was observed using "large drawing pads" around the house (Gaugh 1985b, 175), and his sister remembers him filling tablets of paper with sketches of horses and of his own hands (Finsel and Finsel 2019, 53). Kline's artistic skill led to respect from his peers as his cartoons became sought-after additions to his classmates' autograph books (48, 63) and also to more formal recognition. In 1930, Kline received the Pennsylvania Scholastic Press Association Silver Award for his work in the *Leni-Lenapian* (69).

Kline began to learn the basics of painting, both in his school art classes and by less formal means. Although his high school art classes focused largely on decorative crafts, he was also introduced to oil paint, charcoal, and pen and ink (Finsel and

Finsel 2019, 60). With the encouragement of his teacher, Kline submitted a painting (in unknown media) to a local contest (the subject was reportedly a Native American crossing a stream) and won a Devoe watercolor paint set as a prize (63). He painted cartoon characters on schoolmates' rain slickers, continued to paint signs, and began to work on a larger scale, painting murals for local businesses (45–46, 56–78). One such commission, now lost, was for a bar in Palmerton, Pennsylvania, which Kline painted after school over the course of several weeks (76). Another commission, done during high school or during a visit in 1933 after he had moved to Boston (reports vary), was a series of vignettes featuring jazz musicians on a local skating rink; the figures were all about three feet high (Metzger and Kline 1989; Finsel and Finsel 2019, 77–78). The jazz figures are in a style similar to that of his early cartoons (fig. 1.3), but the large scale and the act of painting on a solid support foretell Kline's later, mature works. Because his mother was concerned that art was not a financially viable career, Kline would hide his brushes and paint, often under the rhododendron bushes in the yard, to avoid unwanted scrutiny.[2]

Despite his mother's concern, Kline began seriously to consider a career in the graphic arts and wrote to Dr. Frank D. Witherbee, head of admissions at Girard College, asking for advice about art schools for a career in cartooning (Gaugh 1972, 7–8).[3] Although he did not pursue that profession, his love of cartoons stayed with him throughout his life (Gaugh 1985b, 26–27), and he was said never to have bought a newspaper that "didn't have the 'funny pages' in it."[4] In 1931, Kline moved to Boston and enrolled in an English composition course at the Boston University School of

FIGURE 1.3

Franz Kline, *The Jazz Murals, Drummer*, 1932, left wall. Oil on board, private collection. These murals echo Kline's cartooning style, but the large scale (the figures are nearly 3 feet high) and act of painting on a solid support presage his mature work.

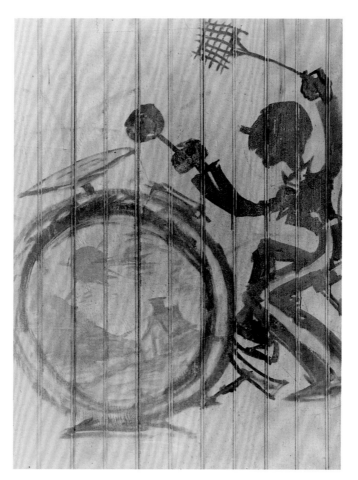

Education with, he later recalled, "the ill-conceived notion of getting a college education and painting in my spare time" (quoted in Rodman 1957, 107). He attended Frank C. Durkee's life drawing classes and also studied at the Boston Art Students' League, which emphasized drawing from live models (Gaugh 1972, 12–13). There he met Frederick Ryan, a fellow student, who had trained in painting at École des Beaux-Arts in Paris and would remain a lifelong friend. Samples of Kline's work from this time demonstrate a great deal of talent, enough to worry Frank Durkee, who told him, "You have a great deal of facility, but if you don't look out it's going to ruin you" (quoted in Gaugh 1972, 13). The Boston Art Students' League offered limited painting instruction by Henry Hensche, an artist who had studied under Charles Hawthorne, a student of William Merritt Chase (Gaugh 1972, 16–17). Details of Hensche's Boston classes have not been preserved, but it is likely that they emphasized still life paintings in which the subject was built up in colored masses in the "light key in which they are seen" (Robichaux 1997, 44). The lack of painting instruction probably did not disturb Kline, who was still intending to be a magazine illustrator or cartoonist, but he maintained a friendship with Hensche, later visiting his studio in Provincetown and naming two paintings for him, *Henry H* (1959) and *Henry H II* (1959–60).[5]

To help support himself in Boston, Kline continued his commercial endeavors, which ranged from painting decorations in clubs to creating gold leaf signs (Gaugh 1985b, 176; Finsel and Finsel 2019, 95–96). He painted a mural, *Diana and the Hunt*, for a café in Boston and was happy to be recompensed in meals (Gaugh 1985b, 17). Kline's submission to the *Boston Globe*'s 1935 Emergency Campaign in support of the city's private hospitals was made into a poster. The realistic drawing of anxious parents watching as a nurse tends to their sick child displays the technical skills learned during his studies in Boston and highlights his emotional sensitivity (Gaugh 1985b; Metzger and Kline 1989, 34 [illus.]; Finsel and Finsel 2019, 174 [illus.]).

In the fall of 1935, with the dissolution of the Boston Art Students' League and the departure of Hensche for Provincetown, Kline decided to expand his horizons and study

FIGURE 1.6
Franz Kline, *Nude Figure Studies*,
1936. Pen and brown ink on wove
paper, 38.42 × 25.4 cm (15⅛ ×
10 in.), National Gallery of Art,
Washington, DC, Gift of Rufus
Zogbaum and Reina Schratter,
2016.60.3.

The Heatherley School of Fine
Arts emphasized life drawing.
The model for this sheet of
sketches was Elizabeth Vincent
Parsons, Kline's future wife.

abroad, later reminiscing, "I'd hoped to go to England and then on to study in Paris, but I never got to Paris at that time" (Kuh 1962, 153). His decision not to travel to the Continent may have been based on financial considerations or language limitations. In 1936, he enrolled in the Heatherley School of Fine Arts, which advertised itself as "A Paris School in London for Artists, Painters, Illustrators and Commercial" (Gaugh 1972, 37). Although concerned enough about the viability of a career as an artist to write to the Heatherley School managing director, Kline's mother provided him with financial support of about £1 per week (approx. £68 in 2021 real wages) as he was unable to work legally in England (37–38). His mother was British born, but this does not seem to have helped Kline on a practical level: he could not obtain citizenship without an eight-year residency.

Following the methodology of the Paris ateliers, the Heatherley School emphasized life drawing, and Kline's teachers included Frederic Whiting, Bernard Adams, and Steven Spurrier, whom he particularly admired (Gaugh 1985b, 176) (fig. 1.4). As Kline wrote to a friend:

> Spurrier is without doubt London's or England's most popular and best illustrator and a very versatile man indeed.... He handles humorous subjects as well, so naturally I became very interested in his ideas and methods of building an illustration. Sketchbook, the model and invention are the forms of reference he uses. So as a result I have rafts of sketches from the streets etc. and a gang of incomplete illustrations etc. The technical side of the thing and so-called flair seems of very little interest to him[,]...hence I am trying to let good drawing predominate the otherwise technical "smartness" my work seems to have. And it is tough! (Gaugh 1972, 46)

The "technical smartness" may have been the same "facility" that Durkee had warned Kline about in Boston. Although he found the work "tough," Kline's sketches of a nude and a child were judged worthy of inclusion in the October 1936 volume of *The Artist: An Illustrated Monthly Record of Arts, Crafts and Industries*, a London journal that regularly included reports from art schools.[6] In addition to classes at the Heatherley School, Kline took advantage of the museums and picturesque streets and inhabitants of London and began a lifelong practice of creating small, quick sketches (a practice undoubtedly encouraged by Spurrier) on any surface available, including his British visa (Gaugh 1972, 44–53) (fig. 1.5).

At the Heatherley School, Kline met his future wife, Elizabeth Vincent Parsons, a dancer who served as a model for life drawing classes (Gaugh 1972, 44) (fig. 1.6). Kline and Elizabeth may have shared an interest in dance, as in 1936 Kline had already begun a lifelong fascination with Vaslav Nijinsky when he acquired a photograph of the dancer in his role as Petrouchka (226), and Elizabeth gave Kline a copy of *The Diary of Vaslav Nijinsky* during their courtship. Elizabeth's family was comfortably well off and had sufficient social status for Elizabeth to have been presented at court (406); her parents may have been trying to help the young couple financially when they commissioned Kline to copy two family portraits by Edmund Havell (53). The looming war and economic issues, however, caused Kline to return to the United States in February 1938 (Gaugh 1985b, 177). He initially returned to Lehighton, then moved to Buffalo, New York, to work as a display designer for a department store. Elizabeth followed, and by the time she arrived in November that year, Kline had moved to New York City and was living at 146 MacDougal Street.

2

The New York Incubator, 1939–1950

Corina E. Rogge, Isabelle Duvernois, Silvia A. Centeno,
Julie Arslanoglu, and Zahira Véliz Bomford

The style, scale, and subject matter of Franz Kline's paintings underwent dramatic transformations between 1939 and 1950. He initially created traditional easel-size still life, figure, and landscape paintings, but by the mid-1940s, Kline was pushing the boundaries of representational art and exploring different approaches to abstraction while continuing to take subjects from his everyday surroundings. His palette varied in color and range, although important aspects of his process remained rooted in his academic training, and his works from this time chronicle his quest for a distinctive visual vocabulary. Kline struggled financially for much of this decade. The abandoned images that are sometimes found below those on the surface of a painting indicate the reuse of supports, likely because of his constantly straitened circumstances. Drawings that survive from this period are usually small and on inexpensive papers.

In 1939, Kline was living in Lower Manhattan without a steady source of income, trying to make ends meet for himself and his new wife, Elizabeth. An important point of entry to the Greenwich Village art scene was Kline's stall at the Washington Square Outdoor Art Exhibit, where in the late summer of 1940 he won a $10 or $15 prize awarded by the Whitney Museum of American Art for a pen and ink drawing (Gaugh 1972, 409–10). Several undated photographs of Kline's stall in the Archives of American Art show that he displayed small framed paintings and works on paper (Gordon 1968, 11 [illus.]).[1] Kline bought and refinished frames to prepare his works for sale, and he also sold empty, refinished frames as a source of income (Gaugh 1972, 355; Gaugh 1985b, 177). Determined to make a living as a professional artist, Kline took odd jobs to supplement his income; he worked as a portrait artist at the 1939 World's Fair in New York, drew caricatures in bars, and painted backdrops for the theater (Gaugh 1972, 92–93, 408–9). Kline and his contemporaries described such efforts as "buckeye work"—stale, prosaic jobs with little artistic merit (Gaugh 1985b, 17)—but Kline chose this over physical labor or work in the service industry. With the aid of a loan from Miss Mathilda A. Roedel, his English teacher at Lehighton High School, Kline purchased a used printing press with the idea of going into commercial printing (Gaugh 1972, 27), although he seems to have used it mostly to make Christmas cards. Franz and Elizabeth lived in near-poverty for much of the 1940s. The financial pressures would increase when Elizabeth's mental health declined and she needed consultations, treatment, and, eventually, admission to a mental hospital.

The providential appearance of two key patron-supporters around 1940 made it possible for Kline to continue to be a practicing artist. Theodore J. Edlich, a physician whom Franz met when he made a house call to the Klines' apartment, eventually purchased some thirty-five works from Kline (de Kooning 1962, 65; Gaugh 1972, 408); and

I. David Orr, a Long Island businessman who may have met Kline through contacts at a Greenwich Village gallery or at his Washington Square art stall, purchased a total of 150 canvases (de Kooning 1962, 65; Kline and de Kooning 1962, 11). A photograph of Orr standing in front of some of his many works by Kline was published by Elaine de Kooning (1958b, 95).

The early works preserved in the family collections of Edlich and Orr provide important evidence of Kline's artistic genesis. These collections contain, in addition to the watercolors and ink sketches made for his Washington Square stall, a large number of small-format paintings in oil on canvas, Masonite, academy board, and even corrugated cardboard. Subjects included New York street scenes, Pennsylvania landscapes, studio interiors, self-portraits, paintings of Nijinsky as Petrouchka, and still lifes with marionettes or puppets (Gaugh 1972; Boime, Kline, and Mitchell 1977; Gaugh 1985b). His patrons also commissioned work: Kline painted portraits of David Orr's family (some are illustrated in Gaugh 1985b, 46), and he painted a portrait of Mahatma Gandhi and a three-fold screen with a view of Washington Square for Theodore Edlich (Gaugh 1985b, 46).[2]

As Orr lived on Long Island, a substantial journey from Manhattan, Kline was allowed to set up a studio in the Orr household; this may have been welcome for several reasons. Easing the burden and cost of travel was important, but perhaps so was obtaining a brief respite from the "bohemian" life of an artist; Kline once defined a bohemian as "someone who could live where animals would die" (O'Hara 1958, 62) (fig. 2.1). Time spent with the Orrs also allowed him to experience the stable family life that had been absent during long periods of his childhood (Gaugh 1985b, 173). Thanks to Orr, we know that Kline would often revisit and revise his work, sometimes repainting it entirely, as in the case of *Green Night* (Gaugh 1972, 414).[3] This painting was Kline's submission to the 120th Annual National Academy of Art show. After the show, while working at the Orr residence, Kline tried to lighten the tonality of the work but found it difficult and eventually painted over the entire composition.

Although he took trips to Long Island to work for the Orrs and to Pennsylvania to visit his family, Kline was very much a creature of Lower Manhattan. Frequenting junk shops and pawnshops, at least partly in pursuit of inexpensive frames, he encountered Mr. von Brandenberg, affectionately known as "The Major," who had a shop on West Fourth Street (Gaugh 1985b, 41). The Major, who may be the "Major von Branden-burg" who served as chair of the Washington Square Outdoor Art Exhibit in the 1950s (43rd Washington Square Outdoor Art Exhibit 1953), gave Kline a tuxedo kitten named

FIGURE 2.1
Undated photograph, likely from the early to mid-1940s, of the Klines' "bohemian" apartment, with their cat, Kitzker. The bare kitchen reflects their constant state of penury during this time.

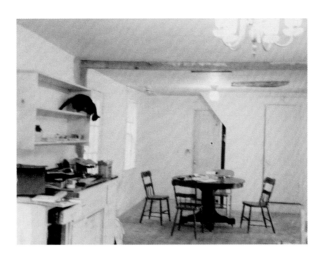

FIGURE 2.2
Franz Kline, *Season's Greetings*,
1940. Etching with plate tone,
13.65 × 12.54 cm (5⅜ × 4¹⁵⁄₁₆ in.)
(plate), 16.99 × 13.65 cm (6¹¹⁄₁₆ ×
5⅜ in.) (sheet). Gift of Edith
and Norman Garmezy in honor
of Richard J. Campbell, in
recognition of his twenty years of
service to the Prints and Drawings
Department, Minneapolis
Institute of Art, 2002.246.

This etching prominently features
the rocking chair that would
become a motif in many of Kline's
figurative works. Kline is standing
at his easel with Elizabeth beside
him, and Kitzker is sitting on the
table. The printing press used to
create this print is shown behind
Kitzker to the left.

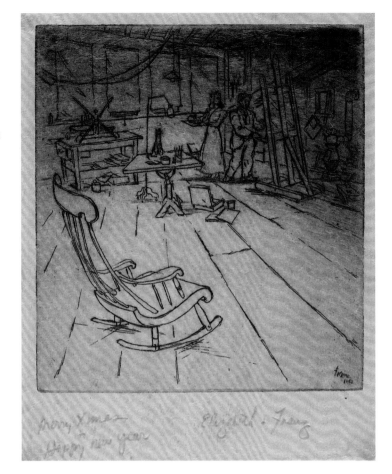

Kitzker or Kistka, who appears on the Klines' 1940 Christmas card (fig. 2.2) and in several paintings and drawings (Gaugh 1985b, 41).[4] Also in the Christmas card etching is a rocking chair; Kline picked it up at a junk shop in the Bowery and featured it in many of his interior sketches and paintings of the 1940s (Gaugh 1972, 109). It is likely that the Washington Square exhibit was where Kline first met Earl Kerkam and through him, Conrad Marca-Relli and Peter Agostini, artists who would form the core of Kline's first group of friends and colleagues in the Downtown art scene and would later provide introductions to other important figures such as Willem de Kooning, who came to exert significant influence on Kline's artistic trajectory.[5]

In August 1940, Kline began work on a commissioned set of paintings for the Bleecker Street Tavern. Whitey, the bar owner, instructed Kline, "Paint me girls";[6] paintings of risqué subjects served as substitutes for the burlesque shows that had been outlawed in Manhattan in the late 1930s. The Bleecker Street Tavern mural series comprised eight to ten paintings,[7] including *Circus Rider* (National Gallery of Art [NGA]), *Bubble Dancer* (NGA), *Apache Dancer* (NGA),[8] *Dancer in a Red Skirt* (NGA), *Hot Jazz* (Chrysler Museum of Art, Norfolk, VA), *Dancing Couple* (private collection), *Masked Ball*, and *Singing Waiter*; the whereabouts of the last two works are currently unknown (Gaugh 1985b, 36–39; Joselow 2004) (fig. 2.3).[9] Most of the extant paintings are 114 × 114 cm (45 × 45 in.) and are the largest works on canvas created by Kline to this point; the other two, *Singing Waiter* and *Dancing Couple*, are 91 × 79 cm (36 × 31 in.). Notes in the files of Elisabeth Zogbaum,[10] Kline's second partner and executrix, relate: "Whitey, unlike the 'understanding' barkeep of romantic story, offered $5 per large canvas; when

FIGURE 2.3
Franz Kline, *Dancer in a Red Skirt (Fiesta)* (Bleecker Street Tavern mural), 1940. Oil on canvas board, 115.57 × 115.57 cm (45½ × 45½ in.), National Gallery of Art, Washington, DC, Woodner Collection, Gift of Dian Woodner, 2014.145.4.

FIGURE 2.4
Infrared reflectogram of *Dancer in a Red Skirt (Fiesta)* (Bleecker Street Tavern mural). No under-drawing or grid lines are visible, and there are no changes to the composition. This suggests that Kline, though likely working from a preliminary sketch, did not transfer his drawing to the canvas.

Kline insisted on the canvas being supplied, Whitey grabbed his arm, swore through his teeth like a burlesque character and yelled at him to get out. But he eventually paid for the canvas plus the $5 commissions."[11] The paintings now held by the National Gallery of Art are oil on canvas, mounted onto a secondary fiberboard support with polyvinyl acetate. Canvas panels were commercially available in the 1940s and 1950s, but the sizes advertised are much smaller than these paintings, and many of the NGA works exhibit bubbling and loss of adhesion between the canvas and the fiberboard, possibly an indication that the mounting was noncommercial. In 1960, the paintings, which had been installed on the barroom walls with flour paste, were removed, mounted, preserved, and framed for a 1961 exhibition at the Collector's Gallery,[12] so the mounting may date from this time (Joselow 2004). The NGA paintings have "Bar Room Painting 1940" and Kline's "logo"—a backward "F" joined with a "K" (perhaps adapted from that of Toulouse Lautrec [Kingsley 2000, 104])—in ligature written on the fiberboard, which could have been added by Kline himself in 1960 or 1961, after they were mounted.

Examination of the four Bleecker Street Tavern paintings held by the NGA provides insight into Kline's materials and working technique at this early point in his career. Infrared reflectography, an imaging technique that can penetrate surface paints to detect underlying carbonaceous materials, shows no indication of underdrawing or enlargement grids in *Dancer in a Red Skirt* (fig. 2.4), and no preparatory sketches for these paintings are known. However, the compositional complexity of *Dancer in a Red Skirt* and *Circus Rider* suggests that these may well have been worked out beforehand. X-ray fluorescence (XRF) analysis of *Dancer in a Red Skirt* and *Apache Dancer* indicates that the paintings have at least one layer of white ground containing barium sulfate and zinc white and/or lithopone (as the latter is a mixture of barium sulfate and zinc sulfide, these materials cannot easily be distinguished by elemental analysis). The presence of expensive pigments such as cadmium red and yellow suggest the use of artists' paints but not necessarily high-quality ones, as a light-sensitive, fugitive pigment (Pigment Red 90, a lead eosin lake) may be present on *Dancer in a Red Skirt*. The binding medium in all cases is primarily a drying oil, but some phthalates, species indicative of alkyds, were detected in a sample taken from *Circus Rider*. The ratio of phthalate to azelaic acid is low, indicating that while an alkyd may be present, it is not the predominant

binder. Markers indicative of colophony (pine resin) are seen in samples from *Circus Rider* and *Dancer in a Red Skirt*. This material is often added to retail trade paints to increase their gloss, leveling, and durability;[13] its presence suggests that Kline may have used a mixture of artists' and non-artists' materials for this large commission. This would be an understandable economizing measure, especially in light of the low fee he was paid. However, the amount of colophony detected is not high, and cheaply made turpentine, which Kline used to clean his brushes and thin his paints, can also contain colophony and thus might be a source for this material. Dammar resin is detected on samples from these two paintings and could indicate that Kline varnished them after completion, which would have provided protection in a smoky and rowdy barroom environment. As previously noted, the paintings were subject to conservation after their removal from the tavern in 1960 (Joselow 2004),[14] so the dammar could derive from a later intervention. However, the current surface varnish of *Circus Rider* appears to be poly(n-butylmethacrylate) (p-nBMA), a polymer not introduced until 1947; it therefore seems likely that the dammar corresponds to remnants of an original varnish that had been incompletely removed before the application of the p-nBMA varnish.

The four Bleecker Street Tavern murals are thinly but vigorously painted with strong, dark lines used to reinforce the edges of the primary figures. The brushwork is loose and dynamic, particularly in *Apache Dancer* and *Circus Rider*. Kline's choice of contrapposto poses for the female figures depicted in *Circus Rider* and *Hot Jazz* and the angular poses in *Dancer in a Red Skirt* and *Apache Dancer* create a sense of agitated movement. In the tension generated by Kline's balancing of dynamic angles we may see elements that anticipate his mature abstract compositions.

In addition to painting commissions, Kline continued to create work for himself. One recurring and intensely personal subject for him was Vaslav Nijinsky in his role as Petrouchka in the eponymous Stravinsky ballet. Kline first encountered the publicity photograph of Nijinsky in Petrouchka costume and makeup taken by the firm of Elliott and Fry in 1936 (fig. 2.5); in this photograph, Nijinsky, his face painted with white clown's

FIGURE 2.5

Vaslav Nijinsky in the Title Role of Petrouchka, 1910–11. Dover Street Studios, 9.84 × 14.44 cm (5 11/16 × 3 7/8 in.), mounted on board, 35.56 × 50.8 cm (14 × 20 in.), Jerome Robbins Dance Division, Roger Pryor Dodge Collection, New York Public Library No. 2054.

This is the photograph taken by the firm of Elliott and Fry on which Kline based at least five paintings.

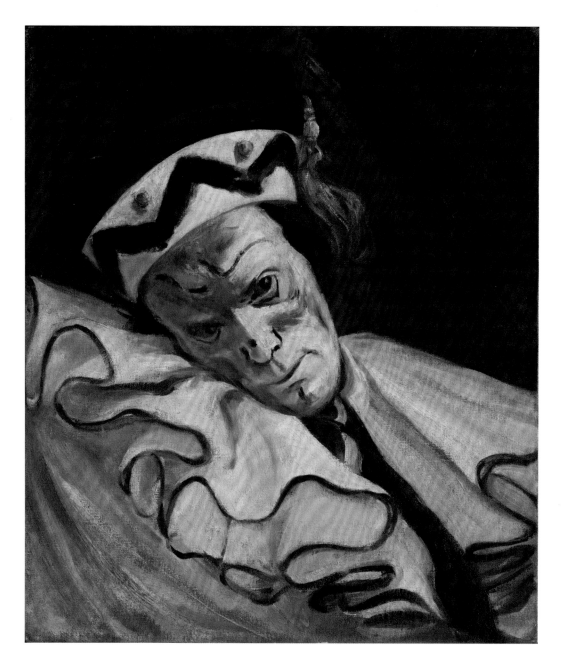

FIGURE 2.6
Franz Kline, *Nijinsky*, 1940. Oil on canvas, 56.5 × 46.4 cm (22¼ × 18¼ in.), The Metropolitan Museum of Art, New York, Gift of Theodore J. Edlich Jr., 1986, 1986.406.2.

makeup, wearing a ruffled collar and tasseled hat, rests his head against his shoulder and gazes at the viewer with an arresting expression of sorrow and distress (Gaugh 1972, 226). During their courtship in London, Elizabeth shared with Kline her copy of Romola Nijinsky's account of her husband's life, which also included a reproduction of this photograph. Kline's recurring depiction of this poignant and romantic figure—half man, half puppet, rejected and misunderstood, whose life ends tragically—suggests that he saw this character as an alter ego (Gaugh 1985b, 67–73). Indeed, Kline told Elizabeth, "I have always felt like I'm like a clown and that my life might work out like a tragedy, a clown's tragedy" (Gaugh 1972, 227).

Kline painted at least five portraits of Nijinsky as Petrouchka between 1937 and 1948 (Gaugh 1972, 231–36), including the 1940 canvas *Nijinsky* (fig. 2.6), purchased by Edlich, who gave it to the Metropolitan Museum of Art (MMA) in 1986. Kline signed

FIGURE 2.7

Elemental distribution maps obtained by MA-XRF in the area of Nijinsky's face. Elements shown include zinc (Zn), barium (Ba), calcium (Ca), lead (Pb), chromium (Cr), and iron (Fe). The white of Nijinsky's face is made with zinc- and barium-containing paints, the blacks with a calcium-containing pigment, most likely a bone or an ivory black, and chromium- and iron-containing pigments are also present in the darker tones and shadows to create modeling. In the barium distribution map, there is an overall, relatively weaker contribution from barium in the ground.

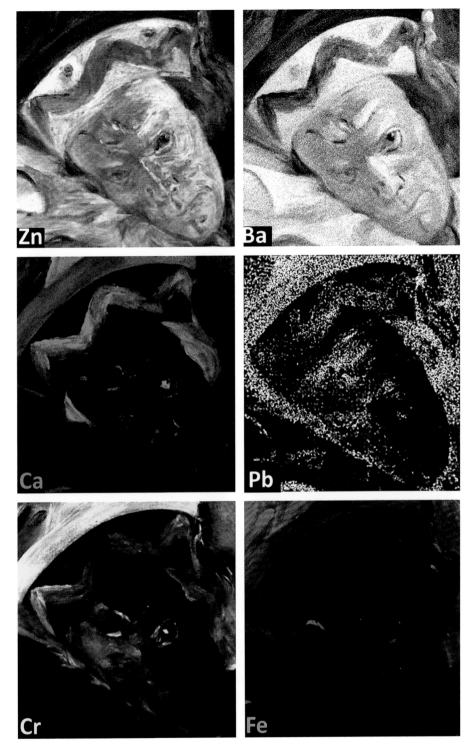

and dated the work and on the stretcher inscribed his address at the time, "71 W 3rd ST NYC," where the couple had moved in January 1940 (Gaugh 1985b, 177). The white ground contains lithopone (barium sulfate and zinc sulfide), calcite, and coarse particles of lead white, which suggests a commercially prepared canvas but not one of high quality. The use of a commercially primed canvas and the absence of underlying compositions—Kline often reused or repurposed supports during these years of financial

hardship—suggest that Edlich may have commissioned the portrait or provided funds that enabled Kline to splurge on a new canvas. No underdrawing or changes to the composition are detected under the paint layer with infrared reflectography, indicating that Kline was in complete control of this composition and painted it *alla prima*.[15] David Orr recalled that Kline had so thoroughly internalized the lines of Nijinsky's face, having painted it over and over, that he could paint it blindfolded (Gaugh 1985b, 71).

Kline's paint application in *Nijinsky* is both skillful and economical and demonstrates his proficiency in traditional painting techniques. The thin gray wash layer that he applied over the ground and allowed to drip down all tacking edges neutralizes the white ground and deepens the dark reddish dramatic background for Petrouchka's figure, which serves as a warm backdrop for the subtle cold shades of white modeling of the clown's face and costume. Kline did not mix his paints on the palette but rather blended them directly on the canvas to create different tones, working wet-in-wet, thinly, and using the dark background to his advantage. A photograph (probably posed) of Kline taken while working on *Nijinsky* (Gaugh 1985b, 68) shows his plain palette, neatly laid out with dark pigments on the left and light tones on the right. Kline is holding several bristle brushes, each showing a different color. The crisp marks left by these brushes in the individual paint strokes attest to the direct and rapid painting process and to the confidence that Orr described.

The appearance and scale of this intimate portrait suggest that Kline probably used artists' oil tube paints to create *Nijinsky*; the pristine nature of the surface paint precluded sampling and media analysis to confirm this supposition.[16] However, nondestructive elemental analysis by macro area X-ray fluorescence (MA-XRF) scanning, which allows one to create maps showing the distribution of elements across the painting, has helped elucidate the pigments used in this work; the results suggest the presence of artists' paints. The paint used to depict the white, pasty makeup contains high levels of zinc and barium, which do not entirely co-localize, suggesting that multiple white paints may be present, perhaps including zinc white and lithopone (fig. 2.7). The presence of calcium in the blacks suggests the use of bone or ivory black. Other modestly priced pigments present in Kline's palette include iron-containing ochres, a chromium-based green such as viridian, synthetic ultramarine blue, and an iron-containing blue, most likely Prussian blue. The more expensive pigments cadmium red and cadmium yellow, indicative of artists' paints, are present in minor amounts and mixed with other pigments. The many shades of Petrouchka's white face and costume are the result of subtle blends of zinc white with other pigments, predominantly traces of blue, red, and green. From his traditional art training in England, Kline knew how to mix a small number of colors to create as many shades and tints as possible, and he used minimum paint for maximum effect with little buildup. A clear, evenly applied glossy coating is likely a modern synthetic varnish, but occasional darker residues visible in some of the deeper troughs of the white paint layer suggest that an aged natural varnish was once present. Apart from the presumed varnish removal and revarnishing, which occurred before Edlich donated the work to the MMA, the painting does not appear to have had any conservation treatment.

When the United States entered World War II in 1941, Kline, along with Conrad Marca-Relli, George McNeil, and John Little, went for a military physical examination but was excused from active duty as he had a dependent to support; it may also be that the doctors detected his rheumatic heart. Kline engaged in secretarial work for the military at Governor's Island but found that the small type of the documents required the use of magnifying glasses, which he detested, and he quit after a relatively brief time.[17] Kline was not the only artist to remain in New York City during the war: Earl

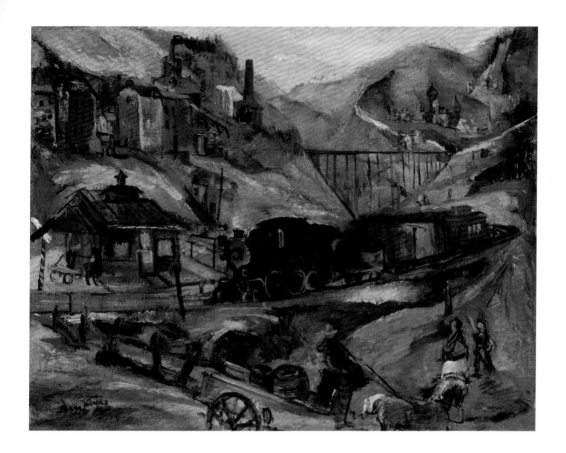

Kerkam (Shearer 2007) and Willem de Kooning, whom Kline would meet in 1943 at Marca-Relli's studio (Gaugh 1985b), were also exempt. In these years Kline continued to show his work; in 1942, he participated in the *116th Annual Exhibition* of the National Academy of Design (Gaugh 1985b), and the following year, he won the S. J. Wallace Truman prize (for a landscape painting by an artist under the age of thirty-five) for *Palmerton, Pa.* (fig. 2.8), at the Academy's *117th Annual Exhibition*. This significant prize ($300, or approx. $4,500 real wage value in 2021) was mentioned in the *New York Times*, the art critic Edward Alden Jewell (1943) writing, "Of the several landscapes thus honored, those by Henry Gasser and Franz Kline are perhaps the most pleasurable." Kline wrote to his mother with quiet modesty:

> Now for some real news that came to me as a complete surprise. First I entered two canvases for the annual National Academy of Art show which you know I exhibited in last spring. Well, they usually take only one picture; that's the rule. This year to my surprise they accepted and are exhibiting the two. And for one of them I have received a $300 prize.... The winning picture was a large painting from memory of Palmerton, Pa., the Lehigh valley—train yard, station and the hills leading home to Lehighton. The composition is slightly abstract and the mood of the painting seems to receive many compliments. Again it was selected from exhibitors from all over the country including work by members of the National Academy. So among hundreds or several thousands mine received the second highest prize award. I tell you I was never so surprised in my life for I would have been pleased enough just to have gotten in the show. I know all this will make you very happy. (Quoted in Gaugh 1972, 196)

Palmerton, Pa., Kline's first publicly acclaimed success, was painted using materials similar to those used in the Bleecker Street Tavern works and *Nijinsky*. The *Palmerton, Pa.* linen canvas was sized with a proteinaceous glue before the application of a lead white ground. The presence of unprimed canvas on the turnover edges suggests that Kline applied the ground himself rather than using a more expensive preprimed canvas. Although the overall tonality is somewhat muted, the pigments present likely include the expensive cadmium red and yellow, indicating the use of artists' paints. There is no visual evidence for the presence of a charcoal underdrawing, but certain outlined areas suggest that Kline may have laid in the composition using a thinned paint applied with a brush. He built up the image by initially thinly applying toning layers and then refining it with thick paint applied with both brush and palette knife. As with the Bleecker Street Tavern murals, he frequently used black lines to emphasize contours and refine details. After completing the work, Kline edged his composition by applying a relatively narrow line of black paint. This thin line would not show when the painting was framed and does not extend to cover the turnover edges, so it is unlikely that Kline intended this painted edge to function in lieu of a frame.

Kline described *Palmerton, Pa.* as "slightly abstract," and although Gaugh (1972, 197–98) acknowledged that Kline may have meant that the details were "summarily treated," he believed that Kline intended primarily to indicate that the painting evoked the Pennsylvania landscape rather than being strictly representational and true to life. Consistent with this, Robert S. Mattison (2012, 22–23) describes the work as a composite, partly imaginary view. In Kline's loose brushwork and masses of color, we see that he has begun to move beyond the requirements of realism and to adopt some of the visual language of other painters of his time; *Palmerton, Pa.* is especially evocative of some works by the Ashcan School.[18] This nascent abstraction slowly came to dominate much of Kline's work over the coming years, which were trying both personally and professionally. Financial struggles did not abate, and Kline continued to rely on the support of the Orrs and Edlich. He also picked up commissions such as the mural cycle for El Chico's restaurant and nightclub and the mural *Lehighton* (1945) for American Legion Post 314's assembly room (Gaugh 1972, 96–100, 202–6).[19] The $600 Kline was paid for *Lehighton* must have been especially welcome as Elizabeth's mental health had started to deteriorate. Initially, Kline brought Elizabeth to Lehighton to stay with his family—his mother was a trained nurse (Finsel and Finsel 2019, 124)—but her condition continued to worsen, and after several brief periods of hospitalization, she was admitted to the Central Islip State Hospital,[20] on Long Island, for treatment (Gaugh 1985a, 63–64).

During this time of personal difficulty, Kline continued his artistic exploration of the world he saw around him. He sketched incessantly; Elizabeth later said, "I remember a series of little sketches of *anything*, figures, cat, furniture, etc. in detail at first and gradually shedding all detail and then representing the subject with a few basic significant lines which retained the idea more than the image" (Gaugh 1985b, 77; original emphasis).[21] In his sketches of Elizabeth from the 1940s, which Kline kept until the end of his life, the artist explored the gamut of representation, from highly realistic to highly gestural (figs. 2.9, 2.10). Elizabeth said that in the early 1940s, Kline often drew her nude as she performed mundane tasks such as "washing dishes or ironing a shirt, etc., so that he would know what all the muscles were doing and how people moved" (Gaugh 1985b, 42). These sketches present Elizabeth as active, with detailed representations of her features. In later drawings, Elizabeth is often depicted clothed and in static poses such as sewing or sitting at a table; these sketches are more gestural, and her facial features are largely absent. Contemporaneous paintings and sketches of other subjects

FIGURE 2.9

Franz Kline, *Seated Woman Doing Handwork*, 1945. Graphite on coated paper mounted to paperboard, sheet (irregular) 22.86 × 24.13 cm (9 × 9½ in.), National Gallery of Art, Washington, DC, Gift of Rufus Zogbaum and Reina Schratter, 2016.60.8.

This realistic drawing depicting Elizabeth sewing exemplifies Kline's graphic skills.

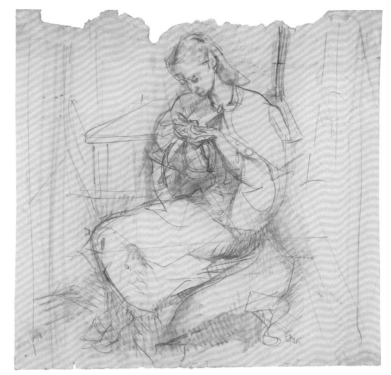

FIGURE 2.10

Franz Kline, *Figure in a Rocker*, 1946. Brush and black ink on wove paper, sheet (irregular) 22.86 × 17.78 cm (9 × 7 in.), National Gallery of Art, Washington, DC, Gift of Rufus Zogbaum and Reina Schratter, 2016.60.4.

Vigorously and gesturally painted, this small ink sketch depicts Elizabeth seated in a rocking chair. The addition of a black outline denoting the final composition is a common technique of Kline's, and the central squareish form at the base of the rocking chair will become a recurring motif in Kline's mature abstract works.

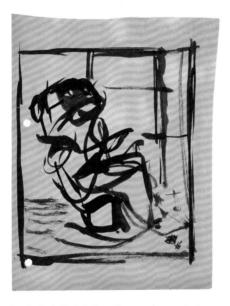

included facial details, so the omissions were specific to Elizabeth: when questioned by Orr as to why some sketches showed Elizabeth as featureless, Kline answered, "She isn't there anymore" (Gaugh 1985b, 43). It is tempting to relate the loss of detail in the depicted figure as an attempt to capture the distancing of Elizabeth from the world (Gaugh 1985a, 63–64; Kingsley 2000, 40–41; Anfam 2004, 50). Kline clearly struggled with how to portray his wife during her mental decline, and this struggle drove him to reexamine the most fundamental form of his artistic expression: sketching. However this experience might have informed his approach to abstraction, the sketches show that Kline was ready to reject otherwise effective aspects of his method in his search for an authentic means of expression. The many highly gestural sketches preserved from

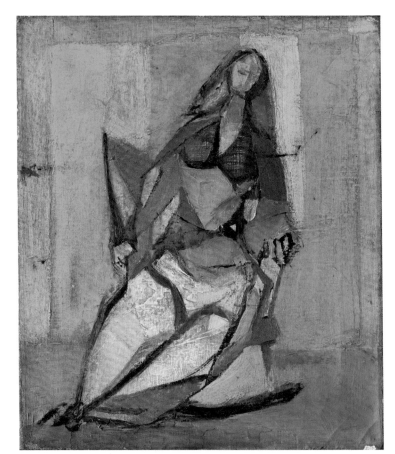

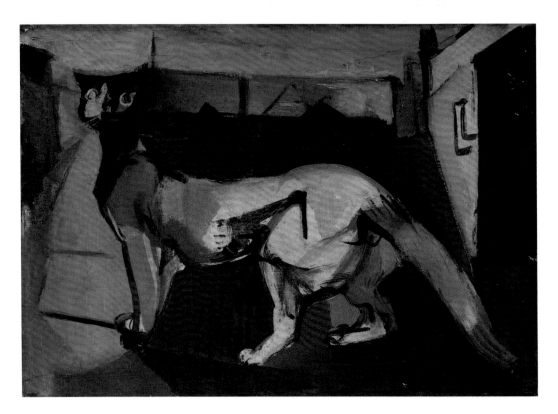

this time effectively convey emotion, and Kline would continue to pursue this quality in sketches and paintings in his fully abstract works throughout his life (Sylvester 1963, 10).

The home life that the Klines shared in the early 1940s must have changed with Elizabeth's mental decline, and it ended when she became an inpatient. Early in her institutionalization, Kline visited Elizabeth every weekend, but she continued to remain unresponsive, and her doctors eventually told Kline that his visits should be suspended (Gaugh 1985a, 63–64).[22] While this would not have freed him from worry, it meant that he had more time to devote to art and to a widening circle of friends and colleagues with whom he engaged, whether talking late into the night at someone's studio or over 15-cent beers at the Cedar Tavern (Gabriel 2018, 289). The Downtown artists' community was becoming close-knit and supportive, and the time that the gregarious Kline was able to invest in these contacts would benefit both him and the group, since this type of informal interaction eventually led to the formation of the Club. Marca-Relli recalled:

> It was a constant exchange. If I went and Franz was working I'd sit and have coffee with him, and he'd go on working; and if Bill [de Kooning] came to my place and I was working—same thing. The only break we'd take around 2 [a.m.].... [W]e'd go down and have a hamburger at Riker's[,]...then [we] came up again. Then we'd talk about Cezanne [sic] and maybe pull out a Velasquez [sic] print. We'd have conversations on art—it was the only food we had.[23]

It is in painted works from this period that we can first fully investigate Kline's working method. In 1998, Rufus Zogbaum, the son of Elisabeth Zogbaum, donated three works to the Metropolitan Museum of Art: *Woman in a Rocker*, *Kitzker*, and *Vase of Flowers* (figs. 2.11–2.13). These figurative small-scale works are indicative of Kline's private life and his evolving painting process during the mid-1940s, and they are intimately related in terms of their domestic subjects, draftsmanship, and palette. The

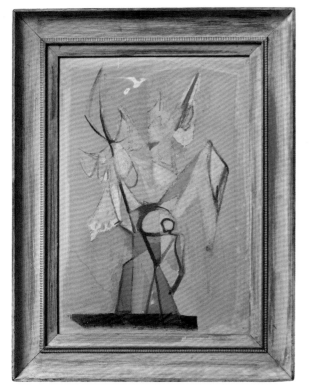
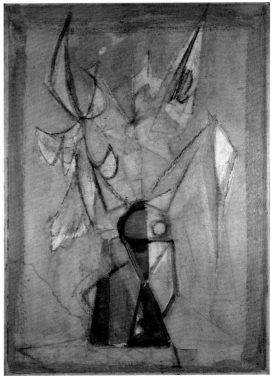

angular brushwork, gestural paint application, and juxtaposition of flat fields of emphatic colors all point to Kline's incremental shift toward abstraction.

The bold still life *Vase of Flowers* stands between figuration and abstraction with its frontal depiction and absence of pictorial depth; the color scheme is relatively cool, brightened by the yellow flowers. Kline painted the still life on a commercially prepared paperboard. The white ground layer is composed mainly of titanium white with calcite and gypsum, with very small amounts of zinc- and barium-containing particles. A fully developed drawing, in a carbon-based black medium, possibly charcoal, was revealed with infrared reflectography and is also visible where Kline left areas of the drawing in reserve (fig. 2.14). Kline filled in the original background around the drawing using bright blue-green paint. Pyrolysis/gas chromatography–mass spectrometry (Py/GC-MS) of microsamples (with and without tetramethylammonium hydroxide [TMAH] treatment) establishes that the blue-green paint contains large amounts of orthophthalic acid or phthalic anhydride, indicating the presence of an alkyd medium. Artists' alkyds were not available at this time, so the presence of an alkyd points to the use of a retail trade paint, such as interior wall paint (Learner 2000). Kline then painted the vase and flowers, including his characteristic thickly brushed outlines, mostly in dark brown, within the reserve he had left in the initial green background. The paint layer is generally thinly brushed on; however, Kline modified his palette as he went over some passages, sometimes more than once, with various shades of yellow, green, or blue. The palette is dominated by blue-green paints and includes bright pink-purple shades, similar to those he used in *Woman in a Rocker* and *Kitzker*. At some point, Kline revised the color scheme of this composition by loosely painting over the green background with a beige color, which in a few locations has intruded on the vase and flowers. The absence of dust particles between the blue-green and beige paint layers suggests that this could have been done fairly soon after completing the still life. The beige paint contains drying oil, likely linseed oil, and relatively high levels of colophony, suggestive of a retail trade paint.

Vase of Flowers has remained unvarnished and is in an American modern gilded frame that has been broadly brushed over with diluted white paint that extends unevenly over the outer edges of the picture, suggesting that it was applied after the painting was framed. The binding medium (a drying oil, possibly walnut, suggestive of an artists' paint) and the pigments (gypsum, calcite, and barium sulfate) on the frame are identical to those of a white paint used in the composition. The simplest explanation is that once Kline finished the work, he framed it, took the white paint used in *Vase of Flowers*, diluted it, and applied this wash over the frame and edges of the work. As the frame does not appear to be damaged, it is unlikely that the wash was intended to mask condition issues. Because Kline purchased and refinished frames, he would have had other choices for framing this piece, so this unusual, bold treatment may have been intended to integrate the semiabstract work and its gilt frame.

In addition to the portraits of Nijinsky, a recurring motif in Kline's work in the early to mid-1940s is the wooden rocking chair that he rescued from a Bowery junk shop (Gaugh 1972, 109). Kline made numerous sketches and paintings of the rocking chair, often with Elizabeth seated in it; both the chair and his wife "were inextricable from his life as an artist" (Gaugh 1985b, 42). *Woman in a Rocker* (see fig. 2.11) features a frontal depiction of Elizabeth in the rocker; her figure fills the picture plane, and the large chair, her long skirt, and the large blue shawl enveloping her are suggestive of an enthroned Madonna. The long, receding, vertical, nearly monochromatic rectangles suggest the wood-paneled wall in their modest apartment that is seen in other contemporary interior scenes. The work was painted on an ANCO standard-size canvas

no. 10 (40.6 × 35.6 cm [16 × 14 in.]) bearing the Long Island company's red ink stencil on the left stretcher bar. This type of stretcher—full-mitered slot mortise-and-tenon joint with keys—made with lightweight white pine was very common and widely used by American artists in the twentieth century (Buckley 2013, 151). The commercially applied ground layer contains lithopone, possibly talc, and anatase, along with traces of a lead-containing compound, likely lead white. Cross-section samples from *Woman in a Rocker* show numerous painting campaigns, although X-radiography does not reveal any information about the underlying compositions. The painting may be opaque to X-rays because Kline covered the earlier images with white ground layers containing anatase, calcite, and possibly talc, along with relatively smaller amounts of zinc white and other opaque pigment particles; this composition is suggestive of an inexpensive retail trade paint (fig. 2.15). The absence of mixing of the different paint layers indicates that the underlying layers had sufficient time to dry before Kline began the next painting campaign. Kline's reuse of store-bought canvases is not at all surprising given his financial situation at the time. In the case of one commission, Kline was asked by three brothers to paint a portrait of their deceased father from a photograph. As the painting migrated from the house of one brother to another, each in turn asked Kline to revise it, and in seeking to recover an early state of the father's likeness, the underlying Kline self-portrait was eventually revealed (de Kooning 1958b, 95).

No specific sketches for *Woman in a Rocker* are known, but Kline was using small sketches as the basis for at least some of his work at this time, including *Elizabeth at Table* (1947) (fig. 2.16). After completing the sketch, Kline would often outline his subject, likely to indicate its final composition or format (Gaugh 1985b, 50) (see fig. 2.10). Although the outlining suggests a decision about format, the ensuing work does not entail a slavish replication of the sketch as painting, as can be seen by overlaying the sketch and the painting. The use of a sketch as a study that would be elaborated or that would evolve during the act of painting would recur throughout Kline's career. The small size of his painted works at this time may have meant that rather than transfer or replicate his sketch on the canvas, he instead used a sketch on paper as a reference while painting. A photograph of *Elizabeth* (1946) in an incomplete state shows no apparent underdrawing on the canvas (Gaugh 1985b, 77);[24] instead, Kline builds up the composition from a series of colored planes. Infrared reflectography of *Woman in a Rocker* does not show any evidence of a dry medium underdrawing beneath the outlines of Elizabeth, but the thick lines of the bone or ivory black paint used by Kline would likely preclude their detection.

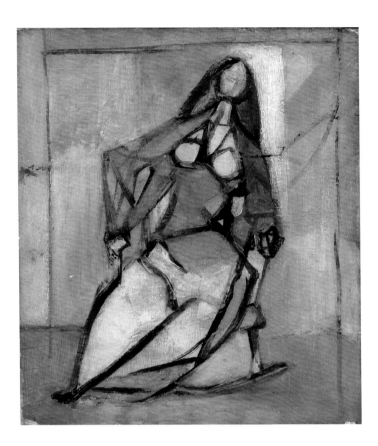

FIGURE 2.17
Infrared reflectogram of *Woman in a Rocker* showing compositional changes. Kline shifted the back of the rocking chair behind Elizabeth from the right to the left, creating counterbalance between the figure and the rocker.

Examination of *Woman in a Rocker* indicates that after applying a new white ground to cover the prior composition and allowing it to dry, Kline first brushed thick black lines to define the picture plane and anchor the figures within the composition. These prominent angular painted strokes outline the figure but also articulate and "cut" through it, resembling the inner wire armature of clay sculptures. These strong gestural painted lines were brushed on in the manner of a quick sketch, indicating major vector lines and framing his model/subject in a three-dimensional space. Kline used broad brushstrokes to paint the background and the rocking chair and a palette knife to paint the figure. With the knife he filled in colors within Elizabeth's bold outlines, often painting over them and reinforcing them later, sometimes more than once, with various shades of dark blue, purple, greens, and earth colors to contrast with and complement the adjacent flat fields of color. Microscopic examination indicates that he worked simultaneously on figure and background, going back and forth, as evidenced by paint casually overlapping the thick outlines (some of these intrusions can be seen with the naked eye), revisiting background colors and the figure's contours. Compositional changes are also detected in the infrared reflectogram (fig. 2.17), revealing that he edited outlines of the rocking chair on the right but later added them on the left as he modified the outlines of the figure's right shoulder and arm. With these modifications, Kline changed the spatial dynamics of the composition: Elizabeth's diagonal posture is now counterbalanced against the rocker, and both stand forward from the vertical lines of the background.

In *Woman in a Rocker* Kline applied different paint colors on top of one another, and any blending that occurred resulted from the scraping and smearing action of the palette knife or from wiping the top paint layer, possibly with a cloth. This is clearly visible in Elizabeth's bust, where the cadmium red paint appears and disappears beneath

some blue paint on the left and a thick layer of paint containing a synthetic organic pink pigment on the right. In these areas, the scraping is deep enough to reveal both the black outlines and the white ground layer, creating a striation pattern. Rather than paint Elizabeth's facial features, Kline deeply scored them into the fresh paint used for her face, and he used the same technique to add some minor lines in the upper right and lower left background. The bold draftsmanship and carefully balanced composition of this small and vividly colorful figurative painting clearly forecast Kline's large abstract black and white compositions of the 1950s. After he finished the composition of *Woman in a Rocker*, Kline applied a white paint, mainly composed of barium white, to the tacking edges. Presumably Kline wanted to clean up the edges, which would have shown evidence of multiple painting campaigns. Kline would sporadically return to this practice throughout his career: the tacking edges of his large black and white paintings of the 1950s and 1960s were often finished with white paint after he had stretched them to their final dimensions.

Kitzker (see fig. 2.12) is the only known full-size painted portrait of the Klines' beloved tuxedo cat, who appears in other domestic scenes from the 1940s, including the holiday card shown in figure 2.2 (Gaugh 1985b, 41). The composition of *Kitzker*, while still figurative, is moving further toward abstraction than either *Vase of Flowers* or *Woman in a Rocker*. The approximately life-size pet portrait is highly stylized, and the colorful background is fragmented and nonrepresentational, though the cat is presumably standing in their studio apartment. The *Kitzker* stretcher is of construction and wood type similar to that of *Woman in a Rocker*, but it is larger and lacks a visible manufacturer's stencil on the reverse. The commercially applied ground layer differs from that of *Woman in a Rocker*; it is composed mainly of calcite and barium white or lithopone, suggesting that this prepared canvas came from a different manufacturer. As he had done for *Woman in a Rocker*, Kline reused a canvas to paint *Kitzker*. X-radiography reveals only a few broad geometrical shapes, somewhat suggestive of Kline's paintings of his studio from the mid-1940s. No underdrawing is visible by infrared reflectography, and *Kitzker* was decisively painted, with no contour adjustments. Kline mostly built the composition brushing on large flat areas of color, reserving his palette knife to accent a few features in the background.

Woman in a Rocker and *Kitzker* were painted using similar techniques, and these two intimate paintings also have a similar palette. Kline's prominent black outlines and use of shades of greens, blues, purples, and beige locate these works within a very specific period. Undeniably, the most dominant and ubiquitous color in these works is a turquoise blue-green created using a copper phthalocyanine-based synthetic organic pigment, which Raman spectroscopy indicates is a phthalocyanine green (PG7). The same pigment may also be present in the blue-green color in *Vase of Flowers*. In *Woman in a Rocker*, Kline composed the entire abstract background using various tints of this pigment; MA-XRF scanning reveals that he did so by mixing the blue-green paint with varying amounts of barium- and zinc-containing whites (fig. 2.18). In *Kitzker*, Kline modified the blue-green tone of phthalocyanine green by mixing it with another synthetic organic colorant, phthalocyanine blue (PB 15:3). The very high color intensity of the copper phthalocyanine-based pigments allowed Kline to "stretch" this paint by mixing very small amounts with other pigments, no doubt for reasons of economy. Although he primarily used phthalocyanine green, Kline showed more variation in his choice of blue pigments. In *Kitzker*, in addition to the phthalocyanine blue, he used cobalt-based blue paints, likely including both cobalt blue and cobalt stannate cerulean blue, and the blue tones in Elizabeth's hair and dress in *Woman in a Rocker* were created using cobalt blue. Kline's painted outlines are calcium-rich, suggesting an ivory or bone

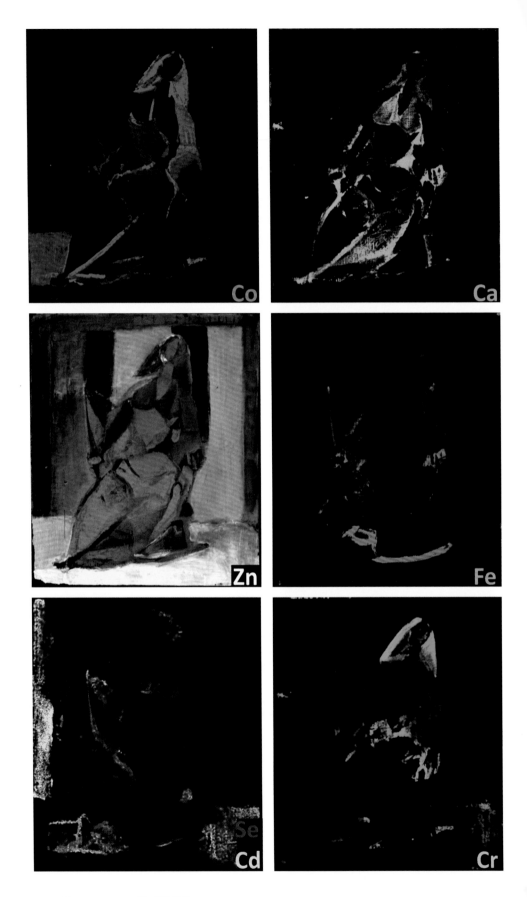

FIGURE 2.18
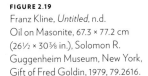

Elemental distribution maps obtained by MA-XRF in *Woman in a Rocker*. Elements shown include cobalt (Co), likely cobalt blue; calcium (Ca) in bone or ivory black; zinc (Zn) as zinc white and/or lithopone; iron (Fe), most likely due to Prussian blue; cadmium (Cd) as cadmium sulfide yellow and, where co-occurring with selenium (Se), as cadmium sulfoselenide red; and chromium (Cr) as viridian or chrome green.

black pigment. Lead white; zinc-, copper-, and iron-containing pigments; cobalt blue; and relatively smaller amounts of the more expensive pigments chromium-based green and cadmium red all define particular features in *Woman in a Rocker*.

Analyses of samples of blue-green and blue paints from *Woman in a Rocker* and *Kitzker* reveal that the binding media of the paints are oils: no alkyds were detected. In contrast, the blue-green paint of *Vase of Flowers* is an alkyd, and Kline's use of the same phthalocyanine green pigment in different media reveals that he was particularly drawn to that color, purchasing paints because of their hue and not on the basis of their binding media. The fatty acid profiles of one sample from *Kitzker* suggest that both linseed and safflower oil are present; the latter is an inexpensive oil sometimes added to linseed oil in retail trade and industrial paints. The possibility that inexpensive fish oil is present in samples from both paintings cannot be excluded. The definitive presence of colophony in one of the samples of blue-green paint from *Woman in a Rocker* and the blue paint from *Kitzker* further supports their being retail trade paints, not artists' paints. Both works have a yellowed coating, and under ultraviolet illumination they exhibit a milky green fluorescence typical of a natural resin varnish, most likely dammar, which was found in the varnish on *Dancer in a Red Skirt* (1940). The very uneven application and deep yellowing of the coatings suggest that these are the varnishes applied by Kline in the mid-1940s; neither painting has been cleaned or treated since entering the Metropolitan Museum's collection in 1998.

The work that Kline identified as his first truly abstract painting, *The Dancer* (1946) (Gaugh 1972, 286–87; Gaugh 1985b, 74 [illus.]),[25] has a very dark tonality accented by areas of thickly applied yellow, quite different from the cool palette of the contemporaneous works *Vase of Flowers*, *Woman in a Rocker*, and *Kitzker*. The colored forms in *The Dancer* are built up very differently from these earlier works, and the compositional balance that becomes such an important aspect of Kline's later, mature work is absent here. In contrast to *The Dancer*, the abstract painting *Untitled* (n.d.) (fig. 2.19), in the Solomon R. Guggenheim collection, bears a clear resemblance to Kline's mid-1940s paintings,

FIGURE 2.19

Franz Kline, *Untitled*, n.d. Oil on Masonite, 67.3 × 77.2 cm (26½ × 30⅜ in.), Solomon R. Guggenheim Museum, New York, Gift of Fred Goldin, 1979, 79.2616.

Although undated, this fully abstract work is evocative of *Woman in a Rocker* (ca. 1945).

FIGURE 2.20

Franz Kline, *Untitled*, 1948. Oil on canvas, mounted on Masonite, 97.1 × 75 cm (38³⁄₁₆ × 29½ in.), Solomon R. Guggenheim Museum, New York, Gift of Alexander Abraham, 1979, 79.2625.

The dark, rather muddy tones of this work are quite distinct from the brighter palette Kline used in the mid-1940s.

FIGURE 2.21

Franz Kline, *Untitled*, 1947. Brush and black ink on wove paper, 43.3 × 67 cm (17¹⁄₁₆ × 26³⁄₈ in.), National Gallery of Art, Washington, DC, Gift of Edward R. Broida, 2005.142.24.a.

This brush drawing reveals Kline exploring the possibilities of abstraction created through line. "White drawings" of this type most clearly presage his mature black and white abstractions.

FIGURE 2.22
Franz Kline, *Untitled*, ca. 1948.
Oil on canvas, 96.5 × 80.9 cm
(38 × 31⅞ in.), Solomon R.
Guggenheim Museum, New York,
Gift of Alexander Abraham, 1979,
79.2624.

Kline created many of the lines in
this painting by deeply scoring
through wet paint and utilizing the
presence of underlying paint of
a lighter color to create contrast.

particularly *Woman in a Rocker*, although the color palette is warm rather than the cool green-blues of *Woman in a Rocker* and *Kitzker*. Though *Untitled* is fully abstract, the black brush lines are evocative of a woman's figure, and the flat planes of color create a more harmonious composition than is found in *The Dancer*; unfortunately, *Untitled* is undated and cannot be definitively located within Kline's early abstract oeuvre.

Examination of works definitively dated to the 1940s makes it clear that Kline's path to abstraction was neither easy nor straightforward. He experimented with color, from the bright, almost fauvist palette of the landscape *Untitled* (1946)[26] and *Rocker* (1948) (Gaugh 1985b, 83) to the dark tonalities of *The Dancer* (1946), *Self Portrait* (ca. 1945)[27] and *Untitled* (1948) (fig. 2.20). He began to explore the use of abstract lines in what Gaugh (1985b, 78) termed his "white drawings" (fig. 2.21), and a series of oil paintings from around 1948 also has strong linear elements (see figs. 2.20, 2.22). In some cases, as in *Untitled* (ca. 1948) (fig. 2.22), Kline created the lines by scoring through thick paint layers with a tool, perhaps the back of a paintbrush, a technique that he also used in *Woman in a Rocker*. A 1948 photograph of Kline in his studio shows artists' paint tubes on the table next to his easel and, on the floor, a can of white house paint (Gaugh 1985b, 83); the paint label is not clearly shown, but the last two letters of the brand name are "EN," so it may be a Glidden or Behlen house paint. Although clearly staged, the photograph indicates that Kline was using both artists' and retail trade paints at this point, as was suspected from analysis of the earlier works. In addition, analysis of two

FIGURE 2.23

Cross-section sample taken from *Untitled*, ca. 1948, 79.2624. The black paint was applied while the underlying green paint was still wet, resulting in wet-in-wet mixing. The clean interfaces of the other paint layers reveal they were applied when the underlying layer was already dry.

0.2 mm

untitled paintings in the Solomon R. Guggenheim Museum (79.2625, 79.2624) shows that some white paints have high levels of silicate fillers and colophony, suggestive of retail trade paint. The use of diverse supports, including canvas and fiberboard as well as scavenged items such as a canvas ledger cover (Gaugh 1985b, 76), indicates that financial constraints still strongly influenced the materials Kline used. Nevertheless, Kline began to utilize larger canvases for both figurative and abstract works. *Large Clown (Nijinsky as Petrouchka)* (1948), at the Wadsworth Atheneum Museum of Art, Hartford, CT is almost 3 feet high; another abstract painting, from the Guggenheim collection, *Untitled* (1948; 79.2615), is approximately 3 ft. × 5 ft. In these works, Kline is moving closer to the scale of the paintings he would show at the Charles Egan Gallery in 1950; his interest in working on a larger scale may have been influenced by his experience with the decorative commissions *Lehighton* and the Bleecker Street Tavern murals.

Many of the paintings that Kline made in the mid- to late 1940s manifest a material record of his struggle to actualize his internal visions. His earlier works such as *Palmerton, Pa.*, the Bleecker Street Tavern murals, and *Nijinsky* (1940) are thinly painted with minimal layering. In contrast, many of his works from the mid- and late 1940s are very thickly layered; cross-section samples reveal the presence of up to twelve different paint layers. The paints are sometimes applied wet-in-wet with the different colors mixing, but in many cases the new paints were applied to already dried surfaces (fig. 2.23). Thus Kline seems to have revised works both during the act of painting and after a period of thought and reflection. Elaine de Kooning, writing for *ARTnews*, characterized Kline's process as "one of constant adjustment, refinement, addition and reduction, as he probed for the image in an approach closer to that of Ryder than to any other artist" (1962, 66). It is no coincidence that in later seminal works such as *Wotan* (1950) (see fig. 4.4.) and *Orange and Black Wall* (1959) (see fig. 6.2) we see the thickest buildup of paint as he strove first to simplify to black and white and then to allow color to remerge in his works.

3 Contextualizing Kline

Corina E. Rogge

The first work of the hero is to retreat from the world scene of secondary effects to those causal zones of the psyche where the difficulties really reside, and there to clarify the difficulties, eradicate them in his own case and break through to the undistorted, direct experience and assimilation of what C. G. Jung called "the archetypal images."
—JOSEPH CAMPBELL, *The Hero with a Thousand Faces*

We move within smaller communities rather than an abstract public world at large; within groups, circles of friends and enemies, full of the passion of personal intrigue, differences, backbiting, gossip, and now and then the possible occasions of friendship, the joys and communication in friendship. Hence it is within that concrete and extremely personal context (from which we start) that we must hammer out our own truthfulness and authenticity.
—WILLIAM BARRETT, *What Is Existentialism?*

The fascination of successive generations with the story of Vincent van Gogh illustrates the appeal of the myth of the lonely, tortured artist who struggles to realize their vision and whose unique brilliance goes unrecognized by conventional critics and the rest of the world. Although the Abstract Expressionist movement earned a contemporaneous reputation for individuality that has increased with subsequent scholarship, most of the artists associated with the movement did not struggle in isolation. Franz Kline regularly interacted with overlapping sets or groups of artists that joined Uptown and Downtown, the highly educated and the self-taught, and bohemians and the securely middle-class. Some groups were completely informal, whereas others met, at least for periods, in a more formal fashion. Associations formed, dissolved, or realigned, and even artists who sought to keep this ferment at a distance were defined in part by their response to it. Manhattan was an incubator for competing ideas and philosophies, and many artists within this creative and intellectual environment influenced, and were influenced by, Kline. He was not the only artist who worked in black and white, painted clowns, or had an erroneous mythology of "breakthrough" or action painting constructed around him. To understand Kline and his transition from figuration to abstraction, it is necessary not only to examine his materials and methods, but to provide some comparison with his peers.

Networks among the known and emerging New York artists were fostered in many ways. Gallery shows, openings, after-parties, and studio visits were important, as were cohabitation and shared studio spaces. Kline allowed Earl Kerkam and Emmanuel

Navaretta to crash at his place when they were low on rent money or had been evicted from their spaces (Kline was likely sympathetic, having been evicted three times himself) (Gaugh 1985b, 177–79). Close quarters probably encouraged extensive discussions about art, and Kline said, "People like Earl Kerkam have affected me; I've talked a lot about drawing with him" (Kuh 1962, 143). In 1947, Kline became housemates with John Ferren and Conrad Marca-Relli, sharing Lillian Russell's old house at 52 East Ninth Street. Kline had the fourth floor, Ferren the third, and Marca-Relli the second (Gaugh 1985b, 178), creating an artistic community in a single building. The informal and largely undocumented exchanges that resulted must have been a critical part of the artistic process for them, but similar contacts occurred among all the artists concentrated around Washington Square. Broader and more formally organized venues also existed. In 1949, after the demise of the Subjects of the Artist school, which had been founded by William Baziotes, Robert Motherwell, and Mark Rothko, its former instructors founded Studio 35 as an institution for artists to interact (Chilvers and Glaves-Smith 2009, 685). Studio 35 took over the space abandoned by the Subjects of the Artist school and hosted public lectures on Friday evenings by a variety of artists, including Willem de Kooning, Jean Arp, Barnett Newman, and Motherwell, as well as critics and musicians, including Harold Rosenberg and John Cage (Goodnough 2009), but despite its popularity with the public, the venue was short-lived. The most important arena for contact among the Downtown art community, and certainly for Kline, was another artist-founded association called the Club.

During World War II, well-known emigrés such as André Breton, Marcel Duchamp, and Max Ernst were able to get gallery representation in Manhattan because of their established careers and name recognition; the emerging Downtown artists resented this competition. The sculptor Philip Pavia characterized it as a "war of the roses," with the European artists, most of whom were of the Surrealist school, holding the white flower of purity (conferred by gallery and museum shows) while the Downtown artists had only the red flower of ambition (Edgar 2007, 21–23). Although there was contact across this divide—the critic Dore Ashton said that everyone went to any art-related talk they could (Hellstein 2010, 17)—the "Yankee gang" of Downtown artists, including Aristodimos Kaldis, Landès Lewitin, Pavia, Peter Agostini, Kerkam, the de Koonings, Kline, Emmanuel Navaretta, and Marca-Relli, began to congregate regularly in the Waldorf Cafeteria at Sixth Avenue and Eighth Street (Edgar 2007, 3–19). The location was convenient to most of these artists' studios and provided a focal point for those who did not work or live nearby (Marca-Relli participated when on leave from his military posting in New Jersey). Although there are few records of topics of discussion, Pavia recollected that art topics ranged from Pablo Picasso to Paolo Uccello and from Impressionism to Surrealism as the group sought to separate symbolism from abstraction (Edgar 2007, 3–19).

Because the large circle of artists would occupy tables without spending much money, the Waldorf management introduced countermeasures against these less than desirable regulars, mandating minimum orders, closing the toilets, and limiting the number of chairs at each table (Stevens and Swan 2004, 285–86). The efforts to discourage their occupation of the cafeteria led the artists to entertain the idea of having their own space, and in 1949 or, less likely, 1948 (accounts vary; see Edgar 2007, 53; Hellstein 2010, 17–18), a portion of the Waldorf crowd decided to rent a third-floor loft at 39 East Eighth Street that was equipped with both a restaurant stove and a bathroom and that had previously been used as a studio. While renovating the space, the Club (supposedly so named because they could not agree on a better choice [Hellstein 2010, 19]) officially began with a meeting at Ernestine and Ibram Lassaw's apartment with a core group of

charter members that included Kline, George Cavallon, Charles Egan, Peter Grippe, Willem de Kooning, Ibram Lassaw, Lewitin, Marca-Relli, Pavia, Ad Reinhardt, Milton Resnick, James Rosati, Ludwig Sander, Joop Sanders, Jack Tworkov, and perhaps Lewin Alcopley, Gus Falk, Jan Roelants, and Emmanuel Navaretta (Sandler 1970, 223; Sandler 2003, 28; Edgar 2007, 149).

According to Marca-Relli, "The Club started out with the definite mission of being just a social club. We did not want any art, any culture. It's odd that it turned the other way. We were just looking for a place where we could have a cup of coffee and talk among ourselves as we did in the cafeteria about painting, about art" (quoted in Stevens and Swan 2004, 288). Although the charter members had keys and could come and go as they pleased, Wednesdays were reserved for members-only meetings, Fridays featured panel discussions with invited guests attending, and Sundays, when a donated phonograph was put to good use, were for socializing (Edgar 2007, 53–54). Harold Rosenberg characterized the initial Wednesday meetings as "hilarious" and said that they mostly centered on whose turn it was to sweep or make coffee (Stevens and Swan 2004, 288), but Pavia recalled them as being the best part of the Club, with conversations that included "Kline expounding on portraits, Tworkov on spins, de Kooning on color, Guston on brushstrokes, Rosenberg about the artist and collectivity" (Edgar 2007, 58). Unlike Studio 35, which was open to the public and prone to repetitious subjects and questions (Goodnough 2009, 8), the small size of the Club and the select membership made for discussions that were diverse in subject matter but directly relevant to the members' interests. The Friday night panels were wide-ranging discourses on aesthetics and philosophy, with active participation from the floor; and while the majority of the panels focused on paintings (Willem de Kooning and Kline were the most frequent panelists), there were also those devoted to poetry, music, architecture, Zen and existentialism, and art criticism (Edgar 2007, 158–78). Pavia said that the "panels made the ammunition, it spilled out into two outlets, the Cedar Tavern and Tenth Street—training grounds for the next generation" (Edgar 2007, 59).

Jack Tworkov said of the early days of the Club, "We had created for the first time an atmosphere where American artists could talk to American artists." "People were giving their authentic ideas. They were speaking for themselves and this made the atmosphere intense and unique" (Sandler 1957). As word got out about this new group, membership (or even merely attendance) was sought after, and the Club became an important point of contact between charter Downtown members and Uptown artists such as Newman. Poets and musicians joined, as did the critics Rosenberg, Thomas B. Hess, and Clement Greenberg, and the gallerists Sidney Janis and Samuel Kootz joined their colleague Charles Egan, a founding member (Edgar 2007, 149–57). Museum directors and collectors attended the Friday night lectures and panels, which might feature anyone from Joseph Campbell to composers to Jesuit priests to William Barrett (Stevens and Swan 2004, 290; Edgar 2007, 58–65, 158–78; Hellstein 2010). It was a safer environment for women than the cafeteria scene, so Elaine de Kooning, Joan Mitchell, Grace Hartigan, Louise Bourgeois, Betty Parsons, and others were able to participate more fully (Edgar 2007, 54). After an evening at the Club, members would often go to Rikers for food or to the Cedar Tavern (located at 24 University Place) and continue the discussion (Stevens and Swan 2004, 361) (fig. 3.1).

Artists who were Club members denied that they belonged to a defined artistic movement; indeed, this denial was probably at the root of the inability to agree on any name more specific than "the Club." Their diverse styles led critics and art historians to construe individuality as the motivating force of the movement and to frame it in Cold War terms: rugged American individualism standing up to totalitarian collectivism

FIGURE 3.1
Arthur Swoger (1912–2000),
*Norman Bluhm, Joan Mitchell, and
Franz Kline,* 1957. Gelatin silver
print, 26.7 × 34.9 cm (10½ ×
13¾ in.), Rhode Island School of
Design Museum, 2003.12.1.

The Cedar Tavern, where this
image was taken, was a no-frills
bar where many artists, including
the gregarious Kline, met for
cheap drinks and camaraderie.

(see, e.g., Kozloff 1973; Cockroft 1974; Harris 1993). This characterization seems to have derived first from the macho typecasting of Jackson Pollock by both critics and admirers as a "ring tailed roarer" who "wore the high boots, the blue jeans, and the 'neckercher'" and who "liked to go to saloons and play at bustin' up the joint" (Rosenberg 1961, 58). Other artists contributed to this impression of individualistic triumph; Newman, an outspoken polemicist, is often cited for his statement, "If my work were properly understood, it would be the end of state capitalism and totalitarianism" (1992, 307–8); and Clyfford Still said, "I had made it clear that a single stroke of paint, backed by work and a mind that understood its potency and implications, could restore to man the freedom lost in twenty centuries of apologies and devices for subjugation" (1962, 32). Kline, despite not being prone to analogous statements about his art, tended to be associated with these attitudes.

The trope of Abstract Expressionist painters as solitary, heroic individuals is an oversimplification. Hellstein (2010) has argued that the narrow focus of most Abstract Expressionism scholarship on individuality and interiority overlooks recurring communitarian themes that she uncovers in topics discussed at the Club, including vitalism, Heideggerian existentialism, Paul Goodman's Gestalt therapy, and Zen. Her archival analysis shows that philosophical discussions at the Club were opportunities to explore topics that had currency within the group and that many of these topics reflect a "conception of the individual as fundamentally connected to others and to the world" (10). Rather than focus exclusively on the interiority of these artists, Hellstein considers their individuality in the context of a social aesthetic. For her, the signature styles that these artists developed, from Kline's black and white crossbeams to Pollock's drips and Newman's zips, arose from the process of distinguishing the self within a community of difference—"separate-togetherness"—rather than from pure expressions of individuality in isolation (157). Kline forcefully denied that he painted out of pure individualism: "If you are a painter, you're not alone. There's no way to be alone. You think and you

care, and you're with all the people who care, including the young people who don't know they do" (O'Hara 1958, 63). Lawrence Campbell's (1954) description of Kline's black and white paintings as a "shriek" is evocative, but to label them the product "of the individual who has been forced to push his individuality to the extremes to exist at all" incorrectly isolates Kline and his work; it does not situate both the man and his paintings within a community.

One factor that contributed to the myth of the individual may be that art critics, even those who appreciated and supported the Abstract Expressionist painters, had difficulty describing their paintings using traditional art historical terminology and frameworks; it was easier to discuss the finished work in terms of the artist who made it. Critics frequently discuss Kline's paintings in reference to his life in Pennsylvania and New York; coal mines, locomotives, bridges, and buildings are commonly alluded to (e.g., Hess 1958b; Read and Arnason 1960; Brach 1995; Metzger and Kline 1989). Kingsley (1986, 45), who decried the lack of formal analysis of Kline's work, herself discussed it in terms of his youth, writing that "his work felt physical[,] . . . probably because it was grounded in a sense of the athlete—lightning responses at shortstop, sudden directional changes, stunning trajectories out from the tackling hordes to make the touchdown." Another solution for critics was to use paintings by Kline (and other abstract artists) as Rorschach inkblots and impose their own feelings on the works or write about their own responses to them. Leo Steinberg (1956, 42), when attempting to describe the work in Kline's 1956 solo show at the Sidney Janis Gallery, said, "Gazing at the pictures of Franz Kline. . . . I found myself wondering again exactly what a critic is supposed to do, and concluded that there is nothing for it but to be unapologetically autobiographical."

Kline was talkative and gregarious, but he resisted discussing his process and style or describing what his art meant. Critics could meet the man, but the artist could seem inaccessible, although as Elaine de Kooning (1962, 30) said, "For Franz, 'talk' was an activity which he always kept going around his art. He was never silent or secret." In statements about his art that can be pondered like Zen Buddhist koans (with the attendant risk of projecting one's own views onto him), Kline seems to be trying to verbalize something that is for him ineffable.

"I paint not the things I see but the feelings they arouse in me."
(Rodman 1957, 105)

"I paint an organization that becomes a painting" (Kuh 1962, 144)

"I don't decide in advance that I am going to paint a definite experience, but in the act of painting, it becomes a genuine experience for me"
(Kuh 1962, 144)

"Instead of making a sign you can read, you make a sign you can't read."
(Quoted in Hellstein 2014, 66)[1]

Utterances like these show that Kline recognized his inability to describe what he sought to do when he painted. When asked at a panel, "Tell us more about abstract art," Kline replied, "I thought that was the reason for trying to do it, because you couldn't [talk about it]" ("Abstract Art Around the World Today" 1954). Kline did not write about the philosophy of art, as did some contemporaries like Newman and Motherwell, but his frequent participation in panels at the Club suggests that his contemporaries valued his opinions and insights on a wide variety of topics.

Kline's participation in the Club and the Downtown community was also appreciated because of his kind, open-hearted personality. Mitchell said, "He was always so

generous about other painters, which was unlike many painters," and "he always helped other people."[2] This type of personality would be crucial for the Club to achieve its role as a "fraternal group based on mutual aid and encouragement" (Hellstein 2010, 50). Statements by founding members indicate that they appreciated the supportive nature of their organization. The sculptor James Rosati said:

> All of us were very much concerned about each other in many ways. There was an affinity. There was a comradeship that existed that came about naturally. It wasn't a thing—there was no manifesto. It just worked out that way. And it was very wonderful. (1968)

And John Ferren described the "state of friendship" that was fostered among the group.

> Not necessarily love or agreement but, definitely, respect and the personal recognition of the other and yourself being involved in the same thing. That thing is conveniently labeled Abstract-Expressionism by the critics. It isn't quite so simple. If Abstract-Expressionism is the largest vortex, the antithesis, the rejections, the yet unmade developments are also there. (1955, 22)

Philosophical influences that might underlie the "recognition of the other and yourself being involved in the same thing" can be found in topics examined at the Club (Hellstein 2010). Discussions of Heideggerian existentialism (Barrett spoke on June 22, 1950, and again on June 15, 1951; two more panels on Heidegger were held by April 1952 [Edgar 2007, 158–78]) would have included the concept of Being-With: the idea that an individual can explore truth and authenticity in the context of a small, personal circle rather than in the public sphere or a purely abstract void (Hellstein 2010, 94–99). The importance Ferren attributes to undeveloped, ancillary, and even rejected ideas shows that the group defined itself by exploring ideas together, not by any consensus that might be reached in that exploration; in this way, his "being involved in the same thing" seems to parallel Being-With. Unlike art movements that used manifestos to define insiders and outsiders and were prone to schism, the group that came to be called the Abstract Expressionists accepted one another's differences under the big tent offered by the Club: individuality within pluralism.

In "The American Action Painters," Rosenberg (1952, 22) writes that the nascent movement is not a school, which would exhibit "the linkage of practice with terminology"; instead, what the artists "think in common is represented by what they do separately." Rosenberg develops his concept of action painting as what they "think in common" but offers little as to why "what they do separately" differs so dramatically and results in recognizable styles. Hellstein (2010, 56) argues that creative impulses in the absence of a school hierarchy gave rise to this apparent paradox of Abstract Expressionism—"that one of the most socially and intellectually cohesive artistic groups of the twentieth century produced the greatest plurality of styles." The paradox is resolved when the intellectual cohesion that Hellstein uncovers in her analysis of the Club is not consensus, which might characterize an artistic circle defined by a manifesto, but tolerance of intellectual, philosophical, and artistic diversity, which reflects separate-togetherness. Whatever any subset of these artists did think in common, they also differed. In interview after interview, Abstract Expressionists would mention how a peer's view of positivism, or Surrealism, or any other topic of the day contrasted with their own. The "state of friendship" described by Ferren meant that the Club allowed individuals to express firmly stated positions that could differentiate themselves from others without being cast out. Those who frequented the Club knew what one another thought

on myriad topics and how others' opinions were evolving, just as from studio visits and shows they knew one another's body of work and the way in which that work was changing. The intellectual assertion of the self can be seen as a parallel to the creative expression of the self: making one's own art while being aware of the work of others, and in this personal contextualized process arriving at a distinctive artistic style. Kline was certainly aware of the actions and opinions of his New York School peers, and the development or discovery of his style had to be influenced by them, although as he said, "A painting doesn't have to look like another person's work to have been influenced by it" (Kuh 1962, 143).

The separate-togetherness and personal respect that the Club members and the larger Abstract Expressionist community had for one another explains the lack of overlap in style. Rothko, although not a Club member or regular, said that an artist was concerned with "getting territory, this is your territory, you develop something and it's yours, it's your territory. Once a territory is taken, there's no reason for someone else to take that territory. And to emulate one by imitation would be ridiculous" (quoted in Breslin 1988, 248–49). For Rothko, developing a style and staking a claim to it was a choice of conscious repetition: "If a thing is worth doing once, it is worth doing over and over again—exploring it, probing it, demanding by this repetition that the public look at it" (quoted in Fer 2005, 160). Rothko's prescription for developing a style was of course not shared by everyone in the Manhattan art scene: Tworkov (1957) said that he hoped "to confront the picture without a ready technique or a prepared attitude—a condition which is nevertheless never completely attainable; to have no program and, necessarily then, no conceived style. To paint no Tworkovs." These two attitudes may seem antithetical, but they could be accommodated within the philosophical milieu of the Club. Rothko's paintings can be seen as physical examples of Heideggerian separate-togetherness, where each painting is a unique work of art, but considering it within the entirety of the oeuvre brings greater awareness. An example is the Rothko Chapel, a small, nondenominational chapel in Houston, Texas, the interior of which is dominated by fourteen site-specific paintings that create an immersive environment. Tworkov's approach is consistent with Goodman's interpretation of self in *Gestalt Therapy*: "In ideal circumstances the self does not have much personality. It is the sage of Tao that is 'like water,' assuming the form of the receptacle" (Perls, Hefferline, and Goodman 1951, 427). Despite opinions like Tworkov's, the development of a signature style became one of the commonly accepted hallmarks of the Abstract Expressionist movement (Kingsley 1992; Doss 2006; Kaufman 2008; Temkin 2010).

Kline did not join Tworkov in his rejection of technique and style: he painted "Klines," particularly his iconic black and white works that are instantly recognizable. The use of a black and white palette is one of the best documented examples of the interconnectedness of influences shared by Kline and his contemporaries. Ashton (2004, 27) sets a wide frame for this artistic trend: "After World War II there was a pronounced interest in throwing over the Impressionist embargo on black in both Europe and the United States." But why did certain Abstract Expressionists simplify their palettes? In 1940, Pablo Picasso's masterpiece *Guernica* (1937) was first shown at the Museum of Modern Art;[3] its raw emotional power, conveyed without color and at a grand scale, surely affected the artists who viewed it. Motion pictures in the 1940s were mostly in black and white; the growing popularity of color in cinema and still photography could have inspired some artists to restrict or reject the use of color. Moreover, the increased use of color in other media may have affected the responses of the public and the receptivity of critics to a simplified palette. Kline, Willem de Kooning, and Kerkam were fond of the funnies and had trained as illustrators and graphic artists; perhaps they and

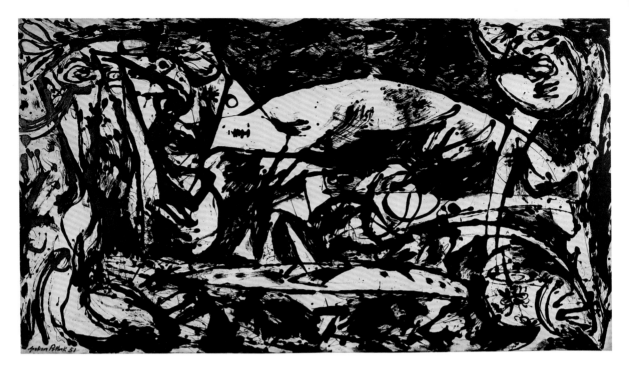

FIGURE 3.2
Jackson Pollock, *Number 14*, 1951.
Oil paint on canvas, 146.5 ×
269.5 cm (57¹¹⁄₁₆ × 106⅛ in.), Tate,
Purchased with assistance from
the American Fellows of the Tate
Gallery Foundation 1988, T03978.

Jackson Pollock created a number
of black and white works in the late
1940s and early 1950s. In this work
Pollock used a syringe to apply
the black paint onto bare canvas;
the "white" seen is the canvas itself.

others were predisposed to black and white by the influence of newspaper and magazine cartoons (Boime, Kline, and Mitchell, 1977, 5; Ashton 2004, 24). Black and white paint was more economical than most colored paints; cash-strapped artists might have been more willing to explore palette choices that cut costs. None of these potential influences can be strictly excluded, and the vigorous social and intellectual discourse among the New York artists at the time makes tracing a single conceptual source for the "black and white movement" of the late 1940s and early 1950s impossible. It is clear that many artists were choosing to simplify their palettes; perhaps this self-imposed limitation made creation and exploration of their new language of abstraction easier. A time line of the use of simplified palettes in finished works helps track the movement as a whole, but causes and effects are hard to assign or disentangle. After all, both Willem de Kooning (in the 1930s) and Kline (in the 1940s) had black and white cats (named Marilee and Kitzker, respectively) (Gaugh 1985b, 41; Stevens and Swan 2004, 144); did the felines inspire interest in a simpler palette, or should we view them as early evidence of their owners' preexisting biases toward black and white?

Pollock and Willem de Kooning seem to have been the first New York School artists to execute *series* of works in black and white: both produced significant numbers of paintings using this rarified palette starting in 1948 and continuing into the early 1950s. Pollock's black and white paintings include *Number 26 A, Black and White* (1948),[4] in which he used his innovative drip application method to apply white and black paint to a canvas, with black predominant. In later works, such as *Number 14* (1951) (fig. 3.2), Pollock applied black paint by pouring or by syringe, and the white is provided by the bare canvas. In these works the thinned paint that was applied by syringe bled into the unprimed canvas, giving the feeling of a pen and ink drawing. De Kooning's black and white series includes works such as *Black Untitled* (1948), *Painting* (1948),[5] and *Untitled* (1948–49) (fig. 3.3), which are gestural and filled with forms that appear vaguely biomorphic.

Other artists were also working with a black and white palette, among them Brady Walker Tomlin, Motherwell, and Hofmann. The approach was common enough that

FIGURE 3.3

Willem de Kooning, *Untitled* (1948–49). Oil and enamel on paper, mounted on composition board, 92.1 × 123.8 cm (36¼ × 48¾ in.), Art Institute of Chicago, Gift from the Mary and Earle Ludgin Collection, 1981.260.

The curvilinear forms of some of Kline's transitional abstractions, including *Untitled* (1948) (see fig. 2.20), are clearly influenced by de Kooning. De Kooning's exploration of a limited palette may also have encouraged Kline to explore the possibilities inherent in black and white.

in the spring of 1950 the Samuel Kootz Gallery held a show titled *Black or White: Paintings by European and American Artists*, contrasting works by Europeans such as Picasso, Piet Mondrian, and Joan Miró with Americans such as Willem de Kooning (*Dark Pond*, 1948), Hofmann (*Germania II*, 1949), and Motherwell (*Granada [P86]*, 1948–49). Thomas Hess (1950, 45), reviewing the show in *ARTnews*, wrote, "We see de Kooning, Hofmann and Motherwell, all working from quite different approaches, investing shapes of only black and of only white with a drama usually associated with the full chromatic range." However, none of these works appear to be direct inspirations for Kline's black and white paintings. Evaluation of Kline's work suggests that it is his colored "transitional abstractions" of the late 1940s, such as *Untitled* (1948) (see fig. 2.20), that bear the closest resemblance to works created by de Kooning in this period, with a commonality in their curving brushstrokes and dense layering of paint; Tomlin is often cited as a secondary influence (Gaugh 1974, 294–97; Kline and Foster 1994, 24; Kingsley 2000, 14–16). Kline attended the Kootz Gallery show *Black or White* and on meeting Robert Motherwell said that he was deeply moved by *Granada (P86)* (Heller 1963, 4), but his work bears little resemblance to that of Motherwell. Perhaps more than revealing a new voice or guiding Kline in a particular direction, the Kootz Gallery show helped convince Kline that black and white works could be emotive and painterly, and this, with the encouragement of the inclusion of his black and white drawing in the *Talent 1950* exhibition at the Kootz Gallery later that year, may have focused his efforts (Gaugh 1974, 345). Kline indicated that the simplification of his palette to black and white was not a conscious decision but rather something that evolved organically: "Somebody will say I have a black and white style, or a calligraphic style, but I never started out with that being consciously a style or attitude about painting" (O'Hara 1958, 59). Kline would talk at great length about other painters, living and dead, and what he admired in them. His acknowledgment, "Most young artists start off wanting to paint, like Ingres or Vermeer or Lautrec or somebody; then they get tired of trying that, so they begin to paint the only way they can" (Hess 1958b, 40), has clear autobiographical implications. When speaking at the 1954 Museum of Modern Art forum "Abstract Art Around the World Today," Kline, who had spent fifteen years creating figurative and semiabstract paintings before taking up abstraction, said, "The experiences of trying to be [an artist] forms different subject matters, different ideas of teaching and different forms. Abstract art is the one which is the funniest, and most serious and the most ironic, I think. That's interesting." Perhaps he saw it as simultaneously funny, serious, and ironic that it took renouncing color and figuration and adopting the black and

FIGURE 3.4
Willem de Kooning, *Black and White (Rome)*, 1959. Enamel on paper, 99.7 × 69.9 cm (39¼ × 27½ in.), The Museum of Fine Arts, Houston, Bequest of Caroline Wiess Law, 2004.12.A.

This brush drawing is strongly evocative of Kline's works, exemplifying the influence these two friends had on each other.

white vocabulary used by many of his colleagues and friends to develop his own critically acclaimed language or voice.

Kline finding his voice and producing his striking black and white abstract paintings opened up new territory for others to explore. In 1951, Cy Twombly, working at Black Mountain, painted black and white abstractions that seem to be heavily influenced by Kline's work, including *MIN-OE* (1951) and *Landscape* (1951).[6] Twombly was not the only artist to have internalized Kline; Mark Di Suvero, Robert Rauschenberg, Grace Hartigan, Brice Marden, and Al Held found aspects of Kline's work interesting enough to explore (Anfam and Kline 1994; Gaugh 1985a, 1985b), although none directly imitated him, concurring perhaps with Rothko that to do so "would be ridiculous." Interestingly, Willem de Kooning came the closest to imitating Kline with a set of works created during his 1959 trip to Italy. Paintings like *Black and White (Rome)* (1959; MFAH) (fig. 3.4) and *Black and White (Rome)* (1959; Menil Collection) bear the clear influence of Kline.[7] De Kooning was unhappy in Rome and never spoke about why he chose to channel Kline during this time. In 1951, he had said, "Personally, I do not need a movement" (Morris et al. 1951, 7), but perhaps during this period he missed his friend and his normal milieu and was drawn to re-create aspects of it. AnnMarie Perl (2017) has suggested that de Kooning's Kline-esque experiments caused Kline himself to revisit his spare black and white compositions from the early 1950s in late works such as *Meryon* (1960–61)[8] and *Corinthian II* (1961) (see fig. 6.13), showing the circularity of influence within this small group of artists and friends.

Other generalizations about the nascent Abstract Expressionist movement beyond the myth of the heroic individual have also distorted perceptions of Kline, especially ideas about the artistic breakthrough and the role of spontaneity in abstract painting. Some of the earliest writings about this group of artists as a movement are by Harold Rosenberg, who was socially involved with the artists of the Club and the Cedar Tavern and who attempts in his 1952 article, "The American Action Painters," to describe the new way of painting as one in which "what was to go on the canvas was not a picture but an event."

> At a certain moment the canvas began to appear to one American painter after another as an arena in which to act—rather than as a space in which to reproduce, redesign, analyse or "express" an object, actual or imagined. The painter no longer approached his easel with an image in his mind; he went up to it with material in his hand to do something to that other piece of material in front of him. The image would be the result of this encounter. (Rosenberg 1952, 22)

Action implies spontaneity, which in turn implies speed as the artists attack the canvas with their paint. For many readers, Rosenberg's description evokes Jackson Pollock's physical, seemingly impromptu painting style, as captured in Hans Namuth's famous 1951 film, *Jackson Pollock 51* (Pollock himself believed that Rosenberg's article was about his painting methodology and was appalled by what he viewed as a mischaracterization [Karmel 1999, 261]). Given that the artists were in and out of each other's studios, they knew that struggles with particular works often extended over long periods. Willem de Kooning labored over many paintings for years, working and reworking them (Lake 1999). Joan Mitchell's far-sightedness meant that she had to either back up to see the canvas or use a reducing glass to determine where brushstrokes should go (Lee 2002, 64). The paint was rarely "slapped across the canvas" (de Kooning 1958b, 176), and even when poured it was applied with careful physical skill and control. Kline admitted to David Sylvester that he liked "to do them right away[;] . . . when they come off and I'm done with them, they're marvelous," but he also admitted that some paintings took more time (Sylvester 1963, 12). Philip Guston remembered that Kline would spend "days or weeks reworking the edge of a stroke to give the impression that it was painted with intensity and élan" (Gaugh 1985a, 62)

One common issue in writing about the Abstract Expressionists seems to be the conflation of spontaneity with the visual impact a painting made. Elaine de Kooning, who knew Kline and his working methods well, still often wrote about Kline's work in terms of its seeming spontaneity. For instance, in "Two Americans in Action" (1958b, 176), she writes, "Kline's image is fixed in the brutal gesture of a housepainter's brush dipped in a can of paint and slapped across the canvas," although she then qualifies this by saying, "The 'action' is not necessarily the action of pushing paint around as many Europeans and Japanese, apparently, take it to be." Her characterization succinctly captures the effect of a Kline work on the viewer (and outlasts, for most readers, the caveat that she invokes), but such metaphors clearly should not be taken as descriptions of Kline's actual process. Certainly Kline's paintings affect the viewer with a power that makes the term "action painter" seem applicable; Elaine de Kooning (1958b, 176) again: "Kline's paintings elbow their way through the room in which they are hung." But Kline publicly rejected the idea that spontaneity was necessarily kinetic: "The immediacy can be accomplished in a picture that's been worked on for a long time just as well as if it's been done rapidly, you see" (Sylvester 1963, 12). Ashton (2004, 30) also saw this in Kline's finished works, writing, "Often the startling singleness of first impressions has obscured Kline's rich painterly means."

Although it was well known among contemporaries that many artists, including Kline, Motherwell, and Willem de Kooning, worked from sketches, the idea of the painting as a spontaneous act rather than a reproduction or an expression of a previously held idea gradually led to the view that the use of sketches was anathema, that it made for a somehow inauthentic experience. Rosenberg (1952, 22) used an anecdote about one painter criticizing another for working from sketches to raise the issue: "A sketch is the preliminary form of an image the mind is trying to grasp. To work from sketches arouses the suspicion that the artist still regards the canvas as a place where the mind records its contents—rather than itself the 'mind' through which the painter thinks by changing a surface with paint." Rosenberg saw the suspicion as unwarranted and argued that a sketch and a painting inspired by a sketch are both actions and therefore equally valid: "There is no reason why an act cannot be prolonged from a piece of paper to a canvas. Or repeated on another scale and with more control. A sketch can have the function of a skirmish" (22–23). And Frank O'Hara saw Kline's drawing as a critical part of his process but finessed a distinction between a "study" and a "rehearsal," writing in an insightful assessment of how Kline worked:

> Drawing for Kline represented not only an activity, but also a diary of plastic notions which might be resumed and developed years later, or acted upon immediately. It follows then that many of the drawings indicated as "studies" are more properly events preceding or related to a given oil painting or mimetic rehearsals of gesture awaiting their ultimate and ideal scale, rather than studies in the traditional sense. (1964, 8)

Still, an opinion began to develop that the use of sketches somehow meant that an artist was not authentic or modern, and some artists held this view quite strongly. Barnett Newman (1992, 248) stated, "I am an intuitive painter, a direct painter. I have never worked from sketches, never planned a painting, never 'thought out' a painting. I start each painting as if I had never painted before." In 1964, Donald Judd (1964, 59) said, "Kline's sketch for *Cardinal* (1950) is surprisingly like the painting. Kline would be denounced now as conceptual and premeditated." Artists who frequented the Club in the early 1950s may have accepted such differences in their peers without seeing them as heretics to be denounced, but popular history wants to codify orthodoxy in retrospect, perhaps in sympathy with an ideal of bravado and spontaneous painting.

Perhaps no word is more associated with the Abstract Expressionist movement than *breakthrough*, and Rosenberg pays considerable attention in his 1952 essay to "the big moment," or "the saving moment...when the artist first felt himself released from Value" (Rosenberg 1952, 23, 48). Pollock, Newman, Kline, and Helen Frankenthaler are all credited with (perhaps canonized for) breakthroughs, and the movement as a whole is often characterized as having broken through the traditions of representational, surrealist, or European abstract art. The word has multiple meanings: a breakthrough could relate to extrinsic factors (critical recognition, commercial success) or to the development of a new technique or style. Pollock might be characterized as having had two breakthrough moments: the development of his innovative drip method of paint application and the critical recognition of his 1946 Parsons Gallery show. O'Hara (1964, 6) says that Kline's breakthrough in style was signaled in his first one-man show, after which "he took a firm, if controversial, place in the consciousness of artists and collectors. Public recognition was slower to come, but his next exhibition a year later placed Kline in the company of Pollock, de Kooning, Gottlieb, Rothko, and Still."

In "The American Action Painters," Rosenberg sketches a generic biography for an Abstract Expressionist painter as someone reborn or disconnected from their past:

"With a few important exceptions, most of the artists of this vanguard found their way to their present work by being cut in two. Their type is not a young painter but a reborn one. The man may be over forty, the painter around seven. The diagonal of a grand crisis separates him from his personal and artistic past" (1952, 23). Elaine de Kooning saw Kline as such a "reborn" figure, declaring, "The last *word*, for Franz Kline, was spoken in 1950," and arguing that his explosion of black and white paintings in 1950 was a transformation of his past—that Kline arrived at his style "by swallowing it [his past] in one big gulp" (1958b, 175, 179; original emphasis). Others have also argued that the earlier stages of Kline's career were irrelevant to his mature style (Sandler 1961; Hess 1962b; Kline and Foster 1994; Brach 1995). But his friend Frank O'Hara (1964) traces Kline's first significant abstractions to 1945 and identifies elements of what we now term his signature style in two works from 1947, *Collage* and *Untitled*.[9] Others, including Gaugh (1974), Perl (2017), and the present authors, support O'Hara's view that Kline did not have a single revelatory moment of conversion. He explored different forms of abstract painting before developing his black and white style, and even within his black and white works his style is not static: his lines, forms, and methods of paint application continue to evolve and change as he, like Rothko, continued to explore and probe (Fer 2005). Although Kline's standing in and influence on the art world experienced a tremendous breakthrough in 1950, the "signature style" now associated with him was developing well before that date and evolved until his death, undoubtedly influenced by interactions between the artist and his artistic social circle.

While Kline was, in the words of Elaine de Kooning, "absolutely resolute once he made the commitment to abstraction" (quoted in Kingsley 1986, 43), he was not separated from his past or tied to dogmatic principles. Unlike many of his contemporaries, including Barnett Newman and Willem de Kooning, Kline never rejected or destroyed his early works. In 1959, at the height of his career, Kline said regarding his early Pennsylvania landscapes, "I treasure them as much as my recent black and white abstracts" (quoted in Amram 2001, 22). Kline kept many of his early works and continued to display them in his own home. An undated photograph in AAA, likely taken after Kline's

FIGURE 3.5
Undated photograph taken after Kline's death, showing his residence. Kline treasured his early works and continued to display them prominently; the brush drawing hanging over the fireplace is *Untitled* (1947) (see fig. 2.21), and the uppermost painting on the right wall is *Untitled* (ca. 1951), oil on wood, 51 × 39 cm (20 × 15¼ in.), private collection.

death, shows what appears to be his study with six paintings hanging on the wall (fig. 3.5). Centered immediately over the fireplace is one of his early abstract works, *Untitled* (1947) (see fig. 2.21). This "treasuring" of his personal artistic history shows that he still found merit and felt pride in his early works and excludes him from the set of artists who experienced a wholesale artistic "conversion."

It must also be remembered that Kline was not revolutionary in his materials or methods of paint application. Unlike his contemporaries, he made only sparing use of Magna and alkyd paints, preferring to work in oils, even if they were inexpensive house paints. He did not modify his media like Willem de Kooning (Lake 1999), incorporate objects like Pollock (Rose 1980), or apply paint by pouring or dripping. His tools were mostly brushes, and he preferred working on primed canvas (unlike Frankenthaler). It was his artistic vision and his paintings that were innovative, not the means he used to create them. Kline's refusal to abandon traditional materials and methods may be linked to his appreciation for the past, which was expressed in keeping and displaying his own works and the acquisition of antiques. No midcentury modern for him; he liked Rococo Revival furniture by John Henry Belter and could wax rhapsodic over a beautiful rug—"like a sea of blue."[10] Conrad Marca-Relli called him "a great romantic," because at a time when they had no money, Kline bought a tooled leather bag of little utility, explaining, "But yeah,—you don't understand—I just like this leather bag—I'd like to keep it in the house."[11] Kline was not a revolutionary seeking to depose the art that came before; indeed, he appreciated it as much as the art that was currently being made.

Minimizing the influence of several powerful myths—the abstract expressionist as a heroic individual, the importance of spontaneity in abstract painting, and the artistic breakthrough as a break with the past—is important when considering Franz Kline and his body of work. The analyses in the following chapters that seek to understand Kline's materials and methods are presented by the chronology of his oeuvre, since his approach to abstraction was a series of steps in a long and hard-fought journey, not a single Damascene moment. He experimented with different styles of abstraction, slowly eliminating them until he finally found his artistic voice in the black and white abstractions for which he is most well known today, and examination of these early works reveals approaches that Kline used throughout his career. Kline produced works in his iconic black and white style until his death in 1961 but also explored other styles, eventually incorporating color into his large-scale abstractions, and evidence of his struggles with composition can be identified in paintings at different stages of his mature career. Achieving both stability and change in his style during his continual exposure to the ferment of the Club and the broader art world indicates that he was comfortable both with acknowledging his past work and with reassessing his artistic stance. Elaine de Kooning (1962, 65) described Kline as having "a paradoxical loyalty to the past.... He never abandoned an enthusiasm and there was no such thing as a passing fancy. Nostalgia played a curious and powerful role in his development. It was as though he proceeded in his life and in his art by looking backward." Many of her writings have been used to build or maintain myths about Kline, so there is a certain symmetry in taking the words of this authoritative figure as license to examine Kline's work as an uninterrupted whole in historical context, not through the lens of mythology.

4 A New Voice: Genesis of the 1950 Charles Egan Gallery Show

Corina E. Rogge, Isabelle Duvernois, Silvia A. Centeno,
Julie Arslanoglu, and Zahira Véliz Bomford

Franz Kline was a well-known member of Manhattan's Downtown art community in the 1940s, but his first one-man show, held in late 1950 at the Charles Egan Gallery, marked the first time his abstract work received critical notice and acclaim. In the paintings in this show, Kline, who had been searching for a distinctive voice, at last achieved synergy between his technical range and his artistic vision and produced the first examples of the iconic large-scale black and white works that are now synonymous with his name. Kline's reticence or inability to discuss his methods or approach has left viewers, critics, and art historians with minimal information about how he arrived at what would be recognized as his mature style. Given the dearth of firsthand or contemporaneous accounts of this stylistic genesis, the paintings themselves may stand witness. Technical analysis of paintings from this pivotal moment establishes commonalities and differences between these Kline works and allows us to assess the merits of competing hypotheses about the artist's approach, particularly when contextualized within Kline's oeuvre as a whole.

In choosing to pursue linear abstract compositions at large scale and in an austere black and white palette, Kline said he sought to confront himself with large canvases and paint "an organization that becomes a painting" (Kuh 1962, 144). His creative struggle was internal, but he was also subject to external influences: as described in the previous chapter, Kline interacted extensively with other artists and with critics in his studio, at informal public gatherings, at shows, and at the Club. Timely encouragement from the critic Clement Greenberg when he visited Kline's studio in early 1950 to select a piece for the *Talent 1950* show to be held at the Kootz Gallery in late April may have been especially influential (Gaugh 1985b, 88).[1] Conrad Marca-Relli recalls that Greenberg toured the studio, stopped before a "drawing" on rice paper, and said, "Well, the only original thing that I see here is this. Why don't you show this?" According to Marca-Relli, Kline was shocked, since he had shown Greenberg other paintings that he "was very happy with."[2] Greenberg would say later, regarding that choice, "We rescued Kline. His paintings were bad, but he did good drawings" (Gaugh 1985b, 88).[3] Perhaps the attention paid to his gestural, abstract "drawing" at that moment, by a renowned modernist critic, influenced Kline to move away from his figurative and transitional abstract paintings.

Kline's inclination toward illustration, reinforced by his traditional training in Boston and London, led to small-scale ink sketches being at the heart of his artistic practice throughout his life; during his studio visit, Greenberg likely responded to Kline's graphic skill and facility in this medium. Sketches, which Kline saved in piles around his studio to be consulted as sources of inspiration (Goodnough 1952; de Kooning 1962;

Gaugh 1985b, 90), were an economical way for him to explore compositions or to quickly capture ideas and impressions; they could also be cut up and collaged. The direct relationship between Kline's small ink sketches and his larger gestural works is evident visually, but the only description he gave of how he arrived at his new style occurred in a 1956 interview: "I kept simplifying forms in black and white, breaking down the structure into essential elements" (Karp 1956, 10). Though Kline himself provides few clues as to how his sketches might inform, inspire, or guide his paintings, his contemporaries readily perceived such connections. Frank O'Hara (1964, 9) indicated that Kline's abstract work "evolved naturally from preoccupation with the act of drawing." Elaine de Kooning, a close friend of Kline from the 1940s until his death, wrote of his 1950 work, "The speed and weight of the line kept increasing until finally the objective image was overwhelmed by its own outlines. The line, now a heavy brushstroke, no longer described forms: it had become itself, the only solid form on the paper. The next step, logically—or emotionally—was a bigger brush and a bigger area for it to career through" (1958b, 179).

Kline never elaborated on the logical or emotional reasons for why he began translating his small sketches into large-scale works. After Kline's death in 1962, Elaine de Kooning identified a watershed moment involving a Bell-Opticon [sic, balopticon] opaque projector: a friend (understood to be Willem de Kooning) who had borrowed the instrument for enlarging his own work asked Kline for the small ink sketches he was constantly making.[4] As de Kooning (1962, 67–68) describes the event, Kline handed over a few sketches, and "both he and his friend were astonished at the change of scale and dimension when they saw the drawings magnified bodilessly against the wall. A 4 by 5-inch brush drawing of the rocking chair Franz had drawn and painted over and over, so loaded with implications and aspirations and regrets, loomed in gigantic black strokes which eradicated the image, the strokes expanding as entities in themselves, unrelated to any reality but that of their own existence." De Kooning suggests that this discovery had an overwhelming effect on Kline, who renounced his old styles and from then on painted only in the new (68).

The account of the Bell-Opticon provides a succinct and dramatic connection between Kline's sketches and large-scale abstract paintings but likely oversimplifies reality. Kingsley (2004, 382) has pointed out that a photograph of Kline's 52 East Ninth Street studio taken in the fall of 1950 shows *Cardinal* and a sketch for *The Drum* hanging on the wall but also works in his early abstract style on the easels;[5] and Gaugh (1974, 45; 1985b, 46, 92) established that Kline was still painting figuratively at this time, creating *Wild Horses* and a portrait of David Orr's daughter.[6] Kline may indeed have been influenced by a Bell-Opticon, but it is clear that he did not immediately adopt a new style (or scale) to the exclusion of others.

Charles Egan, one of the very few gallerists showing abstract works by New York artists, had known Kline since at least 1945, when Kline and Willem de Kooning painted the walls of his newly established eponymous gallery at 63 East Fifty-Seventh Street (Stevens and Swan 2004, 225). Egan had given de Kooning his first solo show in 1948 (Stevens and Swan 2004, 251) but had refrained from offering one to Kline, later claiming that Kline "didn't boil" until 1950 (Gaugh 1985b, 88). In the summer of 1950, Kline had taken a position teaching at Schroon Crest, a resort at Schroon Lake in Upstate New York. During this time, Charles Egan visited Kline's Ninth Street studio and decided, based on the recent work he saw there, to offer Kline a solo show (Gaugh 1985b, 178). Although there is no record of which paintings were present in his studio on that visit, Kline's first show at the Charles Egan Gallery, held October 16 through November 4, featured eleven primarily black and white oil paintings on canvas (fig.

ARTISTS IN THE GALLERY:

ALBERS – CAVALLON – DE-NIRO
CORNELL – deKOONING – LEWITIN
HILLSMITH – McNEIL – NAKIAN
NOGUCHI – SISKIND – TWORKOV

FRANZ KLINE

EGAN GALLERY
63 EAST 57 ST., N.Y.C.

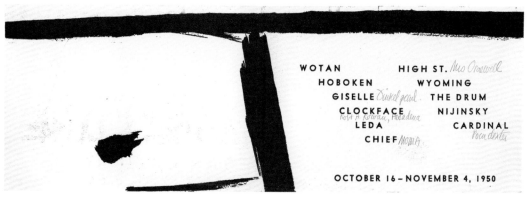

WOTAN HIGH ST.
HOBOKEN WYOMING
GISELLE THE DRUM
CLOCKFACE NIJINSKY
LEDA CARDINAL
CHIEF

OCTOBER 16 – NOVEMBER 4, 1950

FIGURE 4.1

Brochure for Franz Kline's first
solo exhibition, held October 16–
November 4, 1950, at the
Charles Egan Gallery.

4.1), although *Nijinsky* (1950) (fig. 4.2) and *Leda* (1950) contain visible passages of brown and green, respectively (Gaugh and Kline 1979, 10).[7] The canvases varied in size, with *Leda* being the smallest at 76.5 × 64 cm (30¼ × 26¾ in.) and *Cardinal* the largest at 203.2 × 147.3 cm (80 × 58 in.) (Gaugh 1974, 393).

It seems likely that some of these works must have been completed before Egan's decision to offer Kline a show, which in turn suggests that before the summer of 1950 Kline had identified materials and painting techniques that would allow him to work at this larger scale with the same flowing touch that he achieved in his small ink sketches. Because Kline was working in several styles concurrently, differences in the materials or processes used to make these works might reflect conscious choices to help him transpose his ideas from ink sketches on paper to large-scale abstract oil paintings on canvas. The technical analyses described below suggest that Kline relied heavily on preliminary sketches and carefully (although not slavishly) translated them to a larger scale. He seems to have abandoned the mix of retail trade and artists' paints that he used in his figurative or early abstract images in favor of entirely retail trade paints, likely because of their low cost and handling properties. Analyses presented in later chapters show that he would continue to use many aspects of the method that he developed in this period for the rest of his career, although he would later reincorporate artists' paints and colors into his palette.

Preparatory ink sketches on paper are known to exist for eight of the Charles Egan Gallery paintings: *Nijinsky, Leda, Cardinal, Wotan* (figs. 4.3, 4.4), *High Street* (fig. 4.5), *Clockface, The Drum*, and *Hoboken* (Boime, Kline, and Mitchell 1977, 74; Gaugh 1985b, 73, 89, 93; Christov-Bakargiev, Anfam, and Ashton 2004, 72, 183; Kingsley 2000, 412–19).[8] Two sketches exist for *High Street*, one of which, *Untitled (Study for High Street)*, shows significant differences from the painting and appears to be on an unprinted

FIGURE 4.2
Franz Kline, *Nijinsky*, 1950.
Oil on canvas, 115.6 × 88.6 cm
(45½ × 34⅞ in.), The Metropoli-
tan Museum of Art, New York,
The Muriel Kallis Steinberg
Newman Collection, Gift of
Muriel Kallis Newman, 2006,
2006.32.28.

The majority of the paintings
in Kline's first show were black
and white, but brown passages are
visible in this work.

FIGURE 4.3 (opposite, top)
Franz Kline, *Untitled (Study for
Wotan)*, 1950. Mixed media on
paper, 13.8 × 21.7 cm (5⁷⁄₁₆ ×
8⁹⁄₁₆ in.), The Museum of Fine Arts,
Houston, Museum purchase
funded by the Caroline Wiess
Law Accessions Endowment Fund,
96.848.

FIGURE 4.4 (opposite, bottom)
Franz Kline, *Wotan*, 1950. Oil on
canvas mounted on Masonite,
139.7 × 201.5 cm (55 × 79⁵⁄₁₆ in.),
The Museum of Fine Arts,
Houston, Museum purchase,
by exchange, 80.120.

This painting features the
imperfect square that would be a
recurring element in Kline's work.

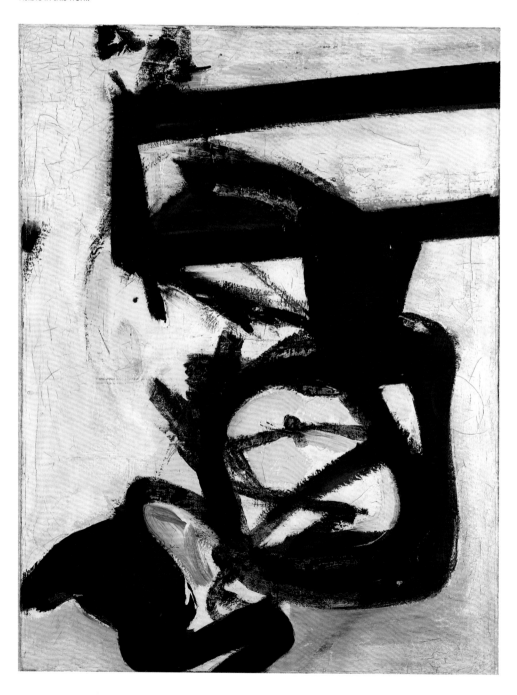

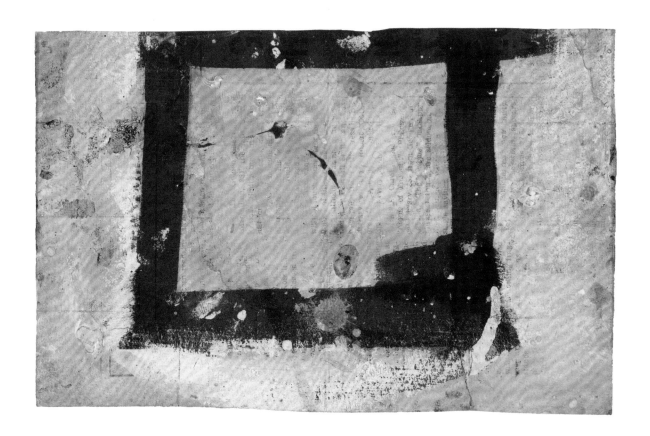

paper.[9] The second study, with the same title, which is in ink on a page from a telephone book, has been gridded for enlargement (illustrated in Christov-Bakargiev, Anfam, and Ashton 2004, 193). *High Street* is not the only composition in this show that Kline explored many times; for example, he made an additional oil on board painting that shows similarity to *Hoboken* and is about one-third its size.[10] Significant differences between the smaller work on board and the final canvas painting may indicate that the former is an instance of Kline revisiting the central forms of *Hoboken*, something that he would do in later works.

The preparatory sketches for three of the four 1950 paintings analyzed in this study, *Nijinsky*, *Wotan*, and *High Street*, display some commonalities but also differences (the fourth painting analyzed, *Chief* [fig. 4.6], does not have a known preliminary sketch). The support for *Untitled (Study for Wotan)* is newspaper, specifically, the August 13, 1950, literary review page of the *New York Herald Tribune* (see fig. 4.3). The studies for *Nijinsky*, *Hoboken*, *Clockface*, and one of the sketches of *High Street* are also on newsprint or printed pages taken from a telephone book.[11] For the sketches for *Cardinal*, *The Drum*, and *Leda* and the second sketch for *High Street*, Kline appears to have used white, unprinted paper, although without direct visual examination of the works it is unclear if this is artists' paper or another type of paper repurposed as a support.[12]

Kline used ink, gouache, and oil paints to create his sketches. The absence of oil staining around the black strokes, their thin consistency, and the way in which they

FIGURE 4.5
Franz Kline, *High Street*, 1950. Oil on canvas, 147.6 × 196.9 cm (58⅛ × 77½ in.), Harvard Art Museums/Fogg Museum, Cambridge, MA, Gift of Lois Orswell, 1971.121.

sink into the paper suggest that ink rather than paint was used on *Untitled (Study for Wotan)*. Media descriptions state that the blacks in the studies for *Cardinal*, *High Street* (both), *Hoboken*, *Nijinsky*, and *Leda* are also ink, while the black for *The Drum* is in oil and *Clockface* is in gouache. White paint is present on the sketches for *Wotan* and *Nijinsky* and clearly absent from those for *Hoboken* and *Clockface* and that for *High Street* on telephone book paper. The quality of reproductions available for the sketches of the others is insufficient to determine if white paint was also applied to the white papers. Kline told Katherine Kuh, "I paint the white as well as the black, and the white is just as important" (Kuh 1962, 144). This tenet seems not to be necessarily true of his sketches, where Kline was largely satisfied with the support acting as white.

Analysis suggests that Kline used two different types of white paints on *Untitled (Study for Wotan)*, and additional types are present in accidental surface drips. One of the whites appears to be a drying oil with the rutile form of titanium dioxide coprecipitated with calcium sulfate anhydrite and may be the same as the surface paint on the Harvard Art Museum's *High Street*. This paint was applied around the black form, and then the second grayish paint, which contains zinc, titanium, and a carbonaceous black pigment, was applied more evenly across the surface. In the sketch for *Nijinsky*, the white paint was also applied after the black ink and overlays it in some regions.

The application of white paint on the sketches for *Nijinsky* and *Wotan* is intriguing because they have been squared for enlargement; the white paint covers the grid lines,

FIGURE 4.6

Franz Kline, *Chief*, 1950. Oil on canvas, 148.3 × 186.7 cm (58⅜ × 73½ in.), Museum of Modern Art, New York, Gift of Mr. and Mrs. David M. Solinger, 2.1952.

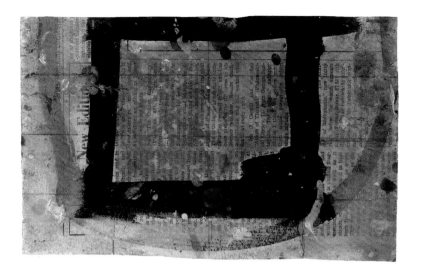

which are now only visible through the thin black ink, although they are revealed fully through infrared reflectography (fig. 4.7). At least one reason for the white paint may have been to cover the grid lines, but the study for *High Street* on newsprint, which was also gridded, has had no white paint applied to mask the lines. As masking the grid lines would negate their use for enlargement, one possibility is that after using the sketches to create the painting, Kline chose to paint over the lines in order to have the sketches more closely resemble the paintings and to be more salable. Another possibility is that at some point during the creation of the paintings the grid lines on the sketches became distracting and prevented ready comparison between the sketches and the paintings, so Kline painted over the lines.

In addition to the grid lines on three of the sketches, there is other physical evidence indicating that Kline used sketches, underdrawings, and other techniques to help translate his small sketches into large-scale works on canvas. The thinly painted works *Chief* and *High Street* both have charcoal markings that are visible to the naked eye but more clearly detected by infrared reflectography. The charcoal lines recorded in *Chief* seem to denote ends and angles of the major forms and demarcate geometric locations and relationships (fig. 4.8). A set of angled lines at the bottom corners of the canvas meet in the vertical center, although not the horizontal center, of the canvas. A set of lines on the proper left side create a vertical drop one quarter of the width of the painting. The mark-ups beneath *High Street* are more extensive and harder to interpret, but the charcoal marks also seem to indicate the locations of major forms rather than being a proper grid (fig. 4.9). *High Street* also has linear marks impressed in the paint, suggesting that Kline may have used a "snap line" technique, in which a tensioned string is pulled and released to snap back against the surface and create a straight line. This technique is somewhat unusual for canvas paintings but was often used in mural or theater design (*New York Tribune* 1881), and *High Street* is the only painting we have studied to date where Kline used this technique. Kline seems to have used snap marks mostly to create a set of vertical lines, though some angled snap marks are also present. Although the sketches for *Wotan* and *Nijinsky* are gridded, infrared reflectography reveals no indication of squaring on the paintings themselves (fig. 4.10); however, the thick paint layers on both these works could prevent sufficient penetration of the infrared light. Further complicating the search for underdrawings, *Nijinsky* (1950) was painted on a reused canvas, and the carbon content of the underlying reddish-brown paint layer diminishes the contrast needed to enable detection of carbonaceous grid lines.

FIGURE 4.8
In order to translate the sketch of *Chief* into a large scale painting Kline drew charcoal lines on the canvas, some of which are visible while others are only evident in the infrared reflectogram. Solid red lines indicate charcoal lines visible in normal light or in the infrared reflectogram of *Chief* (1950). Dotted red lines are extrapolations of these lines.

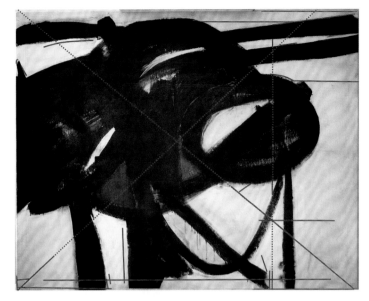

FIGURE 4.9
Kline used multiple types of preparatory markings to plan out the composition of *High Street* (1950). Solid red lines are charcoal lines; dotted red lines are extrapolations of those lines. Solid yellow lines represent other markings, including what may be string impressions in the paint surface; dotted yellow lines are extrapolations of these lines.

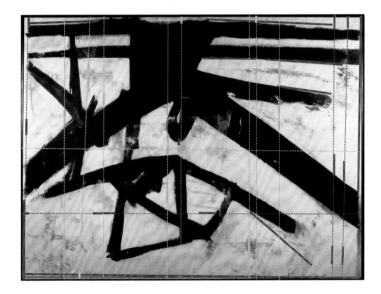

FIGURE 4.10
Infrared reflectogram of *Wotan* (1950). While Kline used a grid for the preparatory sketch for *Wotan*, there is no visible grid on the painting, suggesting he did not directly enlarge the sketch.

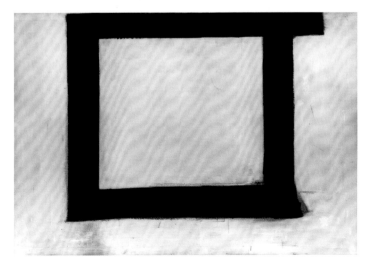

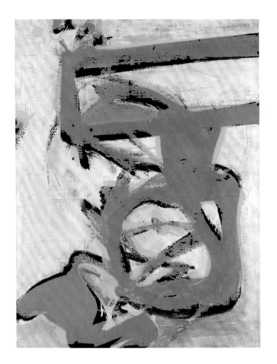

Comparing the sketches with the paintings reveals close associations but never exact replication. These differences indicate that Kline did not use a projector to enlarge his sketches onto canvas and corroborate Kline's explicit denial in a 1962 interview that he enlarged his sketches (Kuh 1962, 145). The sketch for *Nijinsky* and the painting show the closest alignment (fig. 4.11); all the major forms present in the painting are indicated on the sketch, though the painting proportions are slightly taller than the sketch. The most significant differences in shape are in the small black forms at the top of the canvas, which are more solidly black in the sketch, and a few thin black brushstrokes at center left and bottom right, which Kline edited out in the painting. The central black square in *Wotan* is taller than that in the sketch and lacks a feature at the bottom proper left inner corner that is present on the sketch. On *High Street*, several of the diagonal lines are at different angles from those in the newsprint sketch and the bottom feature was decreased in size in the final work (fig. 4.12). "Accidents" such as drips were sometimes retained, sometimes partially covered up, and sometimes fully obscured (but detectable in an infrared reflectogram), indicating that Kline carefully evaluated these occurrences and judged when and where they should be allowed to show. Whereas similarities of composition between a sketch and a painting can be most clearly appreciated by juxtaposing or superimposing images of each, as we do throughout this text, such comparisons give short shrift to the differences between experiencing a 4-inch sketch and a 4-foot painting. The scale of Kline's mature abstract work is a significant factor in its impact on the viewer, and Kline's ability to retain the spontaneity of his small sketches in his large-scale paintings is a testament to his skilled handling of materials, an aspect of Kline that art historical or critical appraisals often neglect.

The canvas supports for *Wotan*, *High Street*, and *Chief* establish a pattern that Kline would continue to use throughout the rest of his career. These works are painted on linen canvas sized with a proteinaceous glue, and all three contain double oil grounds. The compositions of the lower grounds differ: those of *Wotan* and *High Street* contain barium sulfate, zinc white, and silicates; that of *Chief* contains barium sulfate, zinc white, and calcium carbonate (figs. 4.13, 4.14). In contrast, the upper ground of all three

FIGURE 4.13
Cross-section sample taken from *Wotan* (1950) imaged by SEM in the backscatter electron mode, showing from bottom to top: (1) the lower ground layer that contains zinc white, barium sulfate and silicates; (2) the upper lead white ground; and (3) a surface white layer with titanium white (both anatase and rutile forms), calcium sulfate, calcium carbonate, and silicates.

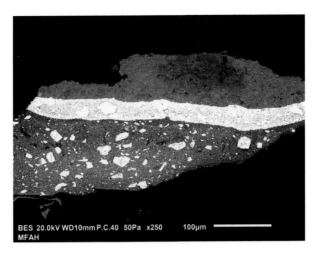

FIGURE 4.14
Cross-section sample of *Chief* (1950) imaged by SEM in the backscatter electron mode, showing from bottom to top: (1) the lower ground layer containing barium sulfate, zinc white, and calcium carbonate; (2) the lead white upper ground.

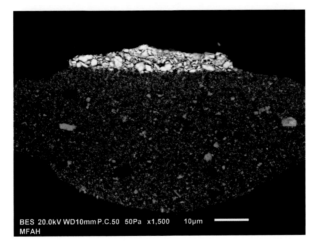

paintings is lead white, with morphologically similar particles. It is unclear if Kline was sizing and priming his own canvases or purchasing them preprimed, but he was under financial pressure and in 1960 recounted the need to borrow money to purchase canvas (11 yards for $40) in or around 1950 (Sylvester 1963). Advertisements in *ARTnews* from 1951 and 1952 promoted priming one's own canvas to achieve savings of up to 70% (and provided instruction booklets on request). The similarity of the upper lead white grounds across the three paintings and the dissimilar lower grounds suggest that Kline could have applied additional lead white grounds onto commercial single-primed canvases, as recommended by instructional texts of the time (Taubes 1944). All the other later canvas paintings examined to date have this base structure of linen canvas, proteinaceous sizing, and a double ground, with the upper ground containing lead white. The remarkable homogeneity suggests that Kline was either fairly consistent in his choice of commercial canvases or that these 1950 paintings document the creation of a "recipe" for his supports that he would continue to use throughout his career.

Nijinsky (1950) is distinct from the other three works studied: for this smaller work, Kline reused an extant canvas, which he had often done throughout the 1940s (see chap. 2). Only a single white ground layer is present, which contains lithopone and lead white, and it is unclear whether this is a commercial priming or one applied by Kline. Cross-section samples show a complex buildup, with as many as fifteen distinct layers of paint: the top fragment of a sample taken from a black area contains eight paint layers

FIGURE 4.15

Cross section of a paint sample taken from a black paint area in *Nijinsky* (1950) photographed with visible illumination, under crossed polars, and a 200x original magnification. This sample does not comprise the full stratigraphy of the cross section; the lower portion is missing. The multiple paint layers indicate that Kline reused the canvas numerous times. Before painting the final composition, he applied the thick reddish-brown layer overall as a ground, visible beneath the surface of the black layer on top of this sample.

FIGURE 4.16

Elemental distribution maps obtained by MA-XRF in *Nijinsky* (1950) showing lead (Pb), calcium (Ca), zinc (Zn), and iron (Fe). Thin scored lines are evident in the lead distribution map, suggesting that Kline had scored the paint with a hard tool in an underlying composition, similar to the technique he used in his transitional abstractions of the 1940s.

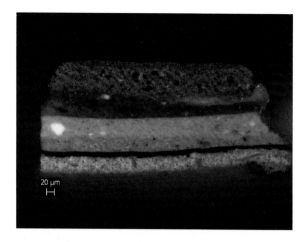

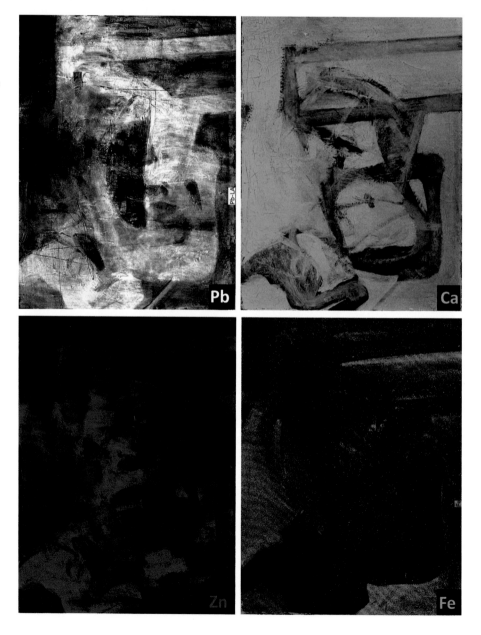

(fig. 4.15), and the bottom half of the sample contains an additional seven layers (not shown). This extensive layering could be due to the presence of multiple underlying compositions, but many of Kline's "transitional abstractions," discussed in chapter 2, are also thickly layered. The deep scoring visible as dark lines in the MA-XRF lead distribution map (fig. 4.16), although not visible in the X-radiograph or on the paint surface, is a common aesthetic technique used by Kline in works such as *Untitled* (1948; SRG 79.2624). The tacking edges of *Nijinsky* reveal traces of paint from an earlier underlying composition—possibly more than one—and the mostly yellow, orange, green, black, and blue colors are often seen in Kline's works from the late 1940s. Unfortunately, this multiple layering prevents a clear reading by X-radiography of earlier underlying compositions. David Lane, a collector who purchased some of Kline's transitional abstractions in 1953, later said that he had the impression that if Kline had not been able to sell them he would have painted black and white abstractions over them (Gaugh 1985b, 170), as seems to have occurred with *Nijinsky* (1950). The thick brownish-red paint layer below the surface black contains the iron-based pigment red ochre, and the MA-XRF map shows iron distributed across the surface of the painting (except where obscured by the central black form), suggesting that the brownish-red layer was applied across the entire painting and was meant to serve as a toned ground for the currently visible design while obscuring the underlying composition. The choice of a toned ground links this painting directly to Kline's earlier figurative works; for instance, in his 1940 *Nijinsky* portrait he applied a cool gray layer to modify the tonality of the white ground before painting the portrait of the dancer. The background of the 1940 portrait is a rich red color, and it is tempting to think that Kline had that painting in mind when he chose the reddish ground color for his 1950 work.

To paint the large works for the 1950 Charles Egan Gallery show, Kline tacked the primed canvases to a solid vertical support, often directly to a studio wall. Tack holes are visible on the raw, unprimed canvas of *High Street*, the only one of these early canvases examined that retains its original tacking margins. Later photos of Kline's studios show that for most of his large works he continued to use this procedure, which gave him a hard backing that provided resistance and support when applying paint with a firm hand and facilitated altering the final size and format of the composition (Gaugh 1985b) (fig. 4.17). Earl Kerkam, with whom Kline shared a studio in 1950, also painted on unstretched canvases so that he could determine the final format after the work was complete (de Kooning 1951).

Contemporaneous accounts suggest that Kline used retail trade paints, not artists' paints, in these 1950 works. In the late 1940s, Willem de Kooning and Kline reportedly both decided to eschew expensive artists' paint in their black and white paintings and instead purchased 5-gallon cans of zinc white and black enamel paint for sign painters and letterers from H. Behlen & Bros., at 10 Christopher Street (Lake 1999, 100). An independent account indicates that Kline's paints came from a store on Christopher Street that made its own house paint and that his brushes came from pawn shops on Third Avenue, Tenth Street, or Eleventh Street.[13] Later documentation by Goodnough in *ARTnews* of the creation of the 1952 work *Painting* confirms Kline's use of house paints at that time (Goodnough 1952; see also chap. 5).

Identification of the binding media strongly supports Kline's use of retail trade paints. The binding media of the black and white paints in the four paintings are mostly drying oils, although one sample of black paint from the turnover edge of *Chief* may contain an alkyd. Visual examination does not suggest that the alkyd-containing area is modern restoration but may instead indicate that Kline himself retouched the work, which he was known to have done. GC-MS analysis of paint micro samples from *Wotan*

and *High Street* reveal that they contain small amounts of odd-numbered fatty acids (e.g., pentadecanoic acid and heptadecanoic acid) and elevated levels of myristic acid, suggesting that a fish oil, such as menhaden, may be present (La Nasa et al. 2021).[14] Plentiful and cheap, menhaden oil was often added to house paints in lieu of more expensive oils, such as linseed, to reduce their cost (Stallsmith 1911; Brannt 1914, 305; DeSesa 1959). Using fish oil instead of vegetable oil also influences the handling properties of paint. A text on paints published in 1957 states, in reference to fish oil:

> It is also used largely in all types of interior finishes where lack of running and easy brushing are essential. This is especially true of so-called metropolitan New York types of paints where the painter must enter an apartment and get through as quickly as possible. This means that he has to work fast, and easy brushing is, therefore, of extreme importance to him. Running would also slow him down, and whether he brushes the paint on in a thin or thick film, there must be no tendency to run. Fish oil satisfies both of these requirements at one time. (Singer 1957, 26)

Paints made using fish oil would therefore have had properties quite distinct from those of artists' paints, which would likely have appealed to Kline. His sketches for these paintings were mostly made with free-flowing ink. To transpose the spontaneity of his small sketches to canvas, he would need a free-flowing paint that could be brushed on easily but not flow down the vertical surface of the canvas.

The pigments in these four paintings are surprisingly diverse given their shared black and white tonality. *Chief, High Street,* and *Wotan* contain bone or ivory black, whereas a carbonaceous black is the main black identified in *Nijinsky.* Throughout his career, Kline strongly preferred bone or ivory black but occasionally employed Mars black in some of his later paintings. Why he would have chosen to use a disfavored pigment on *Nijinsky* is unclear: perhaps that painting was created at a different time, or

a change in manufacturing recipes occurred, or Kline had simply run out of his favored paint and was forced to use a different black. These black pigments can be found in either retail trade paints or artists' paints, so their presence cannot confirm the historical accounts of Kline using house paints.

The white paints used by Kline do likely include retail trade paints. Titanium white coprecipitated with calcium sulfate anhydrite is found in all of Kline's 1950 works analyzed (Rogge and Arslanoglu 2019). Coprecipitated titanium pigments had lower covering power than the pure forms whose manufacture was more difficult, and Weber, an American artists' paint manufacturing company, stopped using titanium coprecipitates in 1946, as soon as the pure rutile form of the pigment became available (Phenix et al. 2017). In contrast, recipes for house paints continued to list the less expensive coprecipitated species until at least 1959 (DeSesa 1959), so the presence of the coprecipitated titanium species suggests a cheaper, retail trade paint.

All the paintings contain coprecipitated titanium whites, but Kline used a variety of different paints to create them. *Nijinsky*, *High Street*, and *Chief* each appear to have a single white surface paint, but these paints differ from one another. All three of these whites contain the rutile form of titanium dioxide, but the white of *High Street* contains rutile coprecipitated with calcium sulfate anhydrite, the white of *Chief* contains the same species admixed with calcium carbonate, and the white of *Nijinsky* has rutile coprecipitated with calcium sulfate anhydrite and mixed with kaolinite. *Wotan* has at least six different types of white paints that contain mixtures of lithopone, zinc white, lead white, barium sulfate, and calcium carbonate, as well as coprecipitated titanium whites. The variability in the whites suggests that Kline was not concerned about the identity of his white paints or pigments but used whatever was available at the time. The use of inexpensive oil and coprecipitated titanium pigments strongly indicates that these white paints are retail trade paints, likely house paints, and Kline may have purchased them from different sources, only caring that they were white, had an oil binder and handling properties he wanted, and were inexpensive.

Kline used a variety of paint application techniques in these four paintings. His most common tools were wide house painters' brushes, but he also used smaller brushes and, more rarely, a palette knife. In addition to adding paint, Kline appears occasionally to have edited an image by removing paint already applied. In *Chief*, Kline used a hard implement such as the back of a brush or palette knife to scrape off paint, reminiscent of the scoring present in his early works (see chap. 2) and the underlying composition(s) of *Nijinsky* (1950). Visual examination of *High Street* reveals abraded areas with the high points of canvas threads exposed, suggesting that in removing paint that he had applied, Kline rubbed or scraped through the two ground layers.

Kline's "rich painterly means" (Ashton 2004, 30) are evident in how he carefully manipulated paint density and glossiness. He thinned some paints to translucency and applied them almost in a wash, while other paints are relatively thick and pasty. The black paints appear to have been thinned more often than the white paints, and black drips are visible on both *Chief* and *High Street*. In these instances it seems that Kline initially applied a thin black wash that he later reinforced with thicker, more visually dense black paint. Fielding Dawson (1989, 57), a friend and student of Kline, wrote that Kline "had the most extraordinary way of being deliberate yet spontaneous in his use of turpentine, so the paint would dry faster where he wanted it to and create a matte area." Kline's thin paint application and dilution of the black paint he used in *Chief* and *High Street* created relatively matte surfaces. In *Wotan*, Kline chose to create very glossy areas in the blacks to enhance contrast with the matte white surface; a similar effect is seen in *Nijinsky*.[15] In *Wotan*, the black paint contains high levels of colophony, sug-

gesting that Kline deliberately chose a high gloss "enamel" to achieve that reflectance.[16] Similar paints found in Willem de Kooning paintings from the 1940s were reported to be Ronan's drop (bone or ivory) black quick-dry lettering enamel (Lake 1999, 99–100).

Kline's use of preparatory sketches and charcoal guiding lines did not mean that he completed these paintings quickly or without difficulty, and *Wotan* in particular bears material witness to his labors. The chemical composition of white paint samples inferred from infrared and Raman spectroscopy and SEM analyses indicates that at least six different white paints are present on *Wotan*, in addition to the two ground layers: (i) lithopone, anatase, rutile; (ii) lead white, anatase, rutile, calcium sulfate anhydrite; (iii) barium sulfate, lithopone, rutile; (iv) anatase, lithopone, zinc white, calcium carbonate; (v) barium sulfate, lithopone, anatase; and (vi) calcium sulfate anhydrite, calcium carbonate, anatase. Multiple layers of different white paints are present in all areas analyzed (fig. 4.18), which suggests that Kline revisited the painting again and again, using whatever white paint he had at hand. Despite the many layers of white paint, there are only two significant revisions of the central square form visible in normal light and in the infrared reflectogram (see fig. 4.10). The height of the bottom bar was slightly decreased, and the proper left corner, which is not square, was decreased in volume; Kline allowed both revisions to show on the surface of the painting. However, the thickness of the paint at the edges of the square suggests that Kline repeatedly refined the interface of the black and white paints on this painting, as well as on *Chief* and *High Street*, where close inspection reveals white covering black and then black applied over the white. Elaine de Kooning, writing after Kline's death, noted that he would work on several canvases contemporaneously, "going from one to another over a period of months, hacking away forms, painting over black with white and white with black to carve out or build up his image" (Kline and de Kooning 1962, 15–16). This practice is confirmed by the layers we detected in *Wotan* and could explain why a painting that Kline refined extensively would show many types of paint, whereas a painting that he completed more quickly would contain fewer paints.

Cross-section samples reveal the number of paint layers present and offer insight into the creation process of a painting, but another important visual cue also exists. The upper grounds in the relatively thinly painted *Chief* and *High Street*, which are a grayer tone than the surface white paints Kline applied, are used as a compositional element; this feature recurs in many of Kline's later works. If, as suggested by chemical composition and particle morphology, Kline applied the upper ground himself, his choice of a slightly grayish upper ground may have been driven in part by his desire to deliberately use whites of different tonalities to create a subtler white-on-white contrast to accompany the obvious white and black contrast. The more heavily painted *Wotan* and *Nijinsky* do not have any remaining exposed ground, but this is relatively uncommon in Kline's black and white paintings. The presence or absence of visible ground may thus serve as a clue to which paintings had longer and more laborious creation processes, allowing us to better appreciate the vagaries in Kline's painting practice.

Another visual clue to Kline's working process is his application (and removal) of paper on wet paint surfaces. Application of a sorbent paper can partially remove the oil binder from paints, enabling faster drying and creating a more matte surface. In a 1957 interview with Seldon Rodman, Kline explained that a canvas that he was working on had sheets of newspaper stuck to it to "make the paint dry quickly" (Rodman 1957, 108). Select areas of *High Street* (1950) and *Nijinsky* (1950) appear to have had paper or a similar material applied to the surface and then removed, creating raised patterns as the paint was lifted and then resettled (fig. 4.19). If Kline was struggling to complete these works before the show, he may have been trying to dry them faster. However, de Koon-

Cross section of a partial sample of *Wotan* (1950) imaged by SEM in the backscatter electron mode. The sample is missing at least the double ground but contains, from bottom to top: (1) white paint that is primarily calcium carbonate with some silicates; (2) white paint that likely contains titanium white and lithopone; (3) a white paint with titanium white and lithopone; and (4) a thin surface layer of black paint with bone or ivory black. The multiple layers of white paint suggest that Kline repeatedly revisited the work using whatever white paint he had at hand.

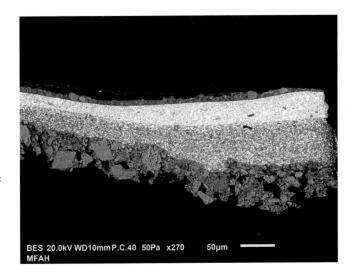

An area of *High Street* that shows topology suggestive of Kline having pressed a piece of paper onto the wet paint surface and then removed it.

ing was reported to have applied paper to his wet paint layers to *slow* drying by limiting air contact and thus enable later reworking (Pranther 1994, 100). As paper can be used to both speed and slow paint drying, it is not clear which effect Kline was attempting to achieve in 1950. His later use of collages to create compositions suggest that Kline may also have held or applied paper to the surface of a painting to study the effect of changes to the composition before attempting them in paint.

Once satisfied with the composition—Kline would say, "I caught it," when he deemed a work finished (Gaugh and Kline 1979, 26)—he would outline the final desired format for the composition with charcoal and use that to determine the size of the strainer or stretcher. Such dimensional outlines constitute a direct link to his drawing method, as comparable outlines in ink are visible on the sketches for both *High Street* and *Chief*, as well as in many of his earlier ink sketches (see fig. 2.10). For the Charles

Egan Gallery show, Kline framed the stretched canvases, using thin metal strips to cover the painting edges (Gaugh 1985b, 93). However, on both *High Street* and *Chief* he covered some of the black paint that was visible on the turnover edges with white, likely to neaten the appearance of the works and suggesting that he may not have been averse to displaying his paintings unframed. A 1950s photograph of his studio shows *Cardinal* hanging on his studio wall unframed (Gaugh 1985b, 92), and Kline chose not to frame the majority of his later large-scale works.

The paintings were named after they were finished, often with help from friends such as Elaine and Willem de Kooning or Charles Egan and not infrequently with the aid of a bottle of Scotch (Gaugh 1985b, 93). Some names are references to things Kline liked, such as *Nijinsky*, *Wotan* (from Richard Wagner's Ring Cycle), *Giselle* (from the eponymous ballet),[17] and *Cardinal* (a train); others derive from locales, such as *High Street* and *Wyoming* (a county in Pennsylvania, not the state),[18] or objects evoked by the form of the painting, such as *The Drum* and *Clockface*. The origins of the names were not always clear; Elaine de Kooning (1962, 68) indicated that *Chief* was named after a train, and Kline had titled a 1942 painting of a locomotive *Chief* (Mattison 2012, 30), but Zogbaum said the name derived from a statement made by Earl Kerkam, Kline's friend, fellow artist, and sometime roommate, when he saw the painting: "It's a god-damned Indian chief."[19] The way in which the works were named emphasizes that Kline's black and white abstractions evoke powerful responses and invite independent interpretations by receptive viewers; the titles did not merely inform viewers of the artist's intention. Although Kline likely chose the titles from those offered, this is another instance of his unwillingness to use his own words to describe or characterize his art.

The four 1950 works studied reveal many techniques that Kline would continue to use for the next twelve years but also some that he would abandon relatively quickly as he became more confident in his skills. He never stopped sketching and using works on paper as a resource for his paintings, but he became much more assured in the transposition of sketch to canvas: some paintings after these 1950 works have a few visible charcoal markings, but Kline seems to stop employing them after 1952. Whereas in his early works Kline used both artists' and retail trade paints, at this stage Kline appears to use only the latter. This choice may have been driven by economics, but the handling properties of house paints were likely critical as he sought to emulate the free-flowing ink used in his sketches. Later in his career, when he began to use artists' paints again, he struggled with their quite different properties. Although these paintings exhibit a wide variety of pigments, Kline was very methodical about the sizing and grounds of new canvas. The use of glue sizing and a lower ground and an upper lead white ground in *Chief*, *High Street*, and *Wotan* establishes a pattern that Kline would continue for future large-scale works on canvas.

The paintings in the Egan Gallery show also introduced compositional elements that would recur throughout Kline's career, in particular the imperfect square that features in *Wotan* (see fig. 4.4) and *Leda*. If Kline was "simplifying forms ... into essential elements" (Karp 1956, 10), then his abstract lines might echo his representational work: Kline's sketches of Elizabeth seated often reduced the chair base to a square, and in the sketch for *Wotan* the partially overpainted arc beneath the square may be read as a rocker element (see fig. 4.3). Kingsley (2000, 38) and others see the square as representative of a body or head. This possibility is supported by Kline, who said, "The first work in only black and white seemed related to figures and I titled them as such" (quoted in Baur 1955, 48). Kline also said, "Two squares can be two of the saddest eyes in the world" (Gaugh 1985b, 98), and this idea may have suggested the name of the one-eyed god as the title for *Wotan*, a painting dominated by a single large square. Although

Josef Albers was not part of the Downtown coterie, Kline had undoubtedly seen his 1949 shows at the Egan and Sidney Janis Galleries, and Kline told Frank O'Hara, "It's a wonderful thing to be in love with The Square" (O'Hara 1964, 6). Kingsley contrasted Albers's squares, which are geometrically precise and used as an avenue for color exploration, to Kline's use of the shape.

> Never ruled, never perfect, Kline's square is thoroughly romanticized by the painter's touch. Its edges cut under the whites here, brush over them there; its sides are thicker here than there, more assertive here, more tentative there. One square is tightly compacted, another pulled out of shape like a grimace on a clown's face; one has wings, another the stability of a mausoleum. Albers varied only the colors of his squares—Kline varied their emotional content. (Kingsley 2000, 47)

Nijinsky also features squarelike elements in the lower half of the central form, and Kline would continue to explore the emotions evoked by imperfect squares for the rest of his career, including in his final painting, *Scudera* (see fig. 6.15).

Apart from *Wotan* and *Leda*, *High Street* (see fig. 4.5) and *Cardinal* may be the works that most clearly presage the future of Kline's oeuvre. In *High Street*, the upper horizontal bars touch the edges of the painting and imply a continuation beyond the painting's surface, while the diagonal elements activate the painting and give it a sense of movement. The result is a poised, tension-filled construction. The centrally positioned loop, which Kingsley (2000, 138) terms a "trigger," is an element that also occurs in *Cardinal* and recurs in later works. The primary forms are horizontal and vertical, but in addition to the trigger, *Cardinal* contains arcs and semicircular brushstrokes. The composition is busier than many of Kline's works, and not until the mid-1950s would Kline commonly create such complex structures.

The central form of *Nijinsky*, a work perhaps painted or named in homage to the dancer, who had died on April 8, 1950, has been described as "a whole figure, a bundle of energy gathered up into itself as it springs into the air" (Kingsley 2000, 45) and evokes the coiled power of the dancer. Although *Nijinsky* is more curvilinear than later works, it may augur what Kingsley termed Kline's "lunging animal" paintings, a description she based on a 1940s sketch of Kline's cat Kitzker (Kingsley 2000, 382 [illus.]; and Christov-Bakargiev, Anfam, and Ashton 2004, 169).[20]

Some of Kline's "vocabulary" from this key period figures less prominently in his later work. *Chief, Clockface, The Drum*, and *Hoboken* feature large circular elements, which Kline would abandon after a few years. The rather dry and scratchy black lines of *Giselle* harken back to many of Kline's sketches from 1947–48, which Gaugh characterized as "white drawings" with open compositions (Gaugh 1985b, 78; see also chap. 2 above). The more delicate lines, which read as hesitancy, evidently failed to resonate with Kline; in future work, he used thin lines only in counterpoint to thick lines to create a sense of scale.

Kline himself was satisfied with the results of his labors. He wrote on David Orr's announcement of the show, "Dave, you've made so many things possible and I guess we've both wondered about many of the events, I'm proud of this one" (Gaugh 1974, 47).[21] The critical acclaim was more mixed. Not all viewers who appreciated Kline's earlier work were comfortable with the change of style and scale. One critic wrote:

> Assuredly these paintings hit the eye and arrest the attention, as any explosive spectacle will. But after the initial shock, engendered by stark largeness, one realizes nothing remains to engage the eye or the emotions. For this reviewer,

several small ink-wash drawings, involving similar intentions but of greater complexity, are more rewarding. They are the logical abstract development of Kline's earlier etching work. (Fitzsimmons 1950, 20)

Manny Farber's review in *The Nation* seems unenthusiastic at the outset but proceeds to describe how careful observation reveals the significance and power of Kline's painterly approach.

> Franz Kline, housepainting a huge irregular grate or a figure like a sloppy 'g' on staring white, achieves a malignant shock that is over almost before it starts.... A heroic artist achieves a Wagnerian effect with an almost childish technique. It is the blunt, awkward, ugly shape that counts, not finicky detailing or complication. But these yawning white backgrounds and hulking black images hide a nimble rather than primitive craftsmanship, clever at making facetious emotion appear morbidly violent and suave brushing seem untrained. (Farber 1950, 445)

Thomas B. Hess was impressed enough to include illustrations of *Chief* and *Cardinal* in his 1951 text, *Abstract Painting: Background and American Phase*, writing:

> This mild-mannered Pennsylvania-born, carefully educated artist filled the gallery with mammoth black and white canvases which seemed inevitably "right" and even familiar, although they were also completely new.... Kline is concerned with the scaffolding, with the proper relationship of relatively few, simple shapes.... Kline's structure is an elaborate invention—self-sufficient pictorially and without need of additional seductions to operate within the largest reference.... Emotion is concretized by image. Skipping the intermediate step of metaphor, Kline's stable masses of black and white refer directly to the human condition through the spectator's eyes. (Hess 1951, 137)

Clement Greenberg, who with fellow critic Harold Rosenberg was closely associated with the Abstract Expressionist movement, supplied a succinct quote for an advertisement in the *New York Times*: "Most striking new painter in the last 3 years" (O'Brian 1993, 44). Kline's mother was considerably harsher, saying of his black and white palette, "I'm ashamed of you, trying to do it the easy way" (quoted in Hopkins 1979, 37).

International notice of the show was generated by Isamu Noguchi, a sculptor living in the Village who had had a one-person show at the Egan Gallery in 1948. Noguchi obtained photographs of nine of the paintings from Kline's show and sent them to his friend Sabro (Saburô) Hasegawa, a Japanese calligrapher and painter, telling him that they could be used in any manner.[22] Hasegawa reproduced all nine photographs, including *High Street*, *The Drum*, *Nijinsky*, *Chief*, *Cardinal*, and *Hoboken* (used for the cover) in the first issue of the Japanese journal *Bokubi* (Beauty of the Ink).[23] In an accompanying essay, "The Beauty of Black and White," Hasegawa wrote, "Nijinsky was one of the great dancers of the century. Was his legendary dance not like this painting? Strange movements, stiff and supple, harsh contradiction and strong harmony, projected into the atmosphere with something tragic—powerful." Regarding *High Street*, Hasegawa said, "Here are daring, strong, straight lines and their sorrows and solitudes. Of the nine, this is one of my favorites" (Hasegawa 1951; English trans. in Christov-Bakargiev, Anfam, and Ashton 2004, 308–10). This brought attention to Kline's work in Japan and was the start of a long friendship between Kline and Hasegawa.

Although the show was not a great financial success, two works did sell. Alfred H. Barr, director of MoMA, had asked Dorothy Miller, senior curator of paintings, to

see the show; she was "sufficiently impressed and…felt that the museum must acquire at least one [painting]," according to Elisabeth Zogbaum.[24] As it was unlikely that the museum would be able to raise the funds,[25] Mr. and Mrs. David M. Solinger interceded on the museum's behalf, buying *Chief* and then giving it to MoMA in 1952. And *Leda* was sold to to G. David Thompson (Gaugh 1985b, 95). Two sales out of ten paintings was respectable, but it is unclear how much Kline earned from the show, and Egan apparently would hold back the money from sales of works for some time to keep the gallery afloat rather than passing it on to the artists at once.[26] So, although the show elevated Kline's status in the New York art scene almost overnight, it did not immediately alter his financial circumstances.

5 Beginnings of Success, 1951–1956

Corina E. Rogge

After the critical acclaim of his first solo show, Kline continued to develop what would become his iconic style while maintaining an active role in the Downtown art scene. In 1951, members of the Club, reportedly at the urging of Kline and Marca-Relli, rented, cleaned, refitted, and painted an empty antique store at 60 East Ninth Street that was facing demolition, and from May 21 to June 10 held the *9th St. Show*, featuring the works of seventy-two artists (Metzger 2006). In addition to designing the poster, Kline showed a work originally called *Untitled* but later renamed *Ninth Street*[1] and, according to Philip Pavia, was a driving force behind the decision to hang the works salon-style (Foster 1994, 48).

One year earlier, fifteen artists listed on Kline's *9th St. Show* poster had signed an open letter protesting *American Painting Today, 1950*, the national competitive exhibition announced by the Metropolitan Museum of Art (MMA 1950). Adolph Gottlieb, Willem de Kooning, Barnett Newman, Jackson Pollock, Mark Rothko, and other painters had decried the announced juries as biased against modern painting and refused to participate; their letter, cosigned by ten sculptors, appeared on the front page of the *New York Times* on May 22, 1950, under the headline, "18 Painters Boycott Metropolitan; Charge 'Hostility to Advanced Art.'" The *American Painting Today, 1950*, exhibition opened on December 7, 1950, and was covered by *LIFE* magazine, which published images of the winning works in the January 15, 1951, issue—preceded by a large photograph captioned "The Irascible Eighteen," referring to their protest. Although Kline did not participate in the closed panel Studio 35 meeting at which the protest letter was conceived (Friedman 1978, 96), his involvement in the *9th St. Show*, which served as a sort of Salon des Refusés following the written protest, attests to his growing stature and influence among his peers: Kline began to be a foreground presence in the avant-garde.

Late in 1951, November 7 to December 8, Kline had a second one-man show at the Charles Egan Gallery. Unfortunately, the announcement does not list the paintings, but the show may have included *Painting No. 11* (1951), *Ninth Street* (1951), and *Untitled* (1951) (Christov-Bakargiev, Anfam, and Ashton 2004, 307).[2] Clement Greenberg (1952, 101) followed his one-sentence statement regarding Kline's first show with a more in-depth review of this show: "Kline's large canvases, with their blurtings of black calligraphy on white and gray grounds, are tautness quintessential. He has stripped his art in order to make sure of it." Many Kline works from this moment were featured in *Bokubi* 12, no. 5 (1952), accompanied by an essay by Shiryû Morita and a letter to the editor from Kline. Paintings illustrated in the issue included *Ninth Street* (1951), *Figure 8* (1952), *Painting No. 11* (1951), *Painting No. 7* (1952), *Untitled* (1951), and *Untitled* (1952); another

Kline work, *Painting No. 3* (1952), was the cover illustration.[3] Morita aptly summed up the new works relative to the 1950 paintings: "As to the lines, the works of last year were rather sharp, dry, and unsettled, but those of this year have become more tasteful and settled. In a word the lines have been *deepened*" (Morita 1952; trans. Christov-Bakargiev, Anfam, and Ashton 2004, 311; original emphasis). Indeed, most of the works from this period feature bolder lines than those of the more "sketchy" 1950 works such as *Giselle* and *Cardinal* (*Painting No. 11* is the exception). Among the paintings depicted in this issue of *Bokubi*, squares and rectangles now dominate, with eight paintings including these geometrical forms, one of which, *Yellow Square*, contained color.[4] Circles have largely disappeared, although curves still appear in *Figure 8* and *Ninth Street*, and there is no parallel to the complicated structure of *Cardinal*. Kline, in a letter to Morita that was published as an accompaniment to the photographs of his work, wrote, "I think there might have been improvement in this year's work in the purity of the white areas and in the simplifying of the structure. I have been working mostly with black and white since last year's show. Although the size of the canvas is pretty much the same, I use less gray and the shapes are simpler" (Kline 1952, 4; Kingsley 2000, 151).

Unusually, *Untitled* (1952; MMA), which can have been finished no later than March 18, when Kline posted the last images to Hasegawa for publication (Kingsley 2000, 151), is painted on a repurposed awning fabric rather than Kline's usual choice of artists' canvas. Another unusual feature of the work is that the fabric was stapled to the stretcher through the front rather than having been turned over the stretcher and then tacked at the sides or back of the stretcher bars, as was his custom. Kline seems to have used the entirety of the available fabric, again in contrast to his usual approach. These choices likely reflect Kline's inability to consistently afford materials and suggest that in this case he scavenged a support, a practice to which other Downtown artists had also resorted (Gabriel 2018, 200). Kingsley (2000, 152) identifies in this work the first instance of a new composition trope, consisting of a large vertical element "tied down" to the base or sides of a painting, that will recur in Kline's mature works in black and white and in color (Kingsley 2000, 152).

In 1952, Robert Goodnough, a fellow Downtown abstract artist and participant in the *9th St. Show*, wrote for *ARTnews* one of the few accounts of Kline's working method, "Kline Paints a Picture." In the article, Goodnough describes the creation of *Painting* (1952), originally titled *Abstract Painting* (fig. 5.1). The observations recorded by Goodnough are one of the few windows into Kline's creative process. Having artists document the working practices of other artists was a brilliant decision of *ARTnews*: the artist-writer would likely be granted greater access than most other writers by the individual being documented and would probably have deeper insight into and understanding of the creative process than most nonartists might. Goodnough was writing for a current audience broadly interested in how modern artists created, not for future technical art historians, but his narrative of Kline at work contains key details, many of which are corroborated by other accounts or that we show are consistent with our findings from an analysis of *Painting*. Supplementing a close reading of "Kline Paints a Picture" with comments and observations from friends and peers of Kline and with insights from technical analysis of this and other contemporaneous works, we can infer an even more detailed view of Kline's creative process at that time, despite the artist's general reluctance to discuss his approach.

Goodnough begins his description of Kline at work with Kline's use of sketches.

He does countless drawings, quickly in broad strokes; often on pieces of newspapers. Later he goes through these and may find a theme that has been uncon-

FIGURE 5.1

Franz Kline, *Painting*, 1952. Oil on canvas, 195.6 × 254 cm (77 × 100 in.), Art Institute of Chicago, bequest of Sigmund E. Edelstone, 1984.521.

Kline's seven-month-long creation of this painting was documented in Robert Goodnough's article, "Kline Paints a Picture" (1952) in *ARTnews*.

sciously working its way into the open; something that is common to all or most of the drawings. He may then select one drawing that seems to contain this element most concisely and work directly from it on to the canvas. Or he may, as was the case in the painting shown here, set the drawings aside and work on the canvas with the general feeling he has gotten as a result of making the drawings, ready also to make changes, at any time necessary, as the picture develops. (1952, 37)

In January 1952, according to Goodnough, the sketches "began to feel important enough to the artist to cause him to select a very large canvas" (38). Goodnough indicates that the canvas Kline used for *Painting* was linen, with a "coarse grain," but does not inform readers if the canvas was preprimed or if Kline primed it himself. Analysis of samples taken from the work indicate the presence of an animal glue sizing and two oil-based grounds; the lower ground contains poorly mixed zinc white and calcium carbonate, while the upper ground is primarily lead white. The irregular mixing of the pigments in the lower ground, the similarity of the layering to earlier works, and the significant cost of double-primed canvases suggest that Kline may have continued using the same approach as in 1950: he either applied the second ground himself or applied the sizing and both grounds himself. Kingsley (1985, 7) states that Kline "always had huge pieces of double-sized Belgian linen pinned to his painting wall" but does not cite a source for this information or indicate if the grounds were applied by Kline.[5]

FIGURE 5.2

A painting table in Kline's 14th Street studio showing the neatly arranged brushes and tubes of paint. He mixed his paints in painting trays or directly on the surface of the table. Undated photograph.

Goodnough says that Kline tacked the canvas for *Painting* to a support board, as he had done with the large paintings in his 1950 Charles Egan Gallery show (see fig. 4.17). This was because Kline

> likes a strong back since he pushes the brushes hard against the canvas when working, also it may happen that a canvas will not turn out well and then the unnecessary business of making a stretcher will be avoided. Also, when he starts a painting he still may not know for sure just what size it will need to be—so he uses a canvas somewhat larger than planned on to allow for any necessary additions. *Abstract Painting* 1952 was first started about 3 inches smaller in width than it appears in its final form. (Goodnough 1952, 38)

The large size of the canvases Kline chose to use and his own modest stature (approx. 5 ft. 6 in.) necessitated that he work from scaffolds, ladders, or other supports. Philip Pavia indicated that in front of the canvas "he would push with his feet a wood beer box to a certain spot. After a few trials and errors, he fixed the box into a right spot. He then slanted a plank from the floor with one end on the beer crate. A temporary ramp" (Foster 1994, 46). Kline evidently also kept his studio "uncluttered and orderly," with a table containing brushes (from 1 to 5 in. wide and kept very clean) and paints nearby (Goodnough 1952, 63) (fig. 5.2). In an interview after Kline's death, Piero Dorazio, who had met Kline in 1953 or 1954 (Dossin 2016, 27), said, "I remember…the rollers, the

colors, the brushes, all arranged ready to start, like for a one hundred yard sprint you know—everything was ready—like for a sprint—always ready in a very clean studio, very neat, very well organized like an athlete in a way."[6]

Goodnough noted that Kline's working area was near two windows but that there were also many electric lights because he painted at night. Working at night was evidently a lifelong practice for Kline; Emmanuel Navaretta, who stayed with Kline in 1950, corroborated that Kline was mostly working at night by that time (Gaugh 1985b, 90). Conrad Marca-Relli and John Ferren, Kline's housemates at 52 East Ninth Street in 1952, corroborated his night owl tendencies (Gaugh 1985b, 178). Marca-Relli said that Kline "stayed up until four or five in the morning, made noise, played Wagner, played music, painted at night and dragged his canvases across the floor."[7] Kline admitted, "I like to have the record player in action while I'm working" (Crotty 1964, 10), but his tendency to play loud music late at night was not appreciated by his housemates or others (later, when working in Provincetown, Kline was reportedly arrested for playing his records too loud [MacDonald 1960]). Painting at night requires strong artificial lighting. A photograph of Kline's Ninth Street studio shows a strong ceiling-mounted light aimed at a painting in process (Gaugh 1985b, 92), and a nighttime photograph taken of a later studio, at 242 West Fourteenth Street, which Kline leased from 1957 to 1962, shows the large windows and the extremely strong studio lighting (Christov-Bakargiev, Anfam, and Ashton 2004, 329). This nocturnal working practice may have influenced Kline's predominant use of black and white, as the balance of those tones is not influenced by the difference in color temperature between natural and artificial light.

Goodnough reveals that although Kline did not enlarge his sketches onto canvas using a projector or grid, he did rough out the composition of *Painting* by drawing on the canvas: "Kline began this painting in charcoal, making long, rapidly applied lines that whipped across the canvas to suggest the over-all movement he had in mind, but not to outline the shapes. The drawing process was finished in less than half an hour and amounted to only a few directional lines" (1952, 38). Compared to his 1950 canvases, Kline's works in this period betray fewer compositional lines, indicating his increasing confidence in moving from sketch to painting. Infrared reflectography shows the presence of angled and drop lines similar to those seen in *Chief* or *Untitled* (1952; MMA), and photographs of *Ninth Street* (1951) taken in normal light prior to its auction in 2002 appear to show the presence of charcoal lines in the proper upper right corner and along the left side (Christov-Bakargiev, Anfam, and Ashton 2004, 400). *Painting No. 7* (1952) (fig. 5.3) has a few visible charcoal lines indicating the positions and ends of the major black strokes, but the only mark-ups currently visible on *Painting* (1952) in normal light or in infrared reflectography images are the outlines Kline made to indicate the final dimensions of the work. Clips from a film taken late in his life (Colby 1982; stills in Kline et al. 1984) show that Kline continued to use charcoal underdrawings throughout his career, but in most works, including *Painting* (1952), he covered these markings with black paints that are infrared-opaque, so the underdrawings cannot be detected by infrared reflectography.

Goodnough writes that after Kline created his terse outline of the composition for *Painting*,

> no time was allowed to elapse between the drawing and starting to apply paint—this must be a continuous process without a break, otherwise he might lose the feel of his initial emotion. With house-painters' brushes 2 or 3 inches wide, he immediately began to apply a few bold shapes in black oil color. Then he dipped out a huge gob of paint from a gallon can of zinc white ground in oil,

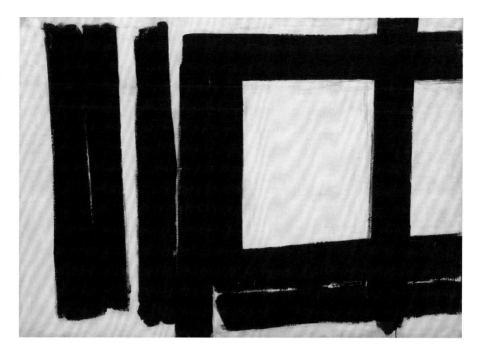

worked it into a malleable condition, took a clean brush and quickly put in several areas of white in relation to the black areas. Then he moved to black again. It was a process of changing often from one to the other so that neither of these two opposites might dominate the other. (1952, 38)

Goodnough reports that Kline preferred to use paint from cans so that "he [would] not be continually squeezing paint from tubes" (38); these must have been retail trade paints, as artists' paints were not available in cans at that time. He confirms that the black oil paint used by Kline was a retail trade paint intended for tinting house paints and that the white paint was Behlen's zinc white, a house paint. Behlen's zinc white was a favorite material of Kline's. "[He] buys it in gallon cans and mixes in some titanium [paint] to give it the right feel," Goodnough writes (39), but does not indicate what type of titanium white paint Kline added. An accompanying photograph of Kline's worktable shows an open can of white paint, presumably the Behlen's zinc white, and a tube of Hi-test artists' oil paint whose label indicates that it is zinc white rather than

titanium white. Although the scene for the photograph was undoubtedly posed, the presence of paints not mentioned by Goodnough indicates that his account of Kline's materials is not exhaustive.

Analysis of paint samples taken from the ground and from the black and white surface paints of *Painting* shows that all are drying oil based, with small amounts of colophony (pine resin); in contrast to works from 1950, none of the markers characteristic of fish oils are detected. The amount of colophony is low, so the material may derive from the use of turpentine as a diluent rather than a deliberate additive included by the paint manufacturer. The black paint is a bone or ivory black with barium sulfate and aluminosilicates. The surface white paints contain zinc white, barium sulfate, talc, and the anatase form of titanium white. Talc is a common extender and rheological modifier added to house paints and thus may be associated with the Behlen's paint (McGonigle and Ciullo 1996). The titanium white pigment is the pure anatase form, not the less expensive coprecipitated form, which suggests that it could derive from an artists' tube paint (Rogge and Arslanoglu 2019). By the early 1950s, some artists' paints already contained the rutile form of titanium dioxide, which has higher covering power and is less prone to chalking (Titanium Pigment Corporation 1955; Phenix et al. 2017). However, 28% of the titanium white artists' oil paints in the Art Materials Research and Study Center use anatase (Rogge and Arslanoglu 2019), so its presence does not necessarily imply a retail trade paint. Apart from the poor mixing of the lower ground, there is no definitive indication that the paints used on the work are retail trade paints, although the presence of talc is strongly suggestive. Therefore, although Kline did use house paints, according to the accounts of both Elaine de Kooning (1962) and Robert Goodnough (1952), they were not necessarily poorly made or inferior materials, as this painting remains in good condition.

Close inspection of the paint surface of *Painting* showed the presence of very small, pinpoint-size discrete areas where red paint had been transferred to the canvas, and the colorant in these spots is Pigment Red 3 (toluidine red, PR3). The red covers only a few square millimeters of canvas, and there is no evidence for the deliberate application of color; this therefore appears to have been an accidental occurrence. The presence of these spots indicates that Kline had colored paints in his studio at this time, although he was showing only black and white paintings. Color had not been excluded or excised from Kline's world or even his process; indeed, Goodnough notes that one of the small sketches Kline used as a starting point for *Painting* included green and orange passages.

Kline often thinned his paints, particularly the blacks, with turpentine (see chap. 4). The thinly applied black areas appear matte, while the areas that were applied more thickly retain a gloss; both types of paint application are still evident on *Painting* today. Kline viewed these gloss differences as important; as Goodnough (1952, 39) writes, "He feels they should be left that way, for to change them merely out of technical consideration would be inconsistent—the emotional results count and not intellectual afterthoughts." Gloss differences in the blacks were important enough to Kline that on at least two later works, *Four Square* and *Mahoning* (1956), he deliberately applied a selective and partial varnish layer to certain black passages. Goodnough reports, "Less thinner is used with the white, though it is well worked first with palette-knife into a smooth puddle before applying, and the whites appear somewhat more thick and shiny than the blacks. This too, adds a kind of conflict on a sensuous level that is not out of keeping with the general conflicting elements of the painting" (39, 63). Visual inspection suggests that Kline used turpentine-thinned blacks in some areas of *Painting* but reinforced other areas with thicker and glossier black paint. It is also evident that Kline applied white over black and black over white. In some cases, this occurred while the

underlying paint was still wet, and wet-in-wet mixing has led to gray areas, but where the black paint was applied over dried surface whites, drying cracks have formed. In an interview with Zogbaum, the painter Ludwig (Lutz) Sander suggested that this type of editing, particularly of edges, derived from the sign painting craft and resulted in what he termed a "cut line."[8] Kline's childhood fascination with an old sign painter's work suggests the possibility that he adapted what some might consider craft skills to suit his needs.

The paint on *Painting* (1952) appears to have been applied mainly by brush, although where the bottommost black vertical line meets the lower horizontal line, an area of thinly applied black paint has been partially removed using a tool such as a brush handle, similar to what is seen on *Chief* (1950). On *Painting*, there are areas of impasto in both the blacks and the whites; Goodnough (1952, 64) indicates that Kline allowed this to happen naturally: "The repeated layers of paint that some of his paintings require may give a feeling of texture. If this is the case it is just a result, and not something sought for intentionally." Much later, Kline himself said, "I don't like to manipulate paint in any way in which it doesn't normally happen. In other words, I wouldn't paint an area to make texture, you see?" (Sylvester 1963, 4). *Painting* also contains textures indicative of paper having been pressed onto still-wet paint and then peeled off, as is seen in *High Street* (1950), but this aspect of Kline's technique was not mentioned by Goodnough, so it is not known if Kline did it to slow or to speed drying. Whatever the reason Kline had for this practice, it may have resulted in the presence of paper on the surface of *Mahoning* (1956); perhaps the paper became too well adhered to the paint to remove easily, so Kline simply incorporated it.

Kline had selected the canvas for *Painting* in January 1952 but did not begin painting until June, and completing the work took another two months. Goodnough (1952, 63–64) indicates that in the initial composition "two black shapes shot upwards to the top of the canvas, but this movement was too strong and directed one's interest outside the picture. After consideration…he decided to put a black area across near the top to give a horizontal direction. Yet he left areas of white just above this to pick up the white below." The presence of small amounts of white at the top of paintings was a common feature throughout Kline's career; his compositions are rarely completely black at the top edge (two exceptions are *Scranton* and *Elizabeth*).[9] Instead, most have "windows," or oculi, of white that prevent the top of the composition from becoming too heavy. In some cases, such as *Wotan* (1950) (see fig. 4.4), inspection and analysis show that Kline has gone back in with white paint to create or reinforce these areas, much as Goodnough describes for *Painting* (1952). In other works, such as *Untitled* (1961)[10] and *Requiem* (1958) (see fig. 6.10), the white "windows" are reserved areas of the ground.

In addition to modifying the composition, Kline chose to alter the overall size of *Painting* (1952). Goodnough relates this as part of his invaluable description of Kline's efforts to finalize the work, giving us insight into a process that Kline himself never clearly articulated, whether because the end game defied simple description or because of a reticence to discuss this internal struggle. Goodnough observed Kline in action as this painting neared completion.

> [Kline] felt a little perplexed. Something wasn't quite right. All the shapes were there, and it almost worked, but not quite. He…hung it sideways to see if that would show what was out of balance…. [H]e knew from the first which side should be up and worked mainly that way. But turning the picture sideways this time gave him a clue. To bring it into balance a little more black and quite a bit more white was needed on what was now the top. It was

fortunate that he had left the canvas larger than he had originally expected the picture to be. He turned it back to its first position and added three inches to the right side which gave the necessary proportions and with some other minor adjustments the forms came into clear relationship and the picture was finished. (1952, 64)

Close inspection suggests that Kline actually extended the composition on both the right and left edges, although perhaps at different times. The white paint in those areas is different from the paint on the central portion of the canvas, with higher levels of calcium, suggesting that when Kline revisited the composition he used a different mixture of white paint(s); this may have been by design or because the paints at hand changed over the months that Kline was creating the work.

Goodnough indicates that at the end of July, when Kline judged that *Painting* was finished, he made a stretcher of the appropriate size and stretched the canvas. The creation of the painting had taken almost seven months, and it is fortunate that Goodnough made the commitment to document its creation. His contemporaneous observations provide a reasonably complete view of Kline's work practices in 1952 that can be compared and contrasted with evidence from technical analysis of other Kline works to draw inferences about changes in practice or process.

Some of aspects of how Kline finalized *Painting* (1952) occur in his other works. The use of different white paints on pieces that Kline evidently struggled to finalize is common, as has been shown in *Wotan* (1950) (see fig. 4.4), in the contemporaneous *Painting No. 7* (1952) (figs. 5.3, 5.4), and in later works such as *Mahoning* (1956) and *Four Square* (1956) (figs. 5.5–5.7). The strong lighting Kline used when painting at night may have diminished slight differences in tonalities of the different white paints, and as they always read as white against the blacks, Kline may not have cared that they did not match. It was not uncommon for Kline to turn canvases, and this was first documented in a photograph taken in 1948 (Gaugh 1985b, 82). As Kline sometimes worked on paintings in different orientations, this aspect of his process can often be seen in the finished work. Although he rotated *Painting* only to evaluate the composition, other works, including *Composition* (1953), *Red Crayon* (1959), *Torches Mauve* (1960), and *Black, White, and Gray* (1959),[11] have visible paint drip marks, indicating that some paint was applied when the canvas was in an orientation different from the display orientation.

The completion of *Painting* in July was fortuitous as Kline had committed to teach in the August summer session at Black Mountain College in North Carolina, following in the footsteps of the de Koonings (1948), Theodoros Stamos (1950), Robert Motherwell (1951), and Jack Tworkov (1952) (Brody, Creeley, and Power 2002, 93–133). Kline may have been attracted to the opportunity by the salary (Willem de Kooning had been paid $200 plus room, board, studio, and round-trip train fare) (Brody, Creeley, and Power 2002, 110), by the honor of having been asked to participate as his friends and colleagues had, or perhaps merely by the prospect of getting out of the city during the summer heat. Kline shared teaching responsibilities with John Cage and Merce Cunningham, and their students included Robert Rauschenberg, Cy Twombly, Fielding Dawson, and Dan Rice (Dawson 1967, 3–19; Harris 1987, 183, 226; Smith and South 2014, 118). Kline may have met Rice before, possibly at a cafeteria in Greenwich Village where Kline and Herman Somberg were having coffee,[12] but the summer at Black Mountain cemented their relationship: Rice remained a lifelong friend, sometimes acted as a studio assistant, and helped Zogbaum during Kline's final illness and after his death with the documentation of his estate.

Franz Kline, *Untitled (Study for Mahoning)*, ca. 1951. Opaque watercolor on paper, sheet 22.7 × 28.3 cm (8¹⁵⁄₁₆ × 11⅛ in.), Whitney Museum of American Art, New York, Purchase with funds from the Drawing Committee and Kathleen and Richard S. Fuld, 2000.114.

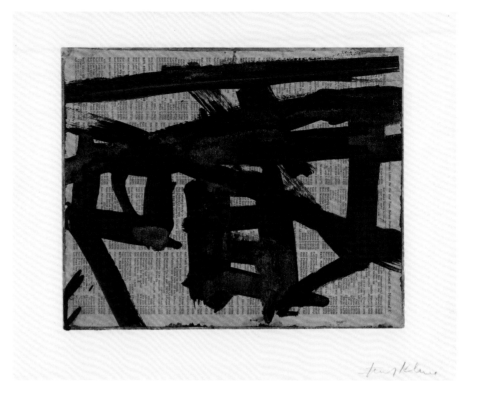

Franz Kline, *Mahoning*, 1956. Oil and paper on canvas, 204.2 × 255.3 cm (80⅜ × 100½ in.), Whitney Museum of American Art, New York, Purchase with funds from the Friends of the Whitney Museum of American Art, 57.10.

Kline often consulted his accumulated sketches for inspiration; this painting was based on a preliminary sketch Kline had completed around 1951.

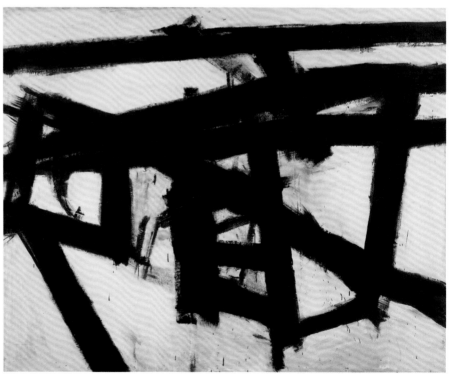

Fielding Dawson would go on to write *An Emotional Memoir of Franz Kline*, which provides some of the only information we have on the classes that Kline taught.

> He talked of the face, and difference in depth from the ridge of the nose to the hollow of the eye, following the nose planes down and then back up to the eye cavities giving strength to the cheekbones—he spoke enthusiastically of the upslanting hollow below the cheekbones, and when he put his hands flat against his own cheekbones his eyes were intent, and brilliant: "from there on it cuts in," and he pressed in on his eye cavities—really the structure of his face, talking of light on the planes, he ended, depth and surface, as in Rembrandt. "If you can get that right," he gestured about his face, "you've got the whole works." (1967, 7)

The description suggests that Kline taught life drawing, similar to what he had studied at the Heatherley School, but student works such as *View from Black Mountain* (1952) by Bill McGee (Lane 1990, 312) bear such a close resemblance to Kline's own contemporaneous works that he must also have either taught abstract painting or permitted students to watch him work. McGee later said:

> [Kline] was an extraordinarily original painter, who possessed no ideas about being a teacher. He did, however, have strong ideas about art and life. Being around Kline was to be around a vibrant form of life and art. One learned from him on a philosophical, humorous and ironic, as well as an intuitive level. It took a lot of figuring out how to get "with him." He could be hard to follow. A person had to be dedicated to him in order to understand him. (Quoted in Lane 1990, 311–12)

Although his primary responsibility that August was teaching, Kline found time for his own work. Several ink on paper sketches now in the Cy Twombly Collection, Rome, were executed at Black Mountain (Anfam and Kline 1994, 50–52). Zogbaum believed that Twombly gathered these up after Kline discarded them. She later wrote, "I do not believe that Franz was aware of it. He would have been amused. He certainly never mentioned it to me. Nor would he have been troubled; he simply would have made a joke of it."[13] In addition to the sketches, Kline finished at least one painting on canvas, *Painting* (1952) (oil on canvas, 165.1 × 104.1 cm [65 × 41 in.]) now at the Wadsworth Atheneum Museum of Art (and not to be confused with the painting of the same name whose creation was described by Goodnough and that is now in the collection of the Art Institute of Chicago).

The Goodnough article had raised awareness of Kline, and he received additional exposure from his participation in solo and group exhibitions in the first half of the 1950s. He had solo exhibitions in 1952 (November 17–December 6) at the Margaret Brown Gallery, Boston; in January 1954 at the Institute of Design and the Allan Frumkin Gallery, both in Chicago; and on April 13–May 8, 1954 at the Charles Egan Gallery (his third solo show there) (Gaugh 1985b; Christov-Bakargiev, Anfam, and Ashton 2004). Works exhibited at the Charles Egan Gallery included *Painting No. 7* (1952) and *Four Square* (1953),[14] which was originally titled *Painting No. 10*. Kline participated in many group exhibitions, including the *American Vanguard Art for Paris Exhibition* organized by the Sidney Janis Gallery (1951–52); the *Second Annual Exhibition of Painting and Sculpture* at the Stable Gallery (1952); the *Annual Exhibition of Contemporary American Sculpture, Watercolors, and Drawings* at the Whitney (1952); the 1952 *Pittsburgh International Exhibition of Contemporary Painting* at the Carnegie Institute; the Fine Arts Festival, Women's College, University of North Carolina, Greensboro (1953); the

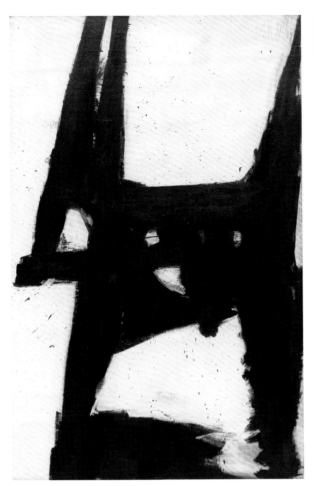

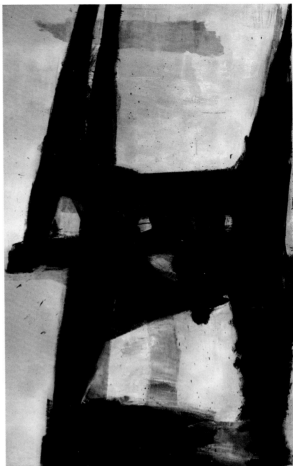

FIGURE 5.7
Franz Kline, *Four Square*, 1956.
Oil on canvas, 199 × 128.9 cm
(78⅜ × 50¾ in.), National Gallery
of Art, Washington, DC, Gift
of Mr. and Mrs. Burton Tremaine,
1971.87.12.

FIGURE 5.8
The infrared reflectogram of
Four Square (1956) reveals that
Kline had originally intended
there to be a horizontal black line
at the top and an additional
vertical line at the bottom of the
painting. However, he revised
his composition, overpainting
those black areas with white and
thus simplifying the composition.

Third Annual Exhibition of Painting and Sculpture at the Stable Gallery (1954); *Young American Painters* at the Solomon R. Guggenheim Museum and other locations (1954); and *The New Decade: 35 American Painters and Sculptors* at the Whitney (1955). He began to be invited to speak about his art, and he participated in panels, including "Abstract Art Around the World Today," at MoMA in 1954, in which Sabro Hasegawa and Josef Albers also participated.

During this period, Kline continued to show and become known for striking, graphic black and white paintings that retained the thicker, more definitive strokes that Shiryû Morita had called "deepened"; his finished works never revisited the "drier," sketchy lines of his 1950 works such as *Giselle*. In 1954, he also began to experiment with the use of massive forms, not just wide brushstrokes. A wide, black base provides a foundation for the composition of *Third Avenue* (1954), and the composition of *Thorpe* (1954) is dominated by a single black massif.[15] He continued to use sketches as a resource for many works, including *Painting No. 2* (1952) and *Mahoning* (1956) (see figs. 5.5, 5.6); for the latter, he revisited an original sketch, dated about 1951, many years later. This delay between the creation of a sketch and a painting was not unusual; in an interview with David Sylvester, Kline said that he would "put [the sketches] away and forget about them, only revisiting them months or years later" (Sylvester 1963, 12). Kline continued to revise his compositions extemporaneously during painting. Comparison of the infrared reflectogram of *Four Square* (1956) and the painting shows that quite major changes in composition occurred: two black painted areas, a horizontal bar at the top,

and a vertical bar bisecting the quadrilateral white form at the bottom of the work have been painted over in white (figs. 5.7, 5.8).

In addition to his ink sketches, Kline expanded his use of collages to explore composition. Although there are a few earlier instances (e.g., *Untitled* [1948]),[16] Kline began to spend considerable effort cutting and rearranging his ink drawings to explore different compositions in the early 1950s (Kingsley 2000, 168–69) (fig. 5.9). He may have adopted this technique from Conrad Marca-Relli, who was fond of it and said, "Collage forces you to think and clarify your ideas, with regard to both space and volumes" (quoted in Giralt-Miracle 1976, 25). In addition to using collage to create studies, at least one small painting from this period has paper pieces incorporated into the composition.[17] This may have been planned, or paper elements that Kline may have been using to explore compositional changes may have adhered and subsequently been incorporated into the composition. In all paintings examined from this time, Kline continues to use drying oil paints, and his paintings all have a double ground, the upper layer of which is lead white based.

Although his style was perceived by others to be iconically black and white, Kline himself never entirely abandoned the use of color. Even as he developed a reputation for black and white works, he went through a lengthy experimental phase to determine how best to use color, an endeavor that included making many small collages and oil on paper studies. The three large works *Yellow Square* (ca. 1952), *Bridge* (1955) (fig. 5.10), and *Shenandoah* (1956)[18] illustrate different approaches that he tried in a larger format. In *Yellow Square*, Kline revisited the basic composition of *Leda* (1950) but chose to use a yellow paint for the square form. In *Bridge*, Kline used brown to create midtones in his composition; he often used his grayish grounds as compositional elements, and

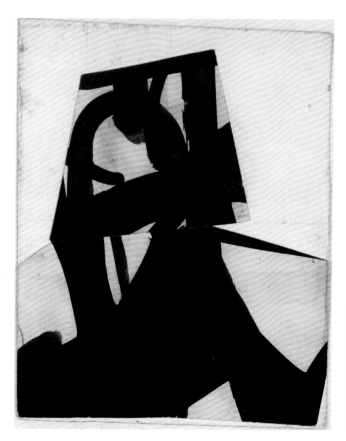

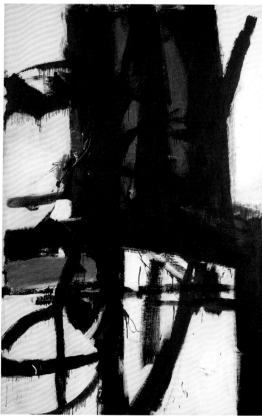

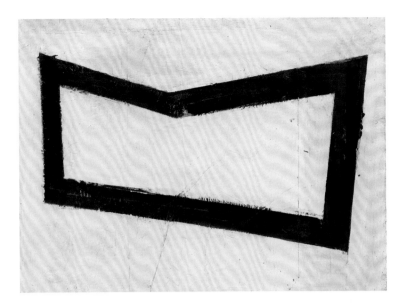

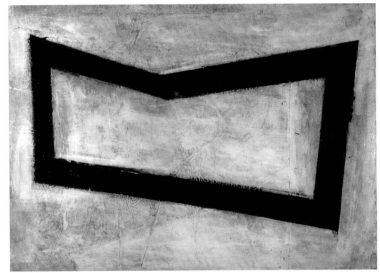

although the brown paint is considerably darker in tone, here it serves a similar role. In *Shenandoah*, small areas of yellow and orange appear from underneath the primary black mass, suggesting that the initial composition contained more color that Kline subsequently overpainted. The impact of this mostly hidden color is similar to partially covered drips or pentimenti in the purely black and white works, in that it makes manifest Kline's thought processes and "uncovers the impulse that lies behind renouncing something—wanting and desiring it, even seeing glimpses of it, and yet, in the end, giving it up" (Christov-Bakargiev 2004, 84).

In 1956, Kline said to Leo Steinberg, "I'm always trying to bring color into my paintings, but it keeps slipping away and so here I am with another black show" (Gaugh and Kline 1979, 12). The title of one work, *Buried Reds* (1953),[19] may reflect such a struggle. One definite case in which color appears to have "slipped away" from Kline is a work of art on paper, *Untitled* (1952) (fig. 5.11). The composition is created with black and white paints applied to paper and collage: numerous small paper pieces have been added to the main sheets of paper to help refine the central form. Infrared reflectance suggests that there was once an additional black area at the bottom of the proper right (fig. 5.12). XRF

spectroscopy indicates that in addition to at least four different white paints, cadmium sulfoselenide and perhaps cadmium sulfide pigments are present in subsurface layers, revealing that Kline experimented with red and orange and/or yellow passages that he subsequently overpainted. Even in the surface paints, the finished piece still seems to communicate the struggle that Kline experienced completing the composition: white edits black, black edits white, and many different white paints are present; these exhibit different extents of yellowing. Those who knew Kline well were aware of his tendency to have his use of color slip away; Elaine de Kooning (1958a, 19) once quipped, "We all have our problems. However, black solves all problems. Ask Franz."

In part, Kline's difficulty dealing with color may have been that he did not "see" black and white as having the same emotional connotations of colors. Speaking to Katherine Kuh, he said, "I'm not necessarily after the same thing with these different combinations, for, though some people say that black and white is color, for me color is different. In other words, an area of strong blue or the interrelationship of two different colors is not the same as black and white. In using color, I never feel I want to add or decorate a black and white painting. I simply want to feel free to work both ways" (Kuh 1962, 152). And in an interview with David Sylvester, Kline said that he could not "translate" a black and white drawing into color.

> My drawings don't change you know. Some of them become more or less similar and then they become boring to me. Then, over say a period of hours or a day, I'd see something in another drawing that probably doesn't have the same familiarity which hooked up to a previous experience in a painting before that, you see? So then I'm not able to translate that particular form into a color. I think color—use of color—obviously works against it. I think that most things that I did develop in color were the ones that worried me the most…and that wasn't because of the color particularly or that I had an attitude about color. I think it was just a question of the feelings of the paintings. (Sylvester 1963, 12)

Just as Kline had worked out through laborious experimentation how to express himself in black and white, he went through a similar process with color. Overpainting is one indication of this struggle, but another may be that the colors that Kline initially allowed to show again were similar to those that he had last used; he returned to what was most familiar. Browns and greens had been present in his 1950 Charles Egan Gallery show paintings, and these are the first colors to reappear in the works from the early to mid-1950s. Green also may simply have been one of Kline's favorite colors; in high school he bought a green suit rather than the normal black or brown, and he wore a green smock at the Boston Art Students' League (Finsel and Finsel 2019, 91). Bud Hopkins (1979, 38), a friend and colleague, noted, "Kline's use of color is personal too, but in the sense of 'I like green and purple' rather than 'Cerulean to me, is the sky.'" Although some observers appreciate Kline only or primarily for his work in black and white, John Russell (1979) wrote in his review of a retrospective of Kline's color paintings, "We feel that the color is right and inevitable…. It fills out, but does not in any way diminish or contradict, our notion of Kline's achievement."

A watershed event in Kline's professional life occurred in 1955 when he joined the coterie of the Sidney Janis Gallery, which represented Pollock, Willem de Kooning, and Rothko at that time (Breslin 1988, 297–98; Stevens and Swan 2004, 319). Sidney Janis had been a successful businessman and with his wife had amassed a significant collection of European art. They parlayed their business experience and love of art into running a gallery, which opened in 1948 at 15 East Fifty-Seventh Street, on the same

FIGURE 5.13
Although Kline's first show at the
Sidney Janis Gallery was not until
1956, this business card dated
1955 authorizes Kline to purchase
supplies on the gallery account.

floor as the Betty Parsons Gallery. The midtown gallery location was clearly no barrier to sales: Mark Rothko's first show at Janis (April 4–May 5, 1955) had been his most successful to date (Joseph and Rauschenberg 2003, 229). Kline had been on Sidney Janis's radar for some time: for the 1950 show *Young Painters in the U.S. and France*, Janis and Leo Castelli had paired Kline's *Nijinsky* (1950) with Pierre Soulages's *Peinture 146 × 97 cm, 17 Fevrier 1950* (1950) (Gindertael 1950).[20] The Janis Gallery had also organized the *American Vanguard Art for Paris Exhibition* that toured to the Galerie de France in 1952 and in which Kline had one painting. Because of his peers' shows there, Kline was aware that the Janis Gallery was considerably more posh than the Egan Gallery, and that its elevators actually worked,[21] but the incentives to switch galleries went beyond the superficial. Janis supported his artists independent of their sales: as soon as de Kooning switched from the Egan Gallery to the Janis Gallery in 1955, he was allowed to purchase painting supplies on credit (Stevens and Swan 2004, 319), lessening the impact of financial pressures on his artistic choices. After Kline joined his gallery, Janis also allowed Kline to purchase supplies on credit: the gallery accounts show numerous unitemized purchases at Central Art Supply, and a business card with a partially legible date ending in "'55" notes, "OK for Franz Kline to open account and charge to us, Sidney Janis" (fig. 5.13).[22]

Access to supplies clearly has an impact on an artist's overall production, so underwriting the purchase of materials was an astute business decision by Sidney Janis; he may also have had additional, subtler motives. Janis reportedly asked Kline to use more stable artists' paints rather than house paints (Gaugh and Kline 1979, 12) (Irving Sandler said Janis went so far as to sneak into Kline's studio and replace his house paints with artists' paints [Rogala 2016, 26]), perhaps because of already perceptible yellowing of some white areas in Kline's works. Although this yellowing happened during his lifetime, Kline was not disturbed by it. In an interview with Sylvester, he said, "The whites, of course, turned yellow, and many people call your attention to that, you know; they want white to stay white forever. It doesn't bother me whether it does or not. It's still white compared to black" (Sylvester 1963, 2). Although Kline apparently thought that the relationship of the forms was not altered by yellowing (which provides insight into Kline's thinking about the relationships between black, white, and color), Janis could not have considered it good for business to have his clients complain about such changes. Janis likely felt that by paying for the materials he could influence their quality or at least keep cost considerations from dominating Kline's decisions about materials. The influence of his new gallerist may have significantly affected the aging and current condition of Kline's later pieces.

Still, house paints differ from artists' paints in many ways, and Kline probably begrudged more than the time spent "continually squeezing paint from tubes" as he began to work with artists' paints. House paints are designed to have different flow characteristics and drying times than artists' paints, and although we have no record of Kline describing this directly, Elaine de Kooning (1962, 68) wrote, "It took months before the artist, used to struggling with rubbery, stringy paint, could adapt himself to its easy flow and yielding ways. He was appalled when he first began to use good tube whites—titaniums, zincs, permalbas, flakes—with their uniformity of surface and lack of body, and again, he had to evolve a completely different way of working—this time to avoid slickness and ingratiating effects."

As there are currently no definitive markers that distinguish artists' oil paints from retail trade oil paints, we do not know if Kline truly did cease using house paints. GC-MS analysis of his later works shows only one instance where fish oils, such as were found in *Wotan* and other early works, may be present; however, the absence of fish oil does not prove that all (or indeed any) of these different paints were artists' paints. The presence of titanium dioxide–calcium sulfate coprecipitated pigments in works dating from 1950 through 1961 suggest that Kline may have continued to use retail trade white paints (Rogge and Arslanoglu 2019), since manufacturers of artists' paints in that period had access to (and in some cases are known to have adopted) the better covering, pure forms of titanium white. However, he certainly did use some artists' materials: undated photos of Kline's studio in the Zogbaum papers clearly show the presence of Shiva and Bocour paints, and there is one receipt from Joseph Torch Artists Materials dated February 19, 1960, documenting the purchase of tubes of cobalt blue, cadmium yellow, burnt sienna, cadmium red light, cadmium red deep, and Torch mauve paints.[23]

The first Kline solo show at Sidney Janis Gallery was held March 5–31, 1956. Paintings on canvas included *New York, NY* (1953), *Wanamaker Block* (1955), *Mahoning* (1956) (see fig. 5.6), and *de Medici* (1956);[24] the last of these included color, as did at least one work on paper (Christov-Bakargiev, Anfam, and Ashton 2004, 318–19). Janis Gallery records indicate that six works sold during the show, earning Kline over $3,200 after the gallery commission, and that during his first year with the Janis Gallery Kline earned almost $12,500.[25] The support of the Janis Gallery during the year before his one-man show probably helped drive Kline's decision to switch galleries, but the sums he received for his paintings certainly validated that decision. Prices commanded by his works were now a far cry from the $5 per canvas Kline had earned for the Bleecker Street Tavern murals. Kline's mother, however, was less impressed. She and Franz's sister, Louise, attended the opening, and Mrs. Kline-Snyder asked, "What happened to Franz? He always painted like Gainsborough and Rembrandt and all the great painters," to which Sidney Janis responded, "Well, my dear, in years to come, people are going to paint like Franz Kline" (quoted in Salisbury 1986, K01).

In addition to this one-man show, Kline exhibited works in the *Modern Art in the United States* exhibition, Tate Gallery, London; *Twelve Americans*, MoMA, New York; *Recent Paintings by Seven Americans*, Sidney Janis Gallery, New York; and *American Artists Paint the City*, XXVIII Biennale, Venice. The Biennale show included *New York, NY* (1953) and *Third Avenue* (1954) (Christov-Bakargiev, Anfam, and Ashton 2004, 402–5). Patrick Heron (1956, 17), a British abstract artist and critic, found Kline's work in the Tate Gallery show to have an admirable graphic vigor, and Achille Perilli's article on Kline in *Civiltà delle Macchine* (1957) waxed poetic, saying that the paintings were evocative of fragments of Assyrian tablets, the skeletons of giant animals, or partially destroyed writing that can only be deciphered through intuition. Kline had achieved financial success and international critical acclaim.

6 Artistic Maturity: Continued Experimentation, 1956–1961

Corina E. Rogge

The second half of the 1950s brought Franz Kline a business-minded dealer, national and international recognition, and financial and emotional stability. A dramatic rise in his income meant that he could afford more spacious and convenient studio spaces, greater expanses of canvas or fiberboard panels for his increasingly large works, and expensive artists' paints with pure, bright colors. Kline found support and love in a partnership with Elisabeth Ross Zogbaum, who served as executrix after his death and to whom we owe a great deal for her efforts to document his life and preserve his works. Although his personal life achieved unprecedented stability, his artistic evolution continued. In the last period of his life, Kline's explorations of abstraction varied in size, tonality, color, and composition, though his working process remained relatively unaltered. These experiments were not always appreciated by his contemporaries; in a review of Kline's 1961 solo show at the Sidney Janis Gallery, Donald Judd (1962, 44) wrote, "Since 1957 Kline's painting has been deteriorating. The current show has nothing equal to the Klines of the first half of the fifties." But Kline actively guarded against becoming static, and one statement he made to another interviewer might have served as his response to Judd: "Well, look, if I paint what 'you' know, then that will simply bore you. If I paint what 'I' know, it will be boring to myself. Therefore I paint what I *don't* know" (Creeley 1968, 173–74; original emphasis).

Some artists associated large paintings with Progressive social movements because of the Works Progress Administration (WPA) mural project and works such as Diego Rivera's mural *Man at the Crossroads* (1934) in Rockefeller Center, but many Abstract Expressionists embarked on the creation of large works because of the personal and technical challenges they presented. Barnett Newman's *Voice of Fire* (1967) achieves the artist's stated intention of immersing the viewer in a field of color, and the difference between inspecting a picture of the painting in a catalog and standing in front of it confirms the power and impact that can be generated by size.[1] Jackson Pollock created large works, including *Mural* (1943), because of his belief that easel paintings were a dying art form;[2] Lee Krasner described these works as "unframed space" (Karmel 1999, 19). Mark Rothko used multiple large canvases to create immersive environments that surround the viewer: the Harvard Murals and the Rothko Chapel. Rothko (1951, 104) openly acknowledged that historically, large works were linked to "painting something very grandiose and pompous" but explained that he painted them despite their potential for pomposity, "precisely because I want to be very intimate and human. To paint a small picture is to place yourself outside of your experience, to look upon an experience as a stereopticon view with a reducing glass. However you paint the larger pictures, you are in it. It isn't something you command."

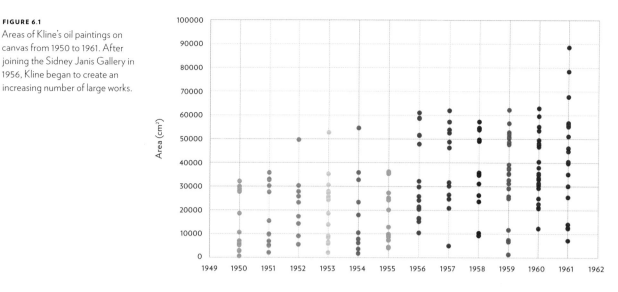

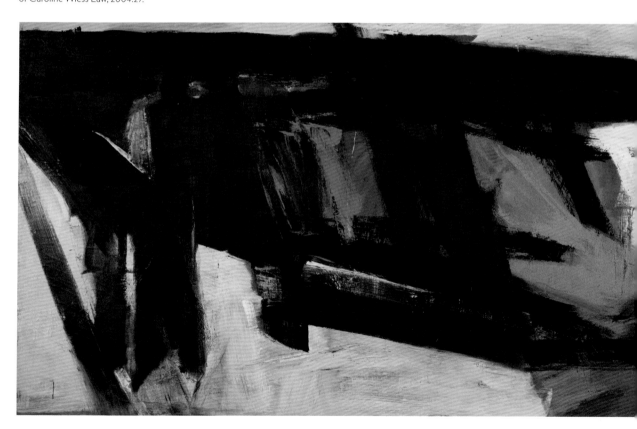

Kline also thought that the size of the work influenced his artistic process: "There's an excitement about the larger areas, and I think you confront yourself much more with a big canvas" (Kuh 1962, 152). A few of Kline's early abstract works were quite large, but his 1946 mural commission *Lehighton* would remain his largest work on canvas until 1961. Prior to 1956, he created only three abstract paintings larger than 40,000 cm² (43 ft.²), but after he joined the Sidney Janis Gallery, almost half of his paintings exceeded this scale, though he never stopped creating smaller easel-size works and studies (fig. 6.1).³ In 1959, he began to explicitly use the word *wall* in the titles of some works, in reference to their large size; the group eventually comprised four paintings: *Washington Wall* (1959), *Orange and Black Wall* (1959) (fig. 6.2), *1960 New Year Wall, Night* (1960), and *Shenandoah Wall* (1961).⁴ Of these four works, only *Shenandoah Wall* was in black and white, although the color in *New Year Wall, Night* is largely restrained to a light gray-blue, dark blue, and pinkish-cream and in poor-quality reproductions might appear to be black and white. The varied palette and materials with which he created these ambitious monumental works attests to the continual development and exploration of his style and process.

Kline made a study for *Shenandoah Wall* (*Study for Shenandoah Wall*, 1960)⁵ and said that he made many small sketches for *1960 New Year Wall, Night* (Kuh 1962), consistent with his previous working process. *Washington Wall* and *Orange and Black Wall* were private, site-specific commissions; *Orange and Black Wall* was commissioned by Robert Scull for his house on Long Island, and *Washington Wall* was commissioned by Jane Suydam for her residence in Washington, DC (Gaugh and Kline 1979). Unsurprisingly, Kline also undertook preparatory planning for these prestigious commissions from well-known collectors. Kline reportedly went so far as to create two studies of different compositions from which Jane Suydam could choose (Gaugh and Kline 1979), and the study used for the final composition still exists: *Washington Wall Study* (1959).⁶ For *Orange and Black Wall*, Kline visited Robert Scull's house in Great Neck, Long Island, to view the drawing room where the painting was to hang over the fireplace (Baker 1997); however, no sketch or plan for the final composition of this work is known.

Our technical analysis of *Orange and Black Wall* finds many commonalities with Kline's earlier pieces and process. The canvas support is linen, sized with a proteinaceous glue, and has a typical double oil ground. The lower ground is pigmented with zinc white, and the upper ground, as is characteristic of Kline's paintings, is lead white. Cross-section samples taken from the painting reveal voids present between the two ground layers, indicating faulty application of the lead white layer, the precise origin of which is unknown. Air bubbles trapped in the grounds of certain works in Jacob Lawrence's *Migration* series are ascribed to his working at cold temperatures, which decreases paint fluidity so that bubbles formed during paint application are trapped by the stiff paint and remain embedded during the drying process (Kirsch and Levinson 2000, 79–83). This phenomenon has not been observed in any of the eighty-five samples taken from twenty-two other Kline paintings, so although it could indicate that Kline added the lead white ground while working in a cold studio, the absence of bubbles in his other works to date suggest instead that the faulty support was created by a canvas supply company.

No preliminary drawing for the final composition of *Orange and Black Wall* exists, so this work, like *Painting* (1952), may have been based on a variety of preliminary drawings or may even have begun without a specific study. Infrared reflectography shows no evidence of charcoal underdrawings, suggesting that, if present, the thickness of the layers of infrared-opaque black paints may obscure them. However, because this painting is in color, Kline may not have used the process captured by Goodnough for the

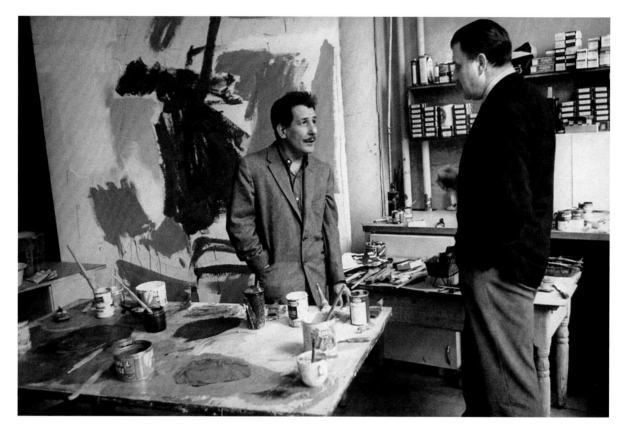

creation of *Painting.* In a 1958 photograph of Kline in his studio taken by Peter Stack-
pole, Kline stands before a painting that is in its beginning stages, and although the
photograph is in black and white, the tonality of the gray passages on the painting
implies that many of the areas are in color. Paint has been applied to only a few areas,
and only sparse, light markings that might be charcoal or pencil lines are visible on
the many areas of exposed ground (fig. 6.3). These light markings differ in weight and
character from the firm, long, sweeping lines described by Goodnough (1952, 38), per-
haps because here Kline was outlining areas that were to be differently colored rather
than gesturally indicating where he would apply strokes of black paint. For some of his
works, Kline may have used very limited dry markings (or none) and instead built up an
image through applications of planes of color.

Kline seems to have used such a technique in some of his early paintings: a photo-
graph of *Elizabeth* (1946) in an unfinished state shows that Kline used planes of color to
build up the form of the central figure and her surroundings (Gaugh 1985b, 77 [illus.]).
Gaugh and Kingsley each ascribe this technique to Henry Hensche's classes at the Bos-
ton Art Students' League, but by the time that Kline painted *Orange and Black Wall* his
process may also have been informed by Hans Hofmann's "push and pull" technique,
in which spatial relationships are developed through color planes (Gaugh 1985b; King-
sley 2000; Hofmann 1967). These photographs suggest that Kline may have approached
some of his works in color differently from his black and white works. Perhaps bold,
strong charcoal underdrawings were an effective way to transfer ideas from a sketch
to canvas for works in which "the line" was the driving creative force but were not
adequate to designate the color relationships critical to a successful work. Kline was
increasingly using collage to create preliminary studies for works as it was easy to cut
colored pieces of paper and manipulate them until a particular arrangement caught his

fancy (Kingsley 2000, 169); if the light, short lines in the Peter Stackpole photo indicate the planned borders of different color fields, perhaps they correspond to the edges and corners of paper in a collage.

Visual inspection of *Orange and Black Wall* shows many areas where underlying paint is visible through thinly applied surface paints. At the proper left side of the canvas, the black horizontal stroke was clearly applied over orange paint, and the white on that side also clearly lies over orange. Sidney Janis, who saw the painting during its creation, recalled that orange spread up and across the entire canvas to the proper right side (Gaugh and Kline 1979, 19). MA-XRF analysis permits mapping of cadmium across the painting; the resulting map confirms Janis's recollection and shows that cadmium

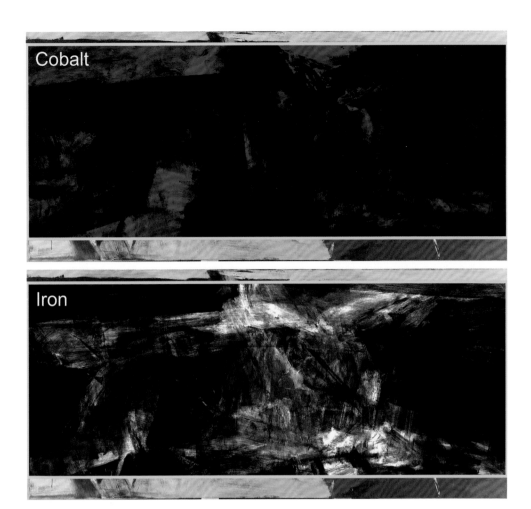

FIGURE 6.5

MA-XRF maps overlaid on
Orange and Black Wall showing
the distribution of cobalt (top) and
iron (bottom). Cobalt blue, now
visible in only a small area near the
top, left of center, was once much
more predominant. The distribu-
tion of iron, related to either
Prussian blue or Mars black, bears
no resemblance to the current
surface, again indicating extensive
revision.

pigments are present below the surface over much of the painting, though not the bot-
tom center (fig. 6.4). The distribution of other elements linked to red and purple colors
is also much wider than the current surface suggests: mercury, which is indicative of
vermilion, is present across half the work, although it is now visible only in the lower
proper left. The tungsten detected in many areas of the canvas likely derives from a
red or pink Rhodamine 6G (PR81) heteropolyacid pigment. These maps should not
be taken to represent distinct "states" of the painting; indeed, they overlap in many
places, and without local cross-section samples it is not possible to reliably determine
the sequence of paint application, but the extensive use of these elements shows that the
painting was once much warmer in tone than it is now. The revisions Kline made were
not restricted to the warm colors: cobalt blue, which is now visible almost exclusively in
a small window near the top, left of center, was once much more predominant. Perhaps
most surprisingly, the distribution of iron, which could indicate Prussian blue and/
or Mars black, bears no resemblance to the current surface (fig. 6.5). Taken together,
these elemental maps testify that Kline struggled to create this painting, working and
reworking it before finally "catching" it.

Cross-section samples taken from *Orange and Black Wall* confirm the presence of
underlying paints below thin surface paints and bear further witness to this difficult
creation process. These samples are very complex: all exhibit multiple drastic revisions
in color, up to fourteen layers of paint. The sample shown in figure 6.6 comes from a
white area at the proper right side of the painting. Over the white grounds at the bot-

tom of the sample are four layers of blue paint, some of which are almost turquoise in color, on top of which is a layer of zinc yellow and finally the surface white. The turquoise blue tone, made from a mixture of phthalocyanine green and zinc yellow, is no longer visible on the surface of the painting. The color of this paint was common in many of Kline's early semiabstract works (e.g., *Woman in a Rocker, Kitzker*; see chap. 2), but he does not appear to have used it, or at least allowed it to show, in many of his mature abstractions; the presence of that color in the cross section shows that he was moved to explore it but eventually painted it over.

Although we have no record of Kline discussing color choices for *Orange and Black Wall*, the general description of Kline's approach to color provided by Bud Hopkins, a friend who reviewed the only major exhibition to date of Kline's colored abstractions, seems to encompass *Orange and Black Wall*.

> Kline's choice of particular colors is idiosyncratic and, oddly, it is most effective when it violates de Stijl dogma. Habitually he relies on the secondary hues—orange, purple, and green—largely, I believe, because the primaries tend to accent the Mondrian connection. Often Kline deliberately muddies a hue and juxtaposes it with a pure tube color; this pairing creates a color parallel for his characteristically juxtaposed hard and soft edges, and further binds the color into his compositional structure. In almost every work he uses a few colors as if they were pure, unmixed tube colors, even though they may in fact be quite personal, invented hues. Kline's structural pressure can force even the weirdest purple into functioning like a pure Mondrian blue. (Hopkins 1979, 39)

John Russell (1979), who reviewed the same show of fifty-four paintings for the *New York Times*, heaped praise on "the glorious effulgence of Kline's color abstractions, which everywhere bespeak a creative nature in full evolution" and, pointing out that Kline was especially prolific in color in 1959, said, "Kline's color has a direct and evident spontaneity, as if the feeling in question had never found outlet in black and white and was the richer and the riper for the delay."

In some samples taken from *Orange and Black Wall*, such as that shown in figure 6.6, the lack of mixing of the paint layers indicates that he applied new layers over dried paint (wet-over-dry), suggesting a period of reflection and contemplation before application of the next color. Kline used wet-in-dry editing extensively but not exclusively: in the cross-section sample shown in figure 6.7, the turquoise paint layer and the black layer above it have clearly been mixed (wet-into-wet application), indicating that Kline

FIGURE 6.6
Cross-section sample taken from *Orange and Black Wall*. Kline explored the use of four different blue paints before eventually painting this area white.

FIGURE 6.7
Cross-section sample taken from *Orange and Black Wall*. This sample shows evidence for both wet-in-dry and wet-in-wet paint application, indicating that while Kline often engaged in a period of reflection and contemplation before modifying his color choice, at other times he very quickly revised the work and his newly applied paint mixed with the underlying layer that was still wet.

applied the turquoise paint and then covered it with the black paint before it had the opportunity to dry. The black paint was allowed to dry but then was itself covered with a dull blue, a bright blue, and, finally, white paint. Goodnough (1952, 38) said of the creation of *Painting* (1952), "Kline paints rapidly, well aware that future changes will be necessary, but feeling that he must get out the present intensity first. After working for about three hours, he stopped and the painting was put aside to jell in his mind. This would happen again and again until the painting reached its final stage, other pictures being worked on in the meantime." These cross sections from *Orange and Black Wall* indicate that during the creation of this work in color Kline experienced periods of intensity and contemplation similar to those witnessed by Goodnough in 1952.

Orange and Black Wall exhibits extensive craquelure that is concentrated in the blacks, particularly in those that surround the central green areas. The presence of craquelure suggests thick paint layers and perhaps the application of fast-drying paint over slower-drying paint, either of which in turn might result from compositional changes. Figure 6.8 shows a cross section from a location below the central green area where thinly applied surface black paint lies over a green paint; underneath these lie thick layers of black and gray paints, as well as a thin purple layer. The multiple paint layers present show that this area, like most other areas analyzed, went through several changes in color: Kline did not originally intend for it to be black or green. Although no full preparatory sketch exists for this painting, the central green and black area in *Orange and Black Wall* is related to an earlier sketch, *Green and Black* (1959) (fig. 6.9). Given that this area was originally neither black nor green, it may be that while struggling to create this work Kline went back through his sketches, found something that caught his eye, and integrated aspects of *Green and Black* into his extant composition, overpainting layers he had already applied. In a 1962 interview, Kline described this aspect of his process: "When I work from preliminary sketches, I don't just enlarge these drawings, but plan my area in a large painting by using small drawings for separate areas. I combine them in a final painting, often adding to or subtracting from the original sketches" (Kuh 1962, 145). Even if *Green and Black* did not initially figure in the creation of *Orange and Black Wall*, it is clear that Kline paused during the creation of the painting and that when he overpainted his initial attempts, he chose to use ideas previously developed in the drawing.

The paints used for *Orange and Black Wall* are primarily drying oils, but phthalates, which are typical markers for alkyds, are detected in three of seven samples at phthalate to azelaic acid ratios of 0.1 to 0.3, above the lower levels detected in the other four samples (0.03 to 0.08, average 0.05). The presence of phthalates in paints is not unique to *Orange and Black Wall*: we detected similar, higher than trace levels of phthalates in three of six samples from *Red Brass* (1959) and one of two samples taken from *Untitled* (ca. 1959).[7] Low but well above trace levels of phthalates (Ph/Az ratios of 0.008 to 0.1) have been found in historical samples of artists' oil paints, and the origin of this phthalate is as yet unclear (La Nasa et al. 2021). The higher phthalate levels in some samples taken from *Orange and Black Wall* and other works could indicate the use of alkyd paints. Artists' alkyds were not introduced until 1970 (Schilling, Keeney and Learner 2004; Schilling, Mazurek, and Learner 2007), and these samples, with relatively low phthalate to azelaic acid ratios, may contain retail trade alkyd paints mixed with oils. An alkyd was used to touch up the edges of *Chief* (1950) (see chap. 4), and alkyds have been positively identified in only one of Kline's later works, *Delaware Gap* (1958);[8] Susan Lake (1999) identified the white paint as an alkyd, whereas the black was a drying oil with resin. Kline's use of alkyds appears to be rare, and he never fully switched to the use of semisynthetic or synthetic binding media, unlike many of his contemporaries.

FIGURE 6.8

Cross-section sample taken from *Orange and Black Wall*. This cross section comes from the central region and reveals that the green square, which is now a prominent part of the composition, was a relatively late addition.

FIGURE 6.9

Franz Kline, *Green and Black*, 1959. Oil and ink on paper, 26 × 27.94 cm (10.25 × 11 in.), private collection, courtesy Allan Stone Gallery, New York.

Kline appears to have consulted this small sketch to resolve the final composition of *Orange and Black Wall* (1959).

As might be expected from a work with such varied colors, many different pigments are present in *Orange and Black Wall*; some of these appear in many Kline works, but others have been detected to date only in this work. In addition to cadmium reds and oranges, Kline used vermilion and Rhodamine 6G (PR81) to create his reds and pinks, and he used manganese violet for purples. Cadmium hues and vermilion are indicative of artists' paints, as these pigments are expensive and not used in retail trade paints. In the photo taken by Peter Stackpole (see fig. 6.3), tubes of paint sit on Kline's worktable, and boxes of paint tubes are on the shelf behind the unidentified visitor; some of these are the Bocour brand and thus artists' materials. Although Kline used cadmium colors in his pre-1950s works, he does not seem to have used vermilion until his later abstract works; X-ray fluorescence suggests that vermilion is also present in *Blueberry Eyes* (1959–60)[9] and *Red Brass* (1959). Although Rhodamine 6G is a fugitive pigment, prone to fading, it has been found in artists' paints (Bruni and Guglielmi 2019), and manufacturers may have added it as a toner to more expensive pigments, such as cadmium colors, to cut costs (Rogge and Epley 2017). At least two yellow pigments are present, cadmium yellow and zinc yellow, both of which are found in early and late Kline paintings. In other works, these are sometimes present with chrome yellow, a

FIGURE 6.10

Franz Kline, *Requiem*, 1958. Oil on canvas, 257.8 × 190.5 cm (101½ × 75 in.), Collection Albright-Knox Art Gallery, Buffalo, New York, Gift of Seymour H. Knox Jr., 1959 (K1959:4).

This dark, moody painting typifies Kline's sfumato works.

pigment that is not found on *Orange and Black Wall* but is found in the contemporaneous work *Red Brass*. Phthalocyanine green seems to have been a Kline favorite, used pure or, in the case of subsurface paint layers on *Orange and Black Wall*, mixed with yellow pigments to create turquoise hues. This pigment is present in his early figurative works, and he used it through all periods. Kline used three different blue pigments in *Orange and Black Wall*: Prussian blue, phthalocyanine blue, and cobalt blue. Some of the purple colors appear to be mixtures of red and blue paints, but manganese violet is also present, and this is the only Kline work in which this species has been identified thus far.

It is in the black pigments that we find the most marked difference between Kline's early and late works. *Orange and Black Wall* contains both bone or ivory black and Mars black, and this painting seems to have been made at the point where Kline transitioned between these pigments. In Kline's early paintings, from 1940 to 1959, he mostly utilized bone or ivory black; *Red Brass* and *Untitled* (1959; SAAM 1971.259) are the exceptions, and these contain a carbonaceous black. In contrast, Kline's paintings from 1960 and 1961 use Mars black, an iron oxide species. Bone or ivory black and Mars black are both commonly encountered in artists' paints, so Kline could have continued to use bone or ivory black, and his reasons for switching are unknown.

Because of its large size, *Orange and Black Wall*, once Kline judged it complete, was probably rolled for transport from his studio to the Scull residence, where it would have been stretched, perhaps with the aid of Dan Rice, who often helped Kline stretch his works.[10] For large works, Kline reportedly used folding stretchers in which the bars in the long dimension have a join that can be either fixed (usually with a metal plate) or loosened to allow the stretcher to fold upon itself, rather like closing a book, to facilitate their movement (Gaugh 1985b). Unfortunately, the original stretcher or strainer on *Orange and Black Wall* was replaced before its acquisition by the museum and the original discarded. Examination of the edges of *Orange and Black Wall* show ridges of paint that suggest Kline added paint after the work was stretched, thus likely in the Scull residence. However, the painting was included in Kline's show at the Sidney Janis Gallery in 1960, so he also could have modified it then. This post-stretching refinement of a work is not very common, or at least not well documented, in Kline's later works but is seen in his earlier figurative paintings (see chap. 2).

The many layers of paint in *Orange and Black Wall* that bear witness to Kline's struggle with its creation were not a common feature of his later works, and only *Cupola* (1958–60) had a longer birthing process.[11] As documented by Gaugh (1985b, 145–46), the original sketch for *Cupola* was dominated by a single massive form, similar to *Thorpe* (1954) (see chap. 5, n. 15), but Kline was unsatisfied with the resulting painting and put it away. In 1960, he revisited it and working from a new sketch added extensive white passages, resulting in a much busier, more active composition, similar to *Mahoning* (1956) (see fig. 5.6), *Lehigh* (1956), and *Rue* (1959).[12] These works have a much more complicated architecture than his earlier works such as *Wotan* (1950) (see fig. 4.4) or later works such as *Riverbed* (1961),[13] and more of the canvas is dominated by blacks.

Explorations in darker tonalities, massive forms, and the use of grays (e.g., *Shenandoah* [1956]) eventually culminated in Kline's sfumato paintings, *Black, White and Grey* (1959), *Siegfried* (1958), and *Requiem* (1958) (fig. 6.10),[14] in which he has blended his blacks and whites to create atmosphere. These works should be considered in the context of color paintings such as *Torches Mauve* (1960) and *Red Dahlia* (1959–60),[15] in which Kline explored the blending of color with his blacks. Many found the change in style from "iconic" Kline paintings disturbing, and Clement Greenberg dismissed them as "malerisch" (Gaugh 1985b, 18), a German word meaning "painterly" and intended in

FIGURE 6.11

Archival photograph of *Corinthian*, 1957, oil on canvas, 203.2 × 304.8 cm (80 × 120 in.), from the Nelson A. Rockefeller Archives.

This painting was destroyed in a fire at the New York governor's mansion on March 2, 1961.

FIGURE 6.12

Archival image of *Drawing for Corinthian II* (1961), ink and gouache on paper, 39.6 × 60.4 cm (15⅞ × 23¾ in.), from the MoMA curatorial archives.

this case to reflect the lack of clean, defined lines that he had praised in earlier Kline paintings. Although these works were not typically "Kline," it should be noted that the Sidney Janis Gallery had no trouble selling them; most were purchased within a year of their completion.

Concomitant with his explorations in these new styles, Kline continued to create compositions that were evocative of his early 1950s works. In some cases, Kline took an earlier composition and explored modifications of it.[16] The clearest example of this is a sequence of four paintings: *Four Square* (1953), *Four Square* (1956) (see fig. 5.7), *Black and White No. 2* (1960), and *Slate Cross* (1961).[17] The first two works are so similar that Kline gave them the same title, and the latter two works differ in their dimensions, but they all have an H-shaped central form. Occurrences like this suggest that new ideas and possibilities occurred to Kline during the creation of a painting or when reconsidering

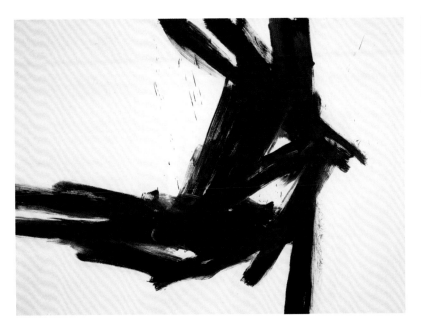

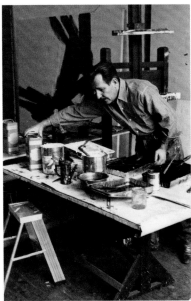

FIGURE 6.13
Franz Kline, *Corinthian II*, 1961. Oil on canvas, 202.2 × 272.4 cm (79⅝ × 107¼ in.), The Museum of Fine Arts, Houston, Bequest of Caroline Wiess Law, 2004.26.

FIGURE 6.14
Fred McDarrah, *Portrait of American painter Franz Kline (1910–1962) as he mixes paint in his studio (14th Street)*, New York, New York, April 7, 1961.

Corinthian II (1961) is stretched and leaning against the wall behind Kline, indicating that he had already completed it by the time this photograph was taken. Fred McDarrah was a staff photographer for the *Village Voice*, and his images of the artists and their studios are invaluable for preserving the history of the Abstract Expressionist movement in New York (McDarrah 1961; Wilentz 2018).

it afterward. Although his process led him in some cases to revise a painting, apparently he sometimes felt that he had "caught" something that he recognized as complete and that the new ideas or possibilities that he had discovered should be explored later, in another work.

One instance of Kline reexploring a particular composition highlights the role of his sketches in his mature process. In August 1957, while vacationing in East Hampton, Kline painted *Corinthian* (1957) (fig. 6.11), which he named in honor of his school, Girard College, whose main gate is at the intersection of Girard and Corinthian Avenues and whose Founder's Hall is a Greek Revival masterpiece surrounded by Corinthian columns.[18] The painting was purchased by Nelson A. Rockefeller in 1958 and hung in the Executive Mansion in Albany when he became governor of New York State in 1959. Kline evidently felt that some aspect of the composition of *Corinthian* deserved reexploration, and he subsequently created at least two additional sketches: *Study for Corinthian II* (ca. 1958–60), an ink sketch on the front page of the September 21, 1958, *New York Times*, and *Drawing for Corinthian II* (1961), an ink and gouache sketch on paper (fig. 6.12).[19] The two sketches are very similar, and in each Kline has taken the backward "C" form of *Corinthian*, elaborated it, and made it balance on a single stroke, creating a more dynamic composition. In the spring of 1961, Kline used these sketches to paint *Corinthian II* (1961) (fig. 6.13); an April 7 photograph of Kline in his studio shows the stretched (and presumably finished) painting on the floor, leaning against the wall behind him as he works (fig. 6.14). More than two years passed between Kline completing the first and second sketches and more than three years passed between the paintings, showing that the process of revisiting and reworking his ideas could take considerable time.

On March 2, 1961, a fire broke out at the New York Executive Mansion in what was called "the greatest art disaster" in US history, as it destroyed much of Governor Rockefeller's personal art collection, including *Corinthian*, as well as the collection that had been donated to New York State by Governor W. Averill Harriman (Grondahl 2011). Rockefeller immediately began to acquire new works of art and evidently contacted Dorothy Miller, paintings curator at MoMA, for assistance. In a letter dated April 28, 1961, Sidney Janis enclosed a photograph of *Corinthian II* and told Miller,

"Kline in a moment of clairvoyance, painted this version about a week before the fire!" adding, "I hesitate to show the painting to others as I'm certain Nelson will want it. It is certainly every bit as fine as the canvas that was lost."[20] Miller and Alfred Barr, director of MoMA, visited the Janis Gallery and reserved *Corinthian II* for Governor Rockefeller, who purchased it in May 1961.[21] Kline's completion of *Corinthian II* shortly before the fire was serendipitous, but his preliminary sketches made years before show that Kline did not create *Corinthian II* in response to the fire.

Whereas Kline struggled with the composition of *Orange and Black Wall*, painting and repainting it, *Corinthian II* was created with great authority and assurance. Beyond the two ground layers (the lower ground is zinc white, and the upper ground is lead white with the rutile form of titanium white and barium sulfate), there appear to be only two additional paints: a Mars black and a surface white paint with barium sulfate and the rutile form of titanium white coprecipitated with calcium sulfate anhydrite. SEM-EDS reveals that the ground layers on *Corinthian II* are very similar to those found on *Merce C* (1961),[22] and XRF spectroscopy suggests that *Untitled* (1961) also has a similar ground structure.[23] The correspondence between these three canvases, all created in 1961, suggests that Kline may have purchased the preprimed canvas from the same manufacturer. The black paints on these three works are all drying oils, with Mars black as the primary pigment and barium sulfate as a filler or extender, and are so similar as to suggest they are the same material, but the surface whites on these three paintings differ. Like *Corinthian II*, *Merce C* may have only a single surface white paint, but it is not the same paint, as it contains the pure rutile form of titanium dioxide and zinc white. *Untitled* has at least two white paints, one containing zinc white and the other titanium white. The variance in white pigments among these works implies that Kline was still not particularly concerned about which white pigments were in his paints and used a variety of materials. Since both *Corinthian II* and *Merce C* contain only a single type of white paint, this suggests that the paintings, both based on sketches, were completed over a relatively short time when Kline had enough of the white paint with which he had begun and did not need to change sources while he was creating them.

Kline's decision to show with the Sidney Janis Gallery was a resounding financial success. Income from his work nearly tripled between 1956 and 1959 and then tripled again between 1959 and 1960. He was no longer a penniless artist forced to live an uncomfortable bohemian lifestyle. Kline invested his money in property, in 1959 purchasing a house at No. 15 Cottage Street in Provincetown and in 1961, a townhouse at 249 West Thirteenth Street in New York, convenient to his Fourteenth Street studio (Gaugh 1985b). He also indulged in his love of cars: he bought a black Thunderbird and acquired a gray Ferrari from Robert Bollt, a New York stockbroker, by trading a painting for it (Kingsley 1985). The painting in question may have been *Untitled* (1960),[24] which was loaned by Mr. and Mrs. Bollt for the 1968 traveling show, *Franz Kline*, organized by the Whitney Museum. At his reunion at Lehighton High School in May 1961, Kline's personal statement was succinct and telling: "I'm an artist, I live in New York, and I own a Ferrari" (Kingsley 2004, 389).

In addition to the 1956 solo show at the Sidney Janis Gallery, Janis gave Kline one-man shows in 1958 (May 19–June 14), 1960 (March 7–April 2), and 1961 (December 4–30). While the earlier shows had featured about twelve to fifteen large paintings on canvas and additional smaller works on a variety of supports, the 1961 show had twenty-four large paintings, none of which had been shown in 1960, indicating an amazing period of productivity. Kline's productivity may have been aided by his use of sketches executed almost a decade earlier; Kingsley (2000) notes that *Spagna* (1961), *Sun Carrier* (1961), and *Zinc Door* (1961) were all based on sketches from the early 1950s.[25] Kline had

not stopped sketching, but to inspire his painting, he used old sketches as well as new. Perhaps the continued development of his painting style was driven in part by certain sketches in which he saw potential but which he could not yet successfully express as paintings.

Kline's increasing renown led to solo shows in Chicago, Atlanta, Rome, Milan, and Paris, as well as the inclusion of his works in well over fifty national and international group shows (Christov-Bakargiev, Anfam, and Ashton 2004). His work also began to garner awards. *Corinthian* (1957) was included in the 1958 *International Guggenheim Award Exhibition*; *1960 New Year Wall, Night* (1960) was selected for honorable mention at the 1960 *Guggenheim International Award Exhibition*; and *Sawyer* (1959)[26] won the $1,500 Flora Mayer Witkowsky prize at the *64th American Exhibition* at the Art Institute of Chicago in 1961 (Gaugh and Kline 1979; Christov-Bakargiev, Anfam, and Ashton 2004). Museums, which are often slow to acquire contemporary works, also began to purchase Kline's paintings. The first such instance was MoMA's 1952 acquisition of *Chief* (1950), but the Solomon R. Guggenheim Museum purchased *Painting No. 7* (1952) in 1954. Seymour H. Knox purchased *New York, NY* (1953)[27] in 1956 and *Requiem* (1958) in 1959, gifting each of these to the Albright-Knox Art Gallery on purchase. The Whitney Museum of American Art purchased *Mahoning* (1956) in 1957. In 1959, the Kunstmuseum Basel became the first European institution to acquire a work by Kline, purchasing *Andes* (1957) (Zimmer et al. 2016).[28] In 1961, Kline gifted *Torches Mauve* (1960) to the Philadelphia Museum of Art, a gift acknowledged in a letter from museum president, R. Sturgis Ingersoll.[29] The Art Gallery of Toronto (now Art Gallery of Ontario) had expressed interest in purchasing this work,[30] and Kline may have been motivated by personal connections over monetary gain when he chose to donate the painting to a museum in his home state.

A significant indicator of Kline's growing international fame was the inclusion of ten of his works in the US pavilion at the XXX Biennale di Venezia in 1960; Philip Guston, Hans Hofmann, and Theodore Roszak were also chosen to participate. Kline and Zogbaum took this opportunity to travel to Europe, flying to Paris on June 7 and then to Venice on June 13, in time to attend the Critics' Opening the next day (Gaugh 1985b). Ten paintings spanning Kline's "mature" career were shown: *Nijinsky* (1950), *Painting* (1952), *Untitled* (1953), *White Forms* (1955), *Shenandoah* (1956), *Delaware Gap* (1958), *1960 New Year Wall, Night* (1960), *Siegfried* (1958), *Black Star* (1959), and *Initial* (1959) (Christov-Bakargiev, Anfam, and Ashton 2004).[31] In a review of the Biennale, K. B. Sawyer wrote:

> Perhaps beyond all American painters Kline has the ability to communicate—or reveal—the act of painting. Each of his oils is a gesture—a gesture we are invited to live. The resistance of fabric to brush, of unyielding arm to resilient surface, is present in our experience of a Kline painting. He brings the viewer closer to the act of painting than any artist working in America today. I cannot see an oil by Franz Kline without absorbing a bit of its energy and power. (1960, 34–35)

Although Kline did not win one of the two top prizes awarded that year—they went to Hans Hartung and Jean Fautrier—the jury bestowed on Kline the Italian Ministry of Public Instruction Prize worth one million lire, or approximately US$1,600 (Tillim 1960). A bit of a scandal seems to have surrounded the prize distributions, as Sidney Tillim (1960, 30) reported that the prize awarded to Kline did not appear in the official list of awards "[or] in any of the Biennale regulations which deal with the prizes." Tillim shares the rumor that while the jury vote on Hartung's award was unanimous,

Fautrier received only a majority of the vote, implying that Kline's award was a sort of consolation prize meant to acknowledge his artistic merit and perhaps absolve the jury of guilt for having selected Fautrier instead of him. These rumors may have circulated during the opening and led to an exchange of insults between Fautrier and Kline, the former screaming, "What are you doing here, damned Yankee—go back to the States—go to hell—and learn how to paint," and Kline retorting, "And you—what are you doing here in Italy—go home and make your pasticcios [pastries] in France"—a clear allusion to Fautrier's heavily impastoed and thickly layered paintings.[32] Kline and Zogbaum left Venice on June 19 and toured through Italy by car, doubtlessly aided by Elisabeth's language proficiency; she had majored in Italian at Barnard and studied abroad at the University of Siena.[33] The couple returned to New York on July 8, and it may have been after his return that Kline finished *Blueberry Eyes* (1959–60), as he told the first owner that the work was named after the color of eyeshadow worn by his companion (Zogbaum) after a trip to Paris (SAAM exhibition label).

After his return from Europe, Kline's health began to deteriorate. Theodore Edlich, his friend, patron, and physician, had evidently diagnosed Kline with a rheumatic heart early in their relationship, but Kline had never told his friends or family.[34] In April 1961, Kline was admitted to the Johns Hopkins Hospital for testing. On returning to New York, Kline wrote to a friend in May, "The doctor's report was thorough and to the point, my drinking days are over, regulated to the dinner hour and I must regulate myself to hours of sleep; so my bar life and long after party days are ended. I've started painting again and feel much better."[35] Kline had been incredibly productive during 1961, but the efforts may have taken a toll, and he had his first heart attack in February 1962. On his release from the hospital, Zogbaum, with the help of Dan Rice, undertook Franz's care, moving a hospital bed for him into her apartment so that he would be under close observation and cooking low sodium food for him; she found the diet unpalatable, and Kline complained that he would never be able to enjoy dinner parties again.[36] Unable to paint and tied to oxygen tubes, Kline was visited by friends, among them, Dan Rice, Earl Kerkam, and Mark Rothko (Finsel and Finsel 2019, 147–48).[37] Rather than exhaust him with conversation, they watched television together. Kline evidently became focused on Benny Paret, who fought a boxing match with Emile Griffith that was televised on March 24, 1962; Paret collapsed during the fight and lapsed into a coma. Zogbaum wrote, "Franz always wanted to know if he had regained consciousness. It always seemed to me that Franz was equating his chance of survival with that of Benny Paret. The injured fighter never regained consciousness."[38] Kline did not recover either. He was admitted to the hospital on May 4, and visits from friends and family continued. Kline died in the arms of his sister, Louise, on May 13, 1962. A funeral was held on May 16 at St. Bartholomew's Protestant Episcopal Church in Manhattan, and a second service was held the following day at Lehighton Episcopal Church. Kline was buried in Hollenback Cemetery, Wilkes-Barre, Pennsylvania. Kline's friends and colleagues held a memorial tribute on what would have been his birthday, May 23, at Grace Church, New York.

To provide Kline with a last link to his artistic career, during which he had fought so hard and suffered so many deprivations, Zogbaum had brought a reproduction of *Scudera* (1961) (fig. 6.15), the last painting he made, to his hospital room; Kline looked at it and said, "Yes. It's all right."[39] *Scudera* features an imperfect central black square, a compositional element to which Kline had often returned since exploring it in his early abstract works *Wotan* and *Leda*, and of which Kingsley (1986, 45) had said, "Its antigravitational pull is felt in many of Kline's finest paintings up until the very end of his life when the black square in *Scudera* ascends heavenward into the blue." Facing

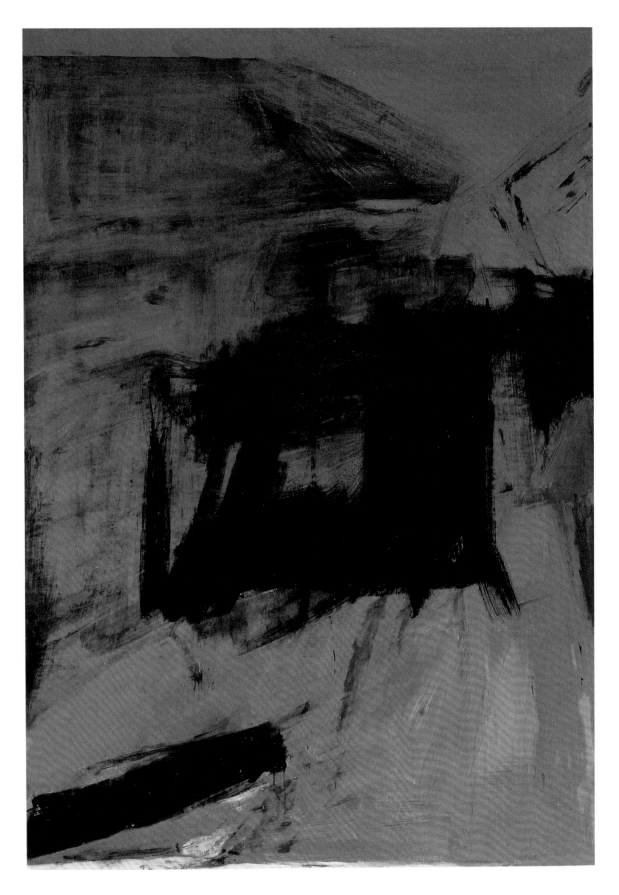

his mortality, Kline could have revisited the form merely to echo previous successes; *Scudera* shows instead that Kline found new inspiration. In contrast to his early abstractions, Kline almost completely eschews the use of white as white; rather, he uses arresting, almost discordant purples and blues and a brooding, even menacing red. In no other painting does he call so heavily on the blues of his palette. Aware that his time was acutely limited, Kline continued to develop his art, exploring and expressing until he "caught it" in oil on canvas. Even at the end, Kline was experimenting. (And even at the end, he would say only, "It's all right.")

Franz Kline's will, dated May 31, 1960, named Zogbaum executrix of his estate.[40] She and Rice inventoried his works remaining in the studio, assigning each a "ZP" (paintings) or "ZD" (drawings) estate number. These numbers were often written on the verso of the work, for instance, *Untitled* (ca. 1948, Guggenheim 79.2624) is labeled "ZP 35" and *Red Brass* (1959) "ZP 66." As a mark of recognition for his long friendship with Kline, Dan Rice was gifted one of Kline's studio tables that he used as a palette, and in 2002 Rice donated it to the Black Mountain College Museum. Kline's will left the equipment and materials located in his Manhattan studio to Charles Egan, along with "two large paintings created by me." It is unknown whether Egan accepted the gift of Kline's studio materials or what became of them, but the "two large paintings" precipitated a conflict. Kline had indicated that Egan should receive first choice of paintings prior to disposition of the remaining works by Zogbaum. Egan selected *Shenandoah Wall* (1961) and *1960 New Year Wall, Night* (1960) (Merryman and Elsen 1987, 447–49), but the Sidney Janis Gallery told Zogbaum that these works had already been purchased (by Janis and the Art Institute of Chicago, respectively) and were thus invalid choices. Egan sued, and the court decided in his favor, as there was insufficient evidence to establish that Janis had actually purchased *Shenandoah Wall* and the Art Institute of Chicago had not approved the purchase of *1960 New Year Wall, Night* until May 14, the day after Kline's death, giving precedence to Charles Egan's claim on the work. Zogbaum sold many of the works remaining in the estate but also generously donated works to museums, in particular, the National Gallery of Art and the Metropolitan Museum of Art, a practice that her son Rufus has continued. These donations are particularly strong in Kline's early work, and it is thanks to the generosity of the Zogbaums that we know so much of his early techniques and materials.

In addition to overseeing the dispersal of Kline's estate, Zogbaum worked to memorialize Kline's artistic efforts and to convey to others what he was like as an individual. In 1987, she established the Franz Kline Foundation, but due to lack of funding it was terminated in 1995 (Vincent 2010). She also devoted a great deal of effort to developing a slide show or film about Kline. In the early 1970s, she began interviewing a variety of people who had known Kline, including Conrad Marca-Relli (artist, February 13, 1975), Louise Bourgeois (artist, n.d.), Robert Goldwater (married to L. B. and director of the Museum of Primitive Art, n.d.), Richard Brown Baker (collector, n.d.), Piero Dorazio (artist, May 5, 1972), Joan Mitchell (artist, September 28, 1971), Count Giuseppe Panza di Biumo (collector, n.d.), and Ludwig "Lutz" Sanders (artist, November 18, 1972). From these interviews and her own knowledge of Kline's personal history, Zogbaum wrote a script, "Franz Kline 1910–1962," for what was to be a thirty-minute 16mm film (or perhaps a slide show with synchronized sound, narration, and voices). She wanted the final work to possess three qualities, power, humanity and intimacy, as "they were the qualities of the painter and the man."[41] It was to be narrated by George Lloyd, with additional narration by Marca-Relli, Dorazio, Clinton Wilder, Richard Brown Baker, Donald Gaynor, Robert Beverly Hale, and herself and would feature artworks by Kline as well as three minutes of color film of Kline at work. Many drafts of the script are

present in the Zogbaum papers at the Archives of American Art; unfortunately, the whereabouts of the accompanying film footage are unknown. Zogbaum's writings indicate that she purchased the film from the unnamed original owner and had it duplicated and that she had intended to deposit it with the Archives of American Art. It is possible that two brief clips from this film were used in *Franz Kline Remembered*, a film from Strokes of Genius: The American Artists Film Series; they show Kline creating a preparatory charcoal sketch on a large canvas and applying black and white paints, although the work in progress cannot be identified. We can hope that in the future some lucky individual will unearth more of this footage, but even by viewing those few seconds of Kline in action, we can appreciate Zogbaum's description: "One can see the way in which he roughs in the forms in charcoal, on the canvas, which is stapled to the drawing wall. It shows Kline's way of mixing his paint, then the particular way of applying the enormous brush, loaded with paint, to the canvas, his wrist turning and manipulating the paint in his special manner."[42]

After Kline's death, the Washington Gallery of Modern Art, the Poses Institute of Fine Arts at Brandeis University, and the Baltimore Museum of Art organized a memorial exhibition that opened in the fall of 1962. A spate of other national and international shows followed in 1963 and 1964 at venues that included the Whitechapel Gallery, Stedelijk Museum, and Kunsthalle Basel (Christov-Bakargiev, Anfam, and Ashton 2004); subsequently, solo exhibitions of Kline's works in museums became sparse. The last exhibition of his mature works in the United States was in 1994 at the Menil Collection, *Franz Kline: Black & White*; and a show devoted to his early figurative works was held at the Allentown Art Museum in 2012–13. An exhibition of his works would be difficult and expensive to mount today, given the large size and fragile state of some of the paintings, perhaps explaining why there have been few opportunities for later generations of viewers, critics, and art historians to experience his works together. Monographs on Kline's work have been scarce, and virtually no research has been undertaken into the technical aspects of Kline's work. The lack of attention paid to a painter who was once characterized as "the third glittering star in the Big Three constellation" of the Abstract Expressionist movement, along with Willem de Kooning and Jackson Pollock (Hamill 1996, 300), and featured in *LIFE* magazine with Willem de Kooning, Mark Rothko, and Clyfford Still (Stern and Seiberling 1959), is at first surprising and then depressing. Seeking to identify causes for this in her article "Franz Kline: Out of Sight, Out of Mind" (1986), Kingsley points to the lack of a powerful New York critic to champion his memory, the preference of critics for more "intellectual" painters such as Rothko and Newman, and the inevitable fading of Kline's impact as a brilliant conversationalist.

These points can all be connected to the relative difficulty of engaging with Kline's work compared to that of his peers. Kline was reticent to speak about his own work, whereas many of his peers wrote and spoke extensively about their own art and thus made themselves accessible to contemporaneous critics and future art historians, who could use the ideas expressed by the artists to seed their own writing. Kline denied those seeds to the viewer, and without Kline's words as a starting point for thinking about his paintings, critical assessments of Kline's work have comprised mostly metaphor-filled passages describing black forms and how they relate to architecture, bridges, or locomotives. Although some insightful work has been done, including that of Gaugh (1985b), Kingsley (2000), Anfam (Anfam and Kline 1994, Anfam 2004), and Foster (1994), which has been cited extensively in this book, the consequences of the limited criticism include the dismissal of Kline as an uneducated nonintellectual and the false assessment of his oeuvre as static. Thomas Hess aptly summed up the common cursory treatment of Kline.

Franz Kline, one of the most original and profound of the New York Abstract-Expressionists, usually receives a skin-deep reading, a couple of hasty categorizations, and then is usually dismissed by the neo-modernists as well as by the neo-conservatives—the vocal, lunatic-as-a-fox fringes—for not being interested in going either way-out on the turpentine-pool orbit or back up the creek where the old new figurations grow. In common inner-temples, Kline is dismissed as a hedgehog with only one trick, which, according to E. C. Gossen of Hunter College, he doesn't even know why he keeps performing, if, indeed, he ever did understand it at all. (1962a, 47, 60)

In life, Franz Kline became a central figure in the Downtown art scene of the 1950s because of his art and *despite* his unwillingness or inability to describe that art in words. Frank O'Hara (1964, 9) thought that Kline spoke elliptically about his work because "his combats were with himself in his art, and were so personal as to defy intellectualization." The dismissive assessment of Gossen and the reverent reflection of O'Hara are impossible to reconcile, and Kline would never have attempted to do so. Franz Kline left us remarkable paintings that have a dramatic impact on viewers, not words to explain his work. While many around him intellectualized the nature of art, seeking to define in words what it was to be an artist at a time when "the abstract" challenged both artists and the public, Kline noted that "history doesn't prove that you are [an artist] because it's always talking about another artist" ("Abstract Art Around the World Today" 1954). The confidence with which Kline pursued his commitment to abstraction and continually explored his working process show that in his mature career he looked to no external authority for validation: he had found his métier, and he used his time to move forward and develop as an artist. We hope that this book shows Kline to be a careful, considered, and talented painter whose work not only evokes deep responses on viewing but amply repays close examination as well.

7

Analysis and Technical Study: Implications for Current Condition and Future Conservation

Corina E. Rogge, Zahira Véliz Bomford, Isabelle Duvernois,
and Maite Martinez Leal

> For all its impact, Kline's most celebrated art—his black and white painting—
> is among the most fragile of our century. In that fateful contrast of appearance
> vs. physical condition, it truly mirrors the artist.
> —HARRY F. GAUGH, *The Vital Gesture: Franz Kline*

Artists' choices of materials and the ways in which they use those materials are an integral part of their signature style, so it is unsurprising that artists' works might age in distinctive ways as a result of the particularities of their creation. Some of Frank van Hemert's paintings exhibited dripping of the paint many decades after their completion because of problematic formulation of the Schmincke oil paints he used (Boon and Hoogland 2014). Piet Mondrian's use of zinc white paints, which are prone to the formation of zinc soaps, has led to the delamination and cracking of his paintings (Raven et al. 2019). Such examples challenge conservators to develop appropriate new treatments, but some artistic choices restrict even standard practices. The surface varnishes used by many artists to saturate and protect their paintings darken over time, and usually these can be carefully removed; but exceptions exist. For example, the high percentage of resin used by Ralph Albert Blakelock and Albert Pinkham Ryder in their pictorial layers changed the solubility of their paints, precluding safe varnish removal from their paintings (Svoboda and Van Vooren 1989; Krez, Mitchell, and Bezur 2017). Many of Kline's iconic paintings have already undergone intervention, but others remain relatively unaltered and retain the artist's nuance of color, gloss, and texture. Only based on a thorough understanding of Kline's materials and techniques can appropriate conservation strategies be devised for the care of these surprisingly vulnerable works.

Gaugh's monograph on Kline, written less than a quarter century after the artist's death, includes a chapter on techniques and conservation that underscores the extent to which works created by Kline had already undergone changes and deterioration due to his materials and methods of paint application (Gaugh 1985b, 155–62). Most of his paintings exhibit one or more common problems that we discuss below in detail, which include yellowing of the white paints, formation of drying and age craquelure, metal soap development, alteration of gloss, cohesive failure of heavily layered paints, and vulnerability to mechanical damage in canvas paintings of large dimensions. Some Kline paintings also have issues arising from unique material choices, so examination of more works may identify additional condition problems. In an interview with David Sylvester, Kline said, "Paint never seems to behave the same. Even the same paint doesn't,

you know. In other words, if you use the same white or black or red, through the use of it, it never seems to be the same. It doesn't dry the same. It doesn't stay there and look at you the same way. Other things seem to affect it" (Sylvester 1963, 4). The condition of various paintings by Kline as they age reinforces this observation: despite the relative stability of his mature artistic process, significant differences in the structural stability and aesthetic integrity of his works can be traced to choices Kline made about materials and techniques.

The concepts of inherent vice and external forces are useful for parsing the origins of condition issues and explaining why a painting has altered over time, resulting in its current appearance. "Inherent vice" refers to intrinsic properties in the constituent materials of objects: fundamental instabilities that will contribute to deterioration over time. For instance, paint layer delamination from the formation of zinc soaps results from the intrinsic chemistry of zinc white oil paints. "External forces" refers to influences from the environment, such as relative humidity or vibrations, which can affect the chemical and physical stability of an artwork. Although intrinsic and extrinsic factors are conceptually distinct, their effects on condition issues can be complex and interrelated: heat and humidity, for instance, increase the rate at which zinc white paints form zinc soaps. Identifying the contributions of inherent vices and external forces and determining if these act synergistically can inform preventive conservation approaches and help in the design or formulation of treatments for specific problems.

Oil-based paints oxidize with age and turn yellow, with the rate dependent on the type of oil and the presence or absence of driers and the extent of yellowing linked to contaminants (Mallégol, Lemaire, and Gardette 2001). As early as the sixteenth century, linseed oil, the most common drying vegetable oil, was known to yellow faster than more expensive poppy seed and walnut oils (Vasari 1907, 230), which are still recommended for use in white, blue, or light paints, reserving linseed oils for darker colors (Doerner 1934, 109–12). Such expensive oils have been identified only in artists' paints; their cost would be prohibitive for industrial or retail trade paints. During the years that Kline was active, linseed oil of different grades and qualities was used in artists' and retail trade paints. The purest grades are cold-pressed linseed oils expressed from the flax seed at room temperature, but these are also the most expensive as the yield is low (Doerner 1934, 100–101). Hot-pressed oils are cheaper because the process yields more oil per weight of seed and would be used in most linseed oil–containing retail trade paints, but they contain more contaminants, are darker in color, and tend to yellow more. Many retail trade paints were formulated with other oils, including safflower, soya bean, and menhaden, which are considered inferior because of their tendencies to yellow (Singer 1957, 9–28; Standeven 2013). Kline's paints are almost always oil, and those made with menhaden oil (including works from the 1950 Charles Egan Gallery show) or hot-pressed linseed oil can be expected to have a greater tendency to yellow than those that are free of these components. Sidney Janis (1967), commenting on differential yellowing in Kline's paintings, stated, regarding a painting from 1954, "On this earlier picture, you'll notice that the whites are ivory.... At that time Franz was not using the pure colors—the tube paint—that he did later on, and these colors have oxidized into a kind of ivory white; but you notice on the later picture of 1961, the whites have remained white because he used tube white." Although Janis asked Kline to use artists' paints (Gaugh and Kline 1979, 12), and both contemporaneous accounts and technical analysis indicate that he did so, the frequent detection of titanium white coprecipitated with calcium sulfate anhydrite in Kline's works throughout the 1950s and 1960s strongly suggests that he also continued to use retail trade paints (see chap. 4).[1]

Yellowing of oil paints is exacerbated, somewhat ironically, by a "good" museum environment. Ultraviolet wavelengths present in sunlight can photobleach yellowed oil films (Levison 1985), but museum environments rigorously eliminate this portion of the spectrum because of its damaging effects on art materials, so oil paintings held by museums naturally yellow over time. Kline often used multiple white paints on a painting, which in some cases have yellowed to different extents (e.g., *Painting No. 7* [1952] [see fig. 5.3] and *Untitled* [1961; SAAM]), and heavily impastoed areas have often yellowed more than thinly painted ones (e.g., *Untitled* [1961; MMA] and *Untitled* [1961; SAAM]). Although Kline professed indifference to the yellowing of his white paints, aspects of his work process indicate that he was sensitive to the tones of his whites. Kline often intentionally retained the slightly grayer hue of the white ground as a tone distinct from the white paint he applied (e.g., *Chief* [1950] and *Corinthian II* [1961]; see figs. 4.6, 6.13); his use of the delicate relationship between white ground and paint suggests that subsequent differential yellowing of his whites may have been an unwelcome aesthetic alteration. Unfortunately, then as now, little could be done to restore the white areas to their original color and recover this subtle relationship.

Alterations in Kline's blacks are more nuanced than those of the whites and tend to manifest as subtle changes in gloss. Several lines of evidence indicate that Kline selected or manipulated his materials to control gloss. Samples of glossy black paint taken from *Wotan* (1950) show high levels of colophony (see chap. 4); Kline either deliberately selected high gloss "enamel" paint or added colophony to the paint. Kline applied some undiluted blacks thickly, and these "fat" areas with high medium-to-pigment ratios are still glossy today. In other regions, Kline diluted the black with turpentine, and these "lean" paints, having a lower proportion of medium, are matte when cured. Oil paint films continue to alter even after they are dry to the touch, and over time the sheen of initially glossy areas may diminish; when Hess reviewed Kline's 1956 show at the Sidney Janis Gallery, he noted, "The blacks differentiate themselves as fat and lean pigments—an effect that may be lost a century from now when the oil has completely oxidized" (1956, 51). Intentional manipulation of gloss through the use of resins is evident in ultraviolet-induced visible fluorescence photographs of Kline works, including *Wotan* (1950), *Painting* (1952), and *Mahoning* (1956), in which certain black areas (but not others) fluoresce an intense green, indicative of resins such as colophony, dammar, or mastic being admixed within the paint (fig. 7.1). These images establish which areas Kline intended to be glossier than others and indicate how carefully he manipulated the interplay of matte and glossy surfaces. Unfortunately, gloss measurements or specular light images have not been recorded over time for any of Kline's paintings, so objective evidence for the degree of change in black paint is unavailable.

Kline applied overall varnishes to his early figurative works, and while he appears never to have varnished his abstract works in this way, in two cases documented in this study he selectively varnished certain black passages in black and white paintings to increase their gloss. A mastic varnish was applied to selected black regions of *Four Square* (1956), and this varnish is also visible where it dripped over white areas of the painting. The varnish has helped retain the gloss in these areas, and yellowing of this natural resin has not noticeably affected the color of the black regions. Selective regions of *Mahoning* (1956) are varnished with a synthetic acrylic thought to have been applied by Kline in 1960 after the original gloss of his resin-rich black paints had been partially lost (Whitney Museum of American Art 2014). As his paintings have entered collections and passed through the hands of conservators, many have been subject to subsequent varnishing. Added varnishes can serve as a (renewable) sacrificial layer, protecting delicate paint surfaces from dust, grime, and visitor interactions, but they may

FIGURE 7.1

Ultraviolet A induced visible fluorescence image of *Wotan* (1950) (detail). The greenish fluorescence in the blacks arises from the presence of colophony and indicates areas Kline intended to be glossy.

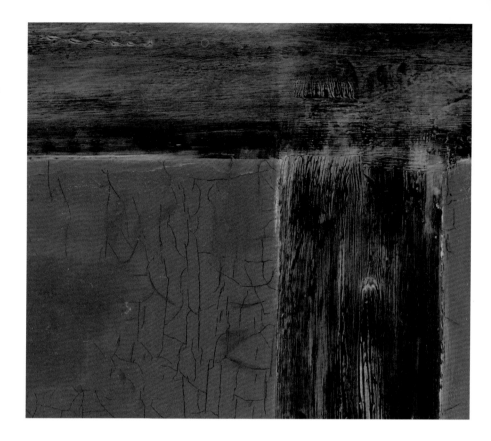

also obscure deliberate gloss differences created by the artist. Nonoriginal varnishes are now sometimes removed to achieve what is considered a more authentic aesthetic presentation. Because Kline would apply varnish to parts of some paintings, care is needed to prevent inadvertent removal of any artist-applied materials when addressing nonoriginal varnishes.

As cured oil paints oxidize and age, the polymer network breaks down into smaller molecules, including fatty acids and dicarboxylic acids, which can migrate to the surface of the painting and form a whitish haze or efflorescence (Ordonez and Twilley 1997). Paints that are media-rich are more prone to efflorescence, but the identities of the pigments present also play a role. Efflorescence is usually difficult to see on areas of white but much more evident on black, and this phenomenon has created a chalklike appearance that masks differences in gloss in the black regions of at least three Kline works: *Painting* (1952), *Wanamaker Block* (1955) (Gaugh 1985b, 161), and *Orange and Black Wall* (1959). Efflorescence can usually be removed relatively easily, but the intervention is not risk-free (Cooper et al. 2014; Rogala 2016, 76).

The use of zinc white and lead white paints by Kline and many other twentieth-century artists is associated with the formation of different types of metal carboxylate complexes known as metal soaps (Casadio et al. 2019 and references therein). In "young" paint films that have not yet undergone significant hydrolysis to release free fatty acids, the metal ions bind to the oil polymer network, forming an ionomer (Hermans et al. 2016). Ionomers have a diversity of metal carboxylate bonds with a range of vibrational energies that give rise to a broad absorption detectable by infrared spectroscopy. Because of Kline's frequent use of zinc white, zinc ionomers are common in his paintings, including those that are still in very good condition. For example, *Corinthian II* (1961) is in pristine condition, yet the infrared spectra of paint samples clearly show

the presence of this type of metal carboxylate (Rogge, Bomford, and Leal 2019). As the oil network ages further, hydrolysis will release free fatty acids and dicarboxylic acids that react with metal ions to form smaller metal carboxylates that are no longer part of the polymer network and can therefore migrate through the paint layer matrix. These metal carboxylates can aggregate and develop into crystalline, lamellar structures that compromise the structural integrity of the paint, leading to interlayer cleavage and paint loss (Corkery 1997; Boon et al. 2006). The complex process of metal soap aggregate formation is still being investigated, but a variety of factors, including relative humidity, temperature, and presence of different additives, play roles in their formation (Casadio et al. 2019).

Metal soap aggregates that form in paints usually adopt one of two morphologies: discrete layers that form at interfaces between paint layers or semispherical protrusions. These aggregates are semicrystalline, and the more homogeneous metal carboxylate bonds give rise to sharp absorbances in the infrared spectra (Hermans et al. 2015). The presence of metal soap aggregates in paintings is associated with increased embrittlement of the paint film and, in consequence, to greater susceptibility of the paint to cracking under applied mechanical stress (Rogala et al. 2010; Rogala 2016). Infrared mapping of cross-section samples from *Red Brass* (1959) and *Orange and Black Wall* (1959) reveals metal soap aggregates at the ground layer interface (and within the pictorial layers of the latter work), explaining the active interlayer cleavage and paint loss observed in these paintings (Rogge, Bomford, and Leal 2019). The cracking and cupping of paint on *Mycenae* (1958) noted by Orrin Riley[2] may be linked to the presence of metal soaps underlying the surface orange paint; cadmium-containing paints, like the oranges favored by Kline, are particularly prone to cracking when applied over zinc white layers (Rogala et al. 2010).

Treatment of unstable, flaking paint layers containing zinc soap aggregates is challenging and carries the risk of accelerating the deterioration. Adhesive systems that are used successfully to treat paint flaking arising from other causes can interact with the fatty acids and metal ions present in the paint matrix, increase their mobility, and actually facilitate metal soap formation and aggregation (Casadio et al. 2019). The frequency and severity of deteriorations related to metal soaps has instigated much ongoing research that attempts to understand and thus perhaps mitigate their formation. Although the conditions and mechanisms that produce metal soaps have been at least partly identified, there is currently no widely valid protocol for conservators faced with the task of stabilizing works manifesting paint embrittlement and delamination resulting from metal soap formation.

Oil paints should be applied "fat over lean," meaning that media-rich, slow-drying paints should be applied over faster-drying, less elastic paints (Gottsegan 2006, 212). If the reverse order of application occurs, drying cracks can form in the upper layers if they are not sufficiently elastic to conform to changes that occur with contraction of the media-rich subsurface paints when these, in turn, eventually dry. Where Kline applied black paint directly onto the lead white ground, drying cracks are less likely as lead white paints are fast drying. However, in his black and white works, Kline sometimes applied zinc or titanium white paints over the ground and later covered these with black paint as the composition evolved. Where this has occurred, incompatible properties of Kline's layered paints have sometimes caused readily visible drying cracks (fig. 7.2), which can also be observed in some white over white areas and in colored works. Although this kind of craquelure may be aesthetically distracting, fortunately it is not usually associated with structural instability. Such patterns of cracking may correlate with areas where Kline adjusted his composition—broadening a black area or reworking the

composition—and analysis of these patterns can lead to a better understanding of the painting's evolution.

Age or mechanical cracks are formed when a paint film fractures because it cannot respond plastically to dimensional changes of its support (fig. 7.3). In extreme cases these cracks can penetrate through all paint layers, including the ground, disrupting the even distribution of inherent stress across the painting's surface. As oil paints polymerize and age, the paint film contracts, which can distort the canvas out of plane where cracks penetrate to the ground. In such instances the crack pattern of the paint

can be seen on the verso of the canvas, a condition known as quilting. Cracking and quilting are exacerbated dramatically in Kline's paintings when the paint film is thick, with multiple layers, but in thinly painted canvases the problem is often minimal.

Shakespeare's Hamlet decried "the thousand natural shocks that flesh is heir to"; paintings, too, are subject to "the whips and scorns of time," and the action of external forces on Kline's paintings is responsible for many of their condition issues. Kline's peripatetic lifestyle—he lived at fifteen addresses between 1939 and 1962—subjected at least some of his paintings to physical stress during or shortly after their creation. Substandard storage conditions, rolling large works for transport or to make space in his studio, and navigating works through narrow stairwells took a toll, and many of Kline's works bear signs of damage in the form of punctures, tears, and raking impacts. One recorded incident suggests that Kline was not particularly concerned with the physical state of his works: when he was evicted from an apartment, his belongings, including his paintings, were left on the sidewalk in the rain, and his response was to laugh and say, "But they're only paintings."[3] This cavalier comment should be offset by the knowledge that Kline sometimes amended or repaired paintings even after they had left his possession. Kline is believed to have retouched areas of damage to *Mahoning* (1956) in 1960, when he also applied the synthetic varnish to some black areas to increase their gloss (Whitney Museum of American Art 2014).

The structure of Kline's paintings was negatively affected during their creation by his practice of stapling canvases onto the wall to provide resistance to the pressure of the brush when applying paint (Goodnough 1952). The relatively cramped conditions of even his largest studio on West Fourteenth Street meant that canvases with which he was engaged might be stapled onto the wall and then taken down several times before he completed them; occasionally, he would also rotate canvases to evaluate the composition or work on them in a different orientation. Such repeated tacking and untacking perforates the canvas, tearing threads and weakening the material that would eventually become the turnover edge and sustain the weight of the stretched canvas. The cycles of tension and relaxation imposed by this process would also have consequences for the long-term integrity of the paint film, especially for heavily layered works. In the 1956 photograph taken by Robert Frank (fig. 7.4), Kline is seated in front of *Untitled* (1951),[4] which is tacked to the wall, and the surface plane of the painting shows several areas of distortion, which are probably the result of repeated handling. Even if such distortions seem to disappear when the painting is stretched, the stresses that gave rise to distortions will accelerate the local formation of mechanical craquelure, which will eventually manifest as an indicator of the original damage to the canvas and paint film.

Stretching a canvas painting helps maintain its structural integrity through even distribution of stresses, but Kline's practice of using fixed corner strainers that lacked provision for dimensional adjustment (and were often rather flimsy and prone to torquing) rather than more expensive, expandable stretchers means that the planes of many paintings were subject to distortion from the time that they were first stretched. Kline and other artists of the New York School rejected traditional figuration but not the convention of applying paint to canvas, and many of their images were created with immense loads of pigment and medium on a textile support of large dimensions with inadequate support from strainers or stretchers. The weight of multiple, thick layers of pigments in oil contributes to the shear forces acting on the paint film, helping to generate fractures in paint layers that might already be structurally compromised by metal soap aggregates or by prior mechanical damage. The inability of the canvas to provide adequate rigidity to support the paint load contributes to mechanical failure in some of Kline's paintings.

FIGURE 7.4

Robert Frank, *Franz Kline, New York City*, 1956. Gelatin silver print, image: 33.7 × 22.5 cm (13 ¼ × 8⅞ in.), sheet: 35.4 × 27.8 cm (13¹⁵⁄₁₆ × 10¹⁵⁄₁₆ in.), The Museum of Fine Arts, Houston, Gift of P/K Associates.

Kline is sitting in front of *Untitled* (1951), which is tacked to the wall. The canvas shows multiple deformations, likely from handling.

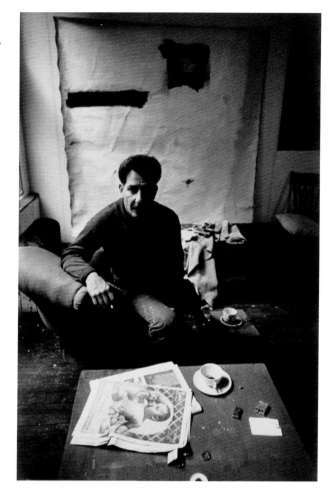

Interaction with private and institutional collectors in galleries and museums was enormously important to the careers of Abstract Expressionists, but active exhibition programs contributed to the deterioration of their individual works. The web of connections between artists, commercial galleries, and museums that developed and flourished in New York in the 1950s and 1960s was probably as effective at promoting artists as the gallery system of Paris in the second half of the nineteenth century, when an international art market gained historic momentum (Hulst 2017, 316–50; Robson 1988, 391–99, 421–81, appendixes B and C; Robson 1995, 255–63). As a result, paintings created in New York in the middle decades of the twentieth century, including those of Franz Kline, were some of the most exhibited artworks up to that time (Robson 1995, 255–63). Cycles of repeated packing, travel, unpacking, and hanging of inherently unstable pictorial structures has contributed to their deterioration (Mecklenburg 1991). The damage done by vibrations in transport is particularly acute for paintings that are slack on their stretchers, lack backing boards, and are not stiffened by wrapping (Marcon 1991; Läuchli et al. 2014). The popularity of Kline's work in the years immediately following his death led to many of his paintings having extensive travel histories. For example, *Wotan* (1950), which had remained in New York from its creation until Kline's death, traveled with the Franz Kline retrospective exhibition in 1964 to Amsterdam, Turin, Brussels, Basel, Vienna, London, and Paris. After its return, it was exhibited in different New York venues in 1966, 1968, and 1970, and further travels to Cleveland, Chicago, and Houston occurred in the 1980s and 1990s. This painting is more well traveled than

many people, and transit handling has torqued the structure and exacerbated the cracking of the fragile paint layers, helping create the surface we see today.

Our examination of over thirty Kline paintings indicate that his thinly layered works such as *Chief* (1950) and *Corinthian II* (1961) are structurally stable despite containing pigments prone to metal soap formation, whereas more heavily layered paintings such as *Wotan* (1950) and *Orange and Black Wall* (1959) display condition issues arising from problems inherent in Kline's materials and painting process. The contrast in condition between thinly and thickly layered paint films is evident in the earliest of Kline's acclaimed abstract works: of the four paintings examined here from Kline's 1950 Charles Egan Gallery show (see chap. 4), the thinly painted works *Chief* and *High Street* are stable, with few visible signs of age other than stress cracking at the turnover edges and drying cracks where black paint overlies white, whereas the more heavily painted *Wotan* and *Nijinsky* display extensive mechanical cracking and interlayer cleavage. The condition problems of *Orange and Black Wall* (1959) are more extreme, probably because it is both heavily layered and very large. Detailed conservation histories given below for *Wotan*, *Nijinsky*, and *Orange and Black Wall* indicate the range of approaches that have been taken to address their serious condition issues. Technical analyses undertaken to help diagnose condition issues have informed both conservation efforts and our understanding of Kline's method. Our understanding of thinly painted Kline works relies primarily on nondestructive elemental analysis, since comparatively pristine paintings present few sampling locations. Because of their compromised condition, the more heavily layered paintings presented more opportunity for sampling, thus providing more information to complement the elemental analysis. The support structures (canvas, sizing and ground layers) of both thinly and thickly painted works are similar, as are the paints Kline used. Elemental mapping and analysis of cross sections show that Kline repeatedly reworked the heavily layered paintings we have examined to date, making dramatic changes in his color choices and composition. The layering that attests to Kline's creative struggles is in large part responsible for the fragile condition of these works, and we expect the more thinly painted works to experience far fewer issues as they age. Because Kline would rework and layer his paints when he strove to express his vision, we have more technical information about the paintings made at critical points in the *development* of Kline's style than about those that were created in his more typical, assured manner.

Wotan (1950) has a complicated treatment history, and some of the early interventions may have been performed by Kline himself. Originally an oil painting on canvas, as indicated by the stretcher creases still evident around all four sides, *Wotan* was removed from its strainer and glued with polyvinyl acetate onto a solid support consisting of two layers of fiberboard. The original turnover edges were trimmed off, and the fiberboard was adhered to the strainer, the edges of which were painted black. Mounting *Wotan* onto a stiffer support was probably an attempt to stabilize the raking damage visible in the X-radiograph (fig. 7.5) and associated cracking of the paint layers due to the fragile calcium carbonate paint layer and embrittled zinc white paints. The signature on the reverse of the fiberboard, "Franz Kline, Egan Gallery 1950–51," suggests that Kline may have performed this mounting himself or had access to the painting during this process, either by virtue of still possessing it or through his relationship with the collector Robert C. Scull, who purchased it from the artist.[5]

Despite being mounted onto a solid support, the white regions of *Wotan* exhibit extensive fine cracking and lifting that most likely arise from a combination of underbound paint and zinc soaps (Rogge, Bomford, and Leal 2019). One underlying white paint layer has very little self-adhesion or tensile strength due to large, coarse particles

FIGURE 7.5
X-radiograph image of an area
of raking damage on *Wotan* (1950),
possibly arising from impact
of the canvas on another object.

FIGURE 7.6
Diagram showing the locations
of consolidations on *Wotan* (1950)
since acquisition by the MFAH
in 1980. The color of the lines
indicates the year in which the
treatment was conducted: 1982
(dark green); 1987 (blue); 1994–95
(pink); 2013 (bright green); 2015
(red).

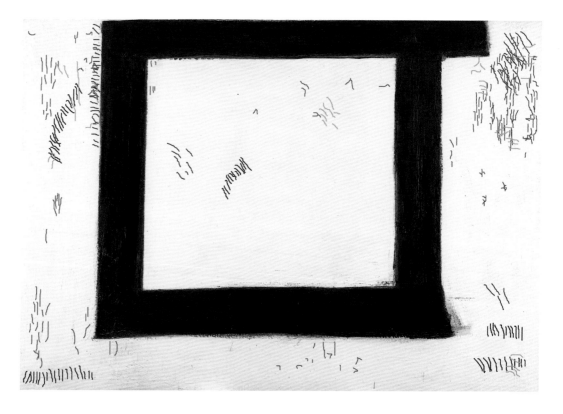

of calcium carbonate and a low media-to-pigment ratio; this underbound layer (shown at the bottom of the section in fig. 4.18) is especially prone to fracture whenever stress is applied. Although the fiberboard support provided some rigidity, handling the work still caused the painting assembly to torque, subjecting the paint layers to stress and causing subsequent cracking in the white regions. A modern aluminum frame whose four sides were secured individually to the backing strainer did not mitigate this detrimental flexing. Since entering the collection of the Museum of Fine Arts, Houston, in 1980, several conservation campaigns have been conducted to address the cracking and lifting paints (fig. 7.6). Although the interventions did stabilize a particular targeted area, they could not address the underlying factors of the paint structure fragility, and cleavage kept recurring.

The fiberboard backing of *Wotan* prevents overall consolidation of the paint from the verso, and the brittleness of the paint precludes removal of the secondary support, so treatment options are limited. In 2015, active cleavage was consolidated, and the whole painting assembly (the original painting, fiberboard panels, and wooden framework backing) was stabilized by incorporating an inflexible aluminum honeycomb panel within a rigid framing structure. Before attaching the honeycomb panel, voids between the strainer members were lined with silicone Mylar to isolate the artist's materials and signature as well as the historical exhibition labels on the fiberboard. Ethafoam inserts were introduced between the strainer members, and the aluminum panel was secured to the wooden strainer using extant holes. Thus prepared, the work was placed inside a new fixed-corner, rigid stainless steel frame designed to accommodate the painting assemblage and added honeycomb panel. Thin Ethafoam inserts were placed between the painting and the lower edge of the frame to equalize the distribution of weight; the honeycomb panel and Ethafoam inserts are removable at any time. The new frame system effectively eliminates torquing of the structure and has helped prevent damage while moving and displaying the painting. This intervention has been successful to date as further consolidation has not been necessary in the subsequent five years.

As early as 1960, *Nijinsky* (1950) was exhibiting blisters, cleavage between paint layers, wide open cracks, and paint losses, which all seem to be caused by the lack of adhesion between the upper and numerous underlying paint layers. Deep drying cracks as well as mechanical cracks are common and prominent in the white painted areas but present to a much lesser degree in the black areas. The surface white paint in *Nijinsky* is composed mostly of titanium white in its rutile form; no zinc white was detected in the samples taken from this paint. However, the elemental distribution map shows that zinc is associated with underlying paints (see fig. 4.16), and its presence may have contributed to the observed flaking and interlayer cleavage. Microscopic examination of deep cracks indicates that the cleavages are occurring between paint layers that lie below the reddish-brown paint that Kline applied overall to act as the ground layer before painting the work. In 1960, before it was gifted to the Metropolitan Museum of Art, these condition issues were treated using a wax-resin mixture to impregnate the verso of the canvas and to consolidate local cracks from the front. Wax-resin can help stabilize flaking paint layers and was commonly used as an adhesive at the time. Unfortunately, this approach was unsuccessful for *Nijinsky*, probably because the thickness of the paint layers and presence of blind cracks and inner delaminations precluded sufficient penetration of the wax-resin mixture. The original dimensions of the work were also altered in 1960, as the tacking edges of the canvas were flattened before being strip-lined on a new, slightly larger stretcher.[6] During this treatment campaign, the painting was also varnished; this varnish was removed in 1981, and the painting was not revarnished so that Kline's original intent would be recaptured to the extent possible. Today,

FIGURE 7.7
Transmitted light photograph of *Orange and Black Wall* (1959), where light shone through the back of the canvas reveals the extensive network of drying and mechanical cracks that penetrate paint and ground layers.

the whites mostly have a matte and dry appearance, whereas the blacks are glossier, but the extensive interventions likely have altered the original sheen of the paints.

The conservation history of *Orange and Black Wall* (1959) is documented only from 1996, the date of a condition report prepared by a private conservator in New York stating that the "painting is in excellent and stable condition" (MFAH Conservation Department Archive), but evidence of earlier treatments indicates that problematic issues had already manifested before that time. *Orange and Black Wall*, like *Wotan*, had an impressive record of travel to exhibitions, and prior to 1996 the canvas turnover edges of the painting had been strip-lined, probably because they had been weakened by repeated stretching and unstretching. Scattered losses had been retouched and some cracks in the paint consolidated, and the painting had been stretched onto a new strainer that was slightly larger than the original.[7] Remnants of a Dutch-language newspaper on the turnover edges suggest that at least one treatment campaign was conducted in Europe while the painting was in the Fondazione Thyssen-Bornemisza, Lugano (ca. 1973–90) (MFAH Conservation Department Archive). In 1996, *Orange and Black Wall* was acquired by the collector Caroline Wiess Law and shipped to her home in Houston, Texas, where painting conservators from the MFAH examined it. Although the replacement strainer was carefully prepared, with all the members covered with canvas, and voids between strainer members were filled with canvas-covered foam inserts

to damp movement of the canvas, additional cracks and paint losses were observed, perhaps arising from vibration sustained during transport. Embrittlement associated with the presence of metal soaps partially accounts for the craquelure observed (Rogge, Bomford, and Leal 2019), but vibration and manipulation of the canvas support from frequent travel further compromised the cohesive strength of the paint layers. The majority of the drying and mechanical cracks visible today were already present in photographs from this date. The extensive network of cracks is best documented in transmitted light (fig. 7.7). In 1997, lifting paint predominantly located in the heavily layered black paint and in one area of white was treated with BEVA® 371 (MFAH Conservation Department Archive).[8] In 2004, the painting was bequeathed to the MFAH, and in 2005 it was treated again. The old strip lining, now failing, was removed and replaced, lifting cracks were consolidated with either BEVA® 371 or gelatin, and the canvas was blind-lined and restretched on a new, stronger stretcher, the lower bar of the former stretcher having split. Cleavage between ground and canvas and between paint layers was evident, which suggests that by this time the metal soap formation was established, though infrared spectra were not acquired at that time. In 2014, additional losses due to interlayer cleavage were noted and another localized consolidation campaign was undertaken (MFAH Conservation Department Archive). *Orange and Black Wall* presents complex ongoing conservation challenges arising from both inherent vice

and external forces acting over time. The painting is now in an environment-controlled, stable environment and receives frequent review of condition and conservation care. Nevertheless, the relatively young paints and the mechanical characteristics of such a heavily built-up paint film mean that continued cracking and cleavage will occur. Treatment restrictions imposed by the definitive presence of metal soaps in the paint structure means that the conservative strategy for care of these works continues to be structural stabilization with local consolidation of cleavage as it arises.

Kline's account at the Sidney Janis Gallery in 1961 and 1962 included payments of several hundred dollars on his behalf to Daniel Goldreyer, a conservator favored by many Abstract Expressionist artists, including Barnett Newman and Ellsworth Kelly (Forder 1994; Gridley 2019).[9] These payments suggest that Kline paintings being sold by Janis were in need of conservation not long after their creation. It is unclear what specific conditions issues Goldreyer addressed or which works he treated. After Kline's death, his executrix, Elisabeth Zogbaum, undertook a general survey of his works, documenting their condition, consulting conservators about issues, and sending works out for treatment if needed. The records indicate that she most often consulted Orrin Riley, a paintings conservator employed by the Guggenheim Museum who also worked for private clients.[10] Riley offered to treat the painting *Mycenae* (1958) and a variety of Kline's works on paper, but it is unclear how many were actually treated. For another client, Riley treated *Untitled* (1952) (see fig. 5.11), now in the Guggenheim collection, which he mounted on an aluminum panel. Like other Kline paintings with built-up paint layers, this work apparently manifested early signs of structural instability. Other conservators working for Zogbaum, when confronted by paintings that had holes or tears, chose traditional linings and adhered the original canvas onto a secondary canvas support, in attempts to improve structural stability.[11] Lining canvases or mounting works on paper onto secondary supports has been undertaken by many conservators, both private and institutional, who have been entrusted with the care of works by Kline. In some cases, such as *Mahoning* (1956), lining in the early 1960s may have been a "preventative measure" to prepare the painting for travel (Matthew Skopek 2015).[12] In other cases, such as *Nijinsky* (1950) and *Chief* (1950), infusion with wax-resin adhesive was undertaken at a similar time (Jim Coddington 2015).[13]

For conservators charged with caring for Kline's works today, the perpetual challenge of reconciling the preservation of the physical materials of an artwork with the demands for its exhibition is informed by the evidence that zinc soap formation and mechanical issues currently threaten the physical integrity of Kline's thickly painted works by promoting interlayer cleavage, and that micro-cracking may eventually affect the integrity or aesthetics of even his thinly painted works. Mechanical stabilization of canvases can slow some of this deterioration. Documenting the glossiness of paint passages may help assess changes to paint film surfaces over long time scales. Establishing a consensus among invested conservators, curators, owners, and art historians about which alterations to the paint film are acceptable as a Kline painting ages, and which changes might justify intervention, could help guide conservation efforts in the near and long term. Absent an established treatment for the effects of zinc soap formation and given the constraints imposed by the materials Kline used, many stakeholders will likely favor "wait and see" strategies. Ongoing research into zinc soaps may lead to new treatments in the future, and we can hope that any stabilizations undertaken in the meanwhile will not prevent these from being applicable. Physical frailty took Franz Kline from the world too soon; recognizing and addressing the frailties in his works will extend the lives of his paintings and enable generations of viewers to experience their impact.

Appendix I

Analytical Methods Used at the MFAH and the MMA

Corina E. Rogge, Silvia A. Centeno, and Julie Arslanoglu

X-Ray Fluorescence (XRF) Spectroscopy

MFAH: XRF spectra from single points were collected using either a portable Bruker Tracer III-V (MFAH) or a portable Bruker/Keymaster Tracer III-V (ARTIC) instrument. The MFAH Bruker Tracer III-V hand-held energy dispersive X-ray spectrometer is equipped with a Si-Pin detector with a resolution of 190 eV. The excitation source was a rhodium (Rh) target X-ray tube, operated at 40 kV and 10 µA current and spectra were collected over 120 sec (live time). The ARTIC Bruker/Keymaster instrument is equipped with a high-resolution silver-free Si-Pin detector with a resolution of approximately 175 eV. The excitation source was an Rh target X-ray tube, operated at 40 kV and 6 µA current, and spectra were collected over 180 sec (live time). Spectral interpretation was performed using the Bruker Artax Spectra 7.4.0.0 Software. Macro area X-ray fluorescence (MA-XRF) mapping of *Orange and Black Wall* was performed with a Bruker M6 Jetstream system equipped with an Rh source operating at 50 kV and 600 µA; the step size and focal spot size were 540 microns, and the dwell time was 11 ms/pixel. The spatial distributions of the elements of interest were obtained using the Bruker M6 Jetstream software.

MMA: XRF mapping was performed with a Bruker M6 Jetstream system equipped with an Rh source operating at 50 kV and 600 uA. For all the paintings mapped, the focal spot size was 700 microns, the dwell time 80 ms/pixel, and the step size 700 microns, except for *Nijinsky* (1950; MMA 2006.32.28), for which a 750 micron step was used. The spatial distributions of the elements of interest were obtained using the Bruker M6 Jetstream software.

Fourier Transform Infrared (FTIR) Spectroscopy

MFAH: Attenuated total reflection (ATR) and transmission spectra were collected using a Lumos FTIR microscope equipped with a motorized germanium ATR crystal with a 100 µm tip (Bruker) and MCTA detector. Transmission samples were prepared by flattening them in a diamond compression cell, removing the top diamond window, and analyzing the thin film in transmission mode on the bottom diamond window. ATR spectra were taken on cross-section samples embedded in Bio-plastic embedding medium (Ward's Science) and polished using Micro Mesh sheets (Scientific Instru-

ment Services). The spectra are an average of 64 or 128 scans at 4 cm⁻¹ spectral resolution. An ATR correction was automatically applied by the Opus 7.0 instrument control and data collection software (Bruker). Sample identification was aided by searching a spectral library of common conservation and artists' materials (Infrared and Raman Users Group, www.irug.org).

MMA: FTIR analysis was performed with a Hyperion 3000 FTIR spectrometer equipped with a mercury cadmium telluride (MCT) detector. Each sample was crushed in a Spectra Tech diamond anvil cell and analyzed through a 15× objective in transmission mode. Spectra were collected at a resolution of 4 cm⁻¹ and obtained as the sum of 128 or 256 scans, depending on the response of the various samples. Spectra were interpreted by comparison with library data bases and published literature.

Raman Spectroscopy

MFAH: Dispersive Raman spectra were collected on an InVia Raman microscope (Renishaw) using a 785 nm excitation laser operating at a power of 75 to 782 µW at the sample as measured using a PM100D laser power meter (Thorlabs) equipped with a S120C photodiode power sensor. A 50× objective was used to focus the excitation beam on the sample supported on a glass microscope slide. The resulting Raman spectra are the average of 1 to 5 scans of 10 sec duration. Spectral resolution was 3-5 cm⁻¹ across the spectral range analyzed. Sample identification was achieved by comparison of the unknown spectrum to spectra of reference materials, the KIK/IRPA Raman reference library (Fremout and Saverwyns 2012), and those published in the literature.

MMA: Raman spectroscopy measurements were done in sample cross-sections and sample scrapings and in situ in selected paint passages using a Renishaw System 1000 coupled to a Leica DM LM microscope. All the spectra were acquired using a 785 nm laser excitation focused on the samples using a 50× objective lens and a 20× long working distance objective when working in situ, with integration times between 10 and 120 s. A 1200 lines/mm grating was used, and powers at the sample were set between 0.5 and 5 mW using neutral density filters. Identification of the materials was done by comparing their spectra to published data.

Scanning Electron Microscopy with Energy Dispersive X-Ray Spectroscopy (SEM-EDS)

MFAH: Backscatter electron images of the uncoated cross-section samples were taken with a JEOL JSM-IT100 SEM running under low vacuum mode with a pressure of 50–55 Pa and a probe current of 40–50. EDS analysis using the integrated detector was performed under the same pressure conditions but with higher probe currents (65–75) to increase the counts.

MMA: Analyses were performed on carbon-coated cross sections using an FE-SEM Zeiss Σigma HD, equipped with an Oxford Instrument X-MaxN 80 SDD detector. Backscattered electron (BSE) images, energy dispersive spectroscopy (EDS) analysis, and X-ray mapping were carried out with an accelerating voltage of 20 kV in high vacuum. The SEM-EDS analyses in the MMA's paintings were carried out by Federico Carò, research scientist in the Department of Scientific Research.

Gas Chromatography–Mass Spectrometry (GC-MS)

MFAH: The samples (approx. 300 µg) were weighed and placed into glass vials and 100 µL of Meth-Prep II (0.2 N methanolic solution of m-trifluoromethylphenyl trimethylammonium hydroxide) (Alltech in toluene 1:2) was added. The vials were warmed on a hotplate at 60°C for one hr. After cooling, the vials were centrifuged, and 1 µL of the solution injected via a 7673 Agilent autosampler into an Agilent 6890 GC coupled to a 5973 mass spectrometer. A splitless injection was used and the injector set to 300°C. A 25 m × 0.2 mm × 0.2 µm DB-5HT column (J&W) was used for separation, and the He carrier gas was set to a flow rate of 1 mL/min with a 1 min solvent delay. The GC oven temperature program was 80°C for 2 min, ramped at 10°C/min to 340°C, an isothermal hold at 340°C for 5 min, a ramp at 20°C/min to 360°C, followed by an isothermal hold of 5 min. The MS transfer line was at 320°C, and the source at 230°C, and the MS quadrupole at 150°C. The mass spectrometer was scanned from 45 to 550 amu at a rate of 2.59 scans per sec. The electron multiplier was set to the autotune value. Fatty acids were quantified with calibration curves created from standard solutions of pure fatty acids.

Pyrolysis/Gas Chromatography–Mass Spectrometry (Py/GC-MS)

MFAH: 3–5 µg samples were placed into a 50 µL stainless steel Eco-cup (Frontier Laboratories) and 3 µL of a 25% methanolic solution of tetramethylammonium hydroxide (TMAH) was introduced for derivatization (Heginbotham and Schilling 2011). After 3 min an Eco-stick (Frontier Laboratories) was fitted into the cup, and the cup was placed into the pyrolysis interface of a Frontier Lab Py-2020D double-shot pyrolyzer where it was purged with helium (He) for 3 min. Samples were pyrolyzed using a single-shot method at 550°C for 6 sec and then passed to an Agilent 7890A GC coupled to a 5975C mass spectrometer via a Frontier vent-free GC-MS adapter. The split injector was set to 320°C with a 50:1 split ratio and no solvent delay. A 40 m × 0.25 mm × 0.25 µm DB-5MS UI column (J&W) was used for separation, and the He carrier gas was set to a flow rate of 1 mL/min. The GC oven temperature program was 40°C for 2 min, ramped to 320°C at 6°C/min, followed by a 9 min isothermal period. The MS transfer line was at 320°C, the source at 230°C, and the MS quadrupole at 150°C. The mass spectrometer was scanned from 10 to 600 amu at a rate of 2.59 scans per sec. The electron multiplier was set to the autotune value.

MMA: Analysis was conducted on an Agilent 6890N gas chromatograph equipped with a Frontier PY-2020iD Double-Shot vertical furnace pyrolyzer fitted with an AS-1020E Auto-Shot autosampler. The GC was coupled to a 5973N single quadrupole mass selective detector (MSD). Samples of 30–50 µg were weighed out in deactivated pyrolysis sample cups (PY1-EC80F Disposable Eco-Cup LF) on a Mettler Toledo UMX2 Ultra microbalance. Samples were then either pyrolyzed without derivatization or derivatized with TMAH before pyrolysis. Derivatization took place in the same cups as follows: 3–4 µL of 25% TMAH in methanol (Fisher Scientific), depending on the sample size, were added directly to the sample in each cup with a 50 µL syringe and, after 1 min, loaded into the autosampler. The interface to the GC was held at 320°C and purged with helium for 30 sec before opening the valve to the GC column. The samples were then dropped into the furnace and pyrolyzed at 550°C for 30 sec. The pyrolysis products were transferred directly to a DB-5MS capillary column (30 m × 0.25 mm × 1 µm) with the helium carrier gas set to a constant linear velocity of 1.5 mL/min. Injection with a 30:1 split was used, in accordance with the sample size. The GC oven temperature program was 40°C for 1 min; 10°C/min to 320°C; isothermal for 1 min. The Agilent 5973N MSD conditions were set as follows: transfer line at 320°C, MS Quad 150°C, MS Source 230°C, electron multiplier at approximately 1770 V; scan range 33–550 amu. For samples run with TMAH, the detector was turned off until 3 min to avoid saturation by excess of derivatizing agent and solvent. Data analysis was performed on Agilent MSD ChemStationD.02.00.275 software by comparison with the NIST 2005 spectral libraries.

Analytical Results

Corina E. Rogge, Silvia A. Centeno, and Julie Arslanoglu

TABLE 1 Pigments and fillers in paintings, including both grounds and pictorial layers, as suggested by XRF and/or SEM-EDS

Title	Year	Accession No.	Lead White	Titanium White	Zinc White	Barium Sulfate	Lithopone	Calcium Carbonate	Calcium Magnesium Carbonate	Calcium Sulfate[a]	Cadmium Red	Vermilion	Red Ochre	PR90	Lead Chromate	Cadmium Yellow	Zinc Yellow	Hansa Yellow 10G[b]	Chromium Oxide Greens[c]	Phthalo green	Phthalo blue	Prussian Blue	Ultramarine	Cobalt Blue	Cerulean Blue	Manganese Violet	Umber	Bone/Ivory Black	Mars Black	Carbonaceous Black
Apache Dancer	1940	NGA 2014.145.1			•	•				•			•		?	•	?		•			?	•					•	•	
Dancer in a Red Skirt	1940	NGA 2014.145.4			•	•				•				?	•	•	•		•		?	?	?	•				•	•	
Nijinsky[d]	1940	MMA 1986.406.2	•		•			•	•	?	•		•			•			•				•						•	
Palmerton, Pa.	1941	SAAM 1980.52	•		•	•				•			•		?	•	?		•			?	?						•	
Woman in a Rocker[d]	ca. 1945	MMA 1998.446.2		•	•			•	•		•	•				•				?	?	•		•					•	
Vase of Flowers[d]	ca. 1945	MMA 1998.446.1		•				•	•	•																			•	
Kitzker	ca. 1946	MMA 1998.446.3			•						•					•				•	?	?		•	•				•	
Untitled	1946	Guggenheim 81.2873	•	•						•			•		•	•	?		•	?	•	•	•	•		•			•	?
Untitled	1948	Guggenheim 79.2615		•	?	•	?	•	•	?			•		•	•													•	
Untitled	1948	Guggenheim 79.2625	•	•	?	•		•	•																				•	
Untitled	n.d.	Guggenheim 79.2616	•	•	•	•	?																						•	
Untitled	ca. 1948	Guggenheim 79.2624	•	•	•			•		•						•	•							•		•	•		•	
Untitled (Study for Wotan)	1950	MFAH 96.848	•	•	•	•				•														•					•	• (ink)
Wotan	1950	MFAH 80.120	•	•	•	•		?		•																			•	
High Street	1950	Harvard 1971.121	•	•	•	•				•																			•	
Chief	1950	MoMA 2.1952	•	•	•			•		•																			•	
Nijinsky[d]	1950	MMA 2006.32.28	•	•	•		•				•	•							•										•	
Painting	1952	ARTIC 1984.521	•	•	•			•		?																			•	
Painting No. 7	1952	Guggenheim 54.1403	•	•	•			•		•																			•	
Untitled	1952	Guggenheim 80.2740	•	•	•					?	•	•							?										•	
Four Square	1956	NGA 1971.87.12	•	•	•			•		•																			•	
Mahoning	1956	Whitney 57.10	•	•	•					?	?		•																•	
Red Brass	1959	MFAH 2004.28	•	•	•	•					•	•			•	•	•				•			•			?			•
Orange & Black Wall	1959	MFAH 2004.27	•	•	•						•	•				•	•				•			•		•		•	•	
Untitled	ca. 1959	SAAM 1971.259	•	•	•						•					•	•	?		•		•	•	•	•					•
Blueberry Eyes	1959–60	SAAM 1982.57		•	•	•		?		?	•	•			?	•	?					•	•	•	•				•	
Corinthian II	1961	MFAH 2004.26	•	•	•	•				•																			•	
Merce C	1961	SAAM 1969.47.64	•	•	•	•																							•	
Untitled	1961	SAAM 1980.5.1	•	•	•	•				?																			•	

[a] XRF and SEM-EDS cannot distinguish among different forms of calcium sulfate: gypsum, $CaSO_4 \cdot 2H_2O$; the hemihydrate, $CaSO_4 \cdot H_2O$; and anhydrite, $CaSO_4$.

[b] Based on the detection of chlorine.

[c] Green chromium oxide pigments include viridian (hydrated chromium oxide, $Cr_2O_3 \cdot 2H_2O$) and chromium oxide (Cr_2O_3). The techniques used cannot distinguish between these species.

[d] The SEM-EDS analyses were done by Federico Carò, research scientist, Department of Scientific Research, Metropolitan Museum of Art.

TABLE 2 Pigments and fillers in grounds and pictorial layers identified by FTIR and/or Raman spectroscopy

Title	Year	Accession no.	Lead white	Anatase	Anatase co-precip	Rutile	Rutile co-precip	Zinc white[a]	Barium sulfate and/or lithopone[b]	Calcium carbonate	Calcium magnesium carbonate	Calcium sulfate anhydrite	Calcium sulfate dihydrate	Kaolinite or halloysite	Talc	Vermilion	Red ochre	PR81	PR4	PR3	Lead chromate	Zinc yellow	Viridian	Phthalo green	Phthalo blue	Prussian blue	Ultramarine	Cobalt blue	Manganese violet	Carbonaceous blacks[d]	Bone or ivory black[d]	Mars black	
Dancer in a Red Skirt	1940	NGA 2014.145.4						•*	•						•													•					•
Nijinsky	1940	MMA 1986.406.2							•	•																			•				
Palmerton, Pa.	1941	SAAM 1980.52	•					•*	•																				•				•
Woman in a Rocker	ca. 1945	MMA 1998.446.2		•					•	•															•								
Vase of Flowers	ca. 1945	MMA 1998.446.1		•					•	•			•												•								
Kitzker	ca. 1946	MMA 1998.446.3							•	•															•	•							
Untitled	1946	Guggenheim 81.2873	•		•			•*	•	•			•	?									•	•			•				?		
Untitled	1948	Guggenheim 79.2615				•		•*	•	•	•	•	•				•					•		•	•								
Untitled	1948	Guggenheim 79.2625						•*	•	•			•	•	•																	•	
Untitled	n.d.	Guggenheim 79.2616	•			•		•*	•				•								•			•									
Untitled	ca. 1948	Guggenheim 79.2624		•		•	•	•*	•				•	•	•								•	•		•							
Untitled (Study for Wotan)	1950	MFAH 96.848		•		•			•	?			•																				
Wotan	1950	MFAH 80.120	•	•	?	•	?	•*	•	•			•																			•	
High Street	1950	Harvard 1971.121	•			•		•	•	•			•																			•	
Chief	1950	MoMA 2.1952	•			•		•*		•			•																			•	
Nijinsky	1950	MMA 2006.32.28	•			•	•			•	•		•		•			•				•		•					•				
Painting	1952	ARTIC 1984.521	•	•				•*	•	•			•								•											•	
Painting No. 7	1952	Guggenheim 54.1403	•			•		•*	•	•			•																			•	
Four Square	1956	NGA 1971.87.12	•			•			•	•			•																			•	
Orange and Black Wall	1959	MFAH 2004.27	•		•			•*	•				•			•		•			•			•	•	•	•	•		•		•	
Red Brass	1959	MFAH 2004.28	•		•			•*	•	•			•	•		•	•					•		•			•	•		•			
Untitled	ca. 1959	SAAM 1971.259	•		?		?	•*	•				•									•		?	•		•					•	
Corinthian II	1961	MFAH 2004.26	•			•	•	•*	•				•																				

[a] Zinc white has no characteristic absorptions within the wavenumber range limits of the FTIR spectrometers used. It does display Raman shift peaks, but as it is a poor scatter it can be difficult to detect. However, zinc oxide reacts with oil binding media to form zinc soaps. In particular zinc stearate and zinc palmitate have very characteristic FTIR absorbances (Robinet and Corbeil 2003; Hermans et al. 2015), and detection of these species can be used as an indicator for the presence of zinc white. Instances where the presence of zinc oxide has been inferred from the detection of zinc soaps are indicated with an *.

[b] Barium sulfate can occur both on its own and in lithopone, a mixture of barium sulfate and zinc sulfide. Raman and FTIR spectroscopy cannot easily distinguish between these materials.

[c] Raman spectroscopy performed in situ on selected paint passages.

[d] Carbonaceous blacks and bone and ivory black all contain amorphous carbon that display broad Raman peaks at around 1590 and 1325 cm⁻¹, which are due to sp² and sp³ hybridized carbons, respectively. Bone and ivory black also contain PO_4^{3-}, a species that displays a weak Raman band at ca. 961 cm⁻¹. This signal, however, is often below the detection limits of the instrument and Raman analysis can often not distinguish carbonaceous blacks from bone or ivory black. The detection of the characteristic C–N stretching peak at ca. 2012 cm⁻¹ in a FTIR spectrum unequivocally identifies the presence of bone or ivory black.

TABLE 3 Binding media of pictorial layers and sizing of grounds as identified by FTIR

Title	Year	Accession No.	Glue Sizing	Drying Oil	Alkyd
Dancer in Red	1940	NGA 2014.145.4	?	•	
Palmerton, Pa.	1941	SAAM 1980.52	•	•	
Untitled	1946	Guggenheim 81.2873	•	•	
Untitled	1948	Guggenheim 79.2615	a	•	
Untitled	1948	Guggenheim 79.2625		•	•
Untitled	n.d.	Guggenheim 79.2616		•	
Untitled	ca. 1948	Guggenheim 79.2624	•	•	
Untitled (Study for Wotan)	1950	MFAH 96.848		•	
Wotan	1950	MFAH 80.120	•	•	
High Street	1950	Harvard 1971.121	•	•	
Painting	1952	ARTIC 1984.521	•	•	
Painting No. 7	1952	Guggenheim 54.1403	•	•	
Four Square	1956	NGA 1971.87.12	•	•	
Orange and Black Wall	1959	MFAH 2004.27	•	•	
Red Brass	1959	MFAH 2004.28	•	•	
Untitled	ca. 1959	SAAM 1971.259		•	
Corinthian II	1961	MFAH 2004.26	•	•	

a Not analyzed.

TABLE 4 Binding media in grounds and pictorial layers identified by GC-MS and Py/GC-MS. The complicated layering structure and small sizes of samples available mean that multiple paint layers are often coanalyzed.

Title	Year	Accession No.	Sample Description	Glue Sizing	12-Hydroxystearate	Colophony	Shellac	Drying Oil	Additional Notes
Circus Rider	1940	NGA 2014.145.3	s3, ground and green			•		•	P/S = 2.4, possibly fish oil (myristic acid [14:0] to palmitic acid [16:0] ratio = 0.14), dammar, dimethyl phthalate (Ph) to azelaic acid (Az) ratio = 1.45, so possible some alkyd is present
Dancer in a Red Skirt	1940	NGA 2014.145.4	s2, ground and green			•		•	P/S = 2.31, possibly fish oil (14:0/16:0 = 0.14), dammar, Ph/Az = 1.45, so possible some alkyd is present
Woman in a Rocker	ca. 1945	MMA 1998.446.2	s3, blue-green			•		•	P/S = 1.6, possible presence of fish oil (presence of C14:0, C17:0, C22:0, no C15:0)
			s4, blue-green					•	P/S = 1.6, possible addition of fish oil (presence of C14:0, C15:0, C17:0 and C22:0), trace of diethyl phthalate (Ph/Az is nearly 0, so unlikely an alkyd)
Vase of Flowers	ca. 1945	MMA 1998.446.1	s1, frame white					•	P/S = 2.5, possibly walnut oil
			s2, painting white					•	P/S = 2.4, possibly walnut oil
			s4, cream			•		•	P/S = 1.3, likely linseed oil, trace of alkyd (Ph/Az = 0.3)
			s5, blue-green			•		•	P/S = 1.7, alkyd also present (Ph/Az = 6.5)
Kitzker	ca. 1946	MMA 1998.446.3	s3, blue-green					•	P/S = 1.3, possible presence of safflower oil (24:0), possible presence of fish oil (presence of C14:0, C15:0, C17:0 and C22:0), presence of diethyl phthalate and trace of dibutyl phthalate (Ph/Az is nearly 0 so unlikely an alkyd)
			s4, blue			•		•	P/S = 2.4, possible presence of fish oil (presence of C14:0, C15:0, C17:0 and C22:0); presence of diethyl phthalate (Ph/Az is nearly 0 so unlikely an alkyd)

Title	Year	Accession No.	Sample Description	Glue Sizing	12-Hydroxystearate	Colophony	Shellac	Drying Oil	Additional Notes
Untitled	1946	Guggenheim 81.2873	s1, multiple layers			•		•	P/S = 1.2, may contain safflower oil (elevated levels of eicosanoic acid (20:0) and docosanoic acid (22:0), Ph/Az = 0.03
			s5, white and ground			•		•	P/S = 1.0, may contain safflower oil, Ph/Az = 0.09
Untitled	1948	Guggenheim, 79.2615	s5, multiple layers			•		•	P/S = 1.0, high levels of colophony, may contain safflower and fish oil (14:0/16:0 =0.14), Ph/Az = 0.2
Untitled	1948	Guggenheim, 79.2625	s1, multiple layers			•		•	P/S = 1.3, may contain safflower and possibly fish oil (14:0/16:0 = 0.12), Ph/Az = 0.6
Untitled	ca. 1948	Guggenheim 79.2624	s4, multiple layers			•		•	P/S = 1.1, high levels of colophony, may contain safflower oil and fish oil (14:0/16:0 = 0.10), Ph/Az = 0.1
Untitled	n.d.	Guggenheim 79.2616	s4, orange, white			•		•	P/S = 1.2, may contain safflower and fish oils (14:0/16:0 = 0.11), Ph/Az = 0.07
Wotan	1950	MFAH 80.120	s18, black and white		•	•		•	P/S = 1.8, Ph/Az = 0.1
			s23, whites			•		•	P/S =1.5, may contain safflower and fish oils (14:0/16:0 = 0.12), Ph/Az = 0.1
			s24, whites	•		•		•	P/S = 1.6, may contain safflower and fish oils (14:0/16:0 = 0.1), Ph/Az = 0.2
			s25, white and black		•	•	•	•	P/S = 1.6, may contain safflower oil, Ph/Az = 0.1
Nijinsky	1950	MMA 2006.32.28	s7, white and red			•		•	P/S=1.4, a small amount of Phthalic acid, di(3, 4-dimethylphenyl) ester (Ph/Az nearly 0 so unlikely an alkyd); possible presence of fish oil (high levels of C14:0 and C22:0 but no detectable C15:0, C17:0 and C19:0)
High Street	1950	Harvard 1971.121	s1, grounds			•		•	P/S = 2.0, may contain fish oil (14:0/16:0 = 0.11), Ph/Az = 0.04
			s2, black, grounds			•		•	P/S = 1.7, Ph/Az = 0.05
			s4, black					•	P/S = 1.5, may contain safflower and fish oil (14:0/16:0 = 0.57)
			s5, white and gray			•		•	P/S = 1.6, may contain fish oil (14:0/16:0 = 0.11), Ph/Az = 0.03
			s6, white and gray			•		•	P/S = 1.6, may contain fish oil (14:0/16:0 = 0.14), Ph/Az = 0.06
			s9, white and ground			•		•	P/S = 1.9, may contain fish oil (14:0/16:0 = 0.16) Ph/Az = 0.04
Chief	1950	MoMA 2.1952	s1, grounds			•		•	P/S = 2.7, wax contamination from treatment, Ph/Az = 0.01
			s2, white			•		•	P/S = 2.4, wax contamination from treatment, may contain safflower and fish oil (14:0/16:0 = 0.27), Ph/Az = 0.05
			s3, white			•		•	P/S = 3.5, wax contamination from treatment, may contain safflower and fish oil (14:0/16:0 = 0.23), Ph/Az = 0.08
			s4, black			•		•	P/S = 1.4, wax contamination from treatment, may contain safflower and fish oil (14:0/16:0 = 0.22), Ph/Az = 0.02
			s5, gray and white			•		•	P/S = 3.9, possible safflower oil, wax contamination from treatment, dammar, Ph/Az = 0.03
			s6, black and gray			•		•	P/S = 1.9, wax contamination from treatment, dammar, Ph/Az = 0.04
			s7, white			•		•	P/S = 1.9, contamination with wax from treatment, Ph/Az = 0.08
			s8, black and white			•		•	P/S = 2.1, alkyd may be present, Ph/Az = 3, contamination with wax from treatment, may contain fish oil (14:0/16:0 = 0.11)

Title	Year	Accession No.	Sample Description	Glue Sizing	12-Hydroxystearate	Colophony	Shellac	Drying Oil	Additional Notes
Painting	1952	ARTIC 1984.521	s1, grounds			•		•	P/S = 1.4, contamination with wax from treatment, Ph/Az = 0.03
			s3, whites			•		•	P/S = 1.3, contamination with wax from treatment, Ph/Az = 0.04
			s4, whites			•		•	P/S = 1.6, contamination with wax from treatment, may contain fish oil (14:0/16:0 = 0.19), Ph/Az = 0.07
			s5, whites			•		•	P/S = 1.8, contamination with wax from treatment, Ph/Az = 0.09
Painting No. 7	1952	Guggenheim 54.1403	s4, white			•		•	P/S = 1.1, may contain safflower and fish oils (14:0/16:0 = 0.12), Ph/Az = 0.12
Four Square	1956	NGA 1971.87.12	s1, grounds					•	P/S = 1.8, Ph/Az = 0.04
			s2, black, grounds			•		•	P/S = 1.5, Ph/Az = 0.12
			s3, white, grounds			•		•	P/S = 1.8, Ph/Az = 0.05
			s4, varnish						Mastic as indicated by methyl eichlerianate, ursonic acid methyl ester, 11-oxo-oleanonic acid, and 3-oxo-olean-18-en-28-oic acid (moronic acid)
Orange and Black Wall	1959	MFAH 2004.27	s7, orange		•			•	P/S = 1.0, Ph/Az = 0.08
			s9, yellow		•			•	P/S = 1.3, safflower oil may be present, Ph/Az = 0.03
			s12, blue					•	P/S = 0.7, Ph/Az = 0.2, contamination with wax from treatment
			s14, pink		•			•	P/S = 0.6, Ph/Az = 0.1
			s17, white and orange		•	•		•	P/S = 1.2, Ph/Az = 0.08
			s18, white and purple		•	•		•	P/S = 0.9, Ph/Az = 0.04
			s19, grounds	•		•		•	P/S = 1.1, Ph/Az = 0.03
Red Brass	1959	MFAH 2004.28	s1, grounds	•		•		•	P/S = 1.5, Ph/Az = 0.04
			s2, white					•	P/S = 1.5, Ph/Az = 0.09
			s5, black					•	P/S = 1.2, Ph/Az = 0.3
			s6, red					•	P/S = 1.1, Ph/Az = 0.1
			s8, purple			•		•	P/S = 1.1, Ph/Az = 0.2
			s18 , blue			•		•	P/S = 1.0, Ph/Az = 0.4
Untitled	ca. 1959	SAAM 1971.259	s1, yellow			•		•	P/S = 1.5, may contain safflower and fish oils (14:0/16:0 = 0.14), contamination with wax from treatment, Ph/Az = 0.02
			s2, black and red			•		•	P/S = 1.1, may contain safflower oil, contamination with wax from treatment, Ph/Az = 0.15
			s4, blue and yellow			•		•	P/S = 1.7, may contain safflower and fish oils (14:0/16:0 = 0.12), contamination with wax from treatment, Ph/Az = 0.37
Corinthian II	1961	MFAH 2004.26	s4, black		•			•	P/S = 1.2, Ph/Az = 0.02
			s5, grounds	•		•		•	P/S = 1.2, Ph/Az = 0.02
			s6, white		•			•	P/S = 1.2, Ph/Az = 0.03, castor oil present
Merce C	1961	SAAM 1969.47.64	s1, black, grounds		•			•	P/S = 1.4, Ph/Az = 0.02
			s2, whites		•			•	P/S = 1.7, may contain safflower and fish oils (14:0/16:0 = 0.12), Ph/Az = 0.02

TABLE 5 Inorganic composition of grounds suggested by SEM-EDS

Title	Year	Accession No.	Lower Ground	Upper Ground (if present)
Nijinsky	1940	MMA 1986.406.2	lithopone, $CaCO_3$, traces of lead white (analyzed as scraping, unclear how many layers present)	
Woman in a Rocker	ca. 1945	MMA 1998.446.2	lithopone, magnesium silicates (possible talc), traces of anatase and lead	
Untitled	1946	Guggenheim 81.2873	lead white, lithopone	$CaCO_3$, silicates, titanium white, lithopone
Vase of Flowers	ca. 1945	MMA 1998.446.1	titanium white, $CaSO_4$, $CaCO_3$, small amounts of Ba and Zn in unknown form	
Untitled	1948	Guggenheim 79.2625	aluminosilicates	lithopone, $CaCO_3$
Untitled	n.d.	Guggenheim 79.2616	titanium white, $CaSO_4$, $CaCO_3$	lead white
Untitled	ca. 1948	Guggenheim 79.2624	titanium white, $CaSO_4$	
Wotan	1950	MFAH 80.120	$BaSO_4$, zinc white, silicates	lead white
High Street	1950	Harvard 1971.121	$BaSO_4$, zinc white, silicates	lead white
Chief	1950	MoMA 2.1952	$BaSO_4$, zinc white, $CaCO_3$	lead white
Nijinsky	1950	MMA 2006.32.28	lithopone, lead white	
Painting	1952	ARTIC 1984.521	zinc white, $CaCO_3$, silicates	lead white, zinc white
Painting No. 7	1952	Guggenheim 54.1403	$BaSO_4$, zinc white, silicates	lead white, zinc white, $BaSO_4$
Four Square	1956	NGA 1971.87.12	$CaCO_3$, silicates, zinc white	lead white
Orange and Black Wall	1959	MFAH 2004.27	zinc white	lead white
Red Brass	1959	MFAH 2004.28	zinc white	lead white
Corinthian II	1961	MFAH 2004.26	zinc white, silicates	lead white, rutile, $BaSO_4$
Merce C	1961	SAAM 1969.47.64	zinc white	lead white, rutile, $BaSO_4$

Appendix III

Works of Art Examined

Artworks marked with an asterisk (*) were subject to scientific analysis. The results are reported in Appendix II, Tables 1–5.

Untitled, n.d.*
Oil on Masonite
67.3 × 77.2 cm (26½ × 30⅜ in.)
Solomon R. Guggenheim Museum,
New York
Gift of Fred Goldin, 1979
79.2616

Nude Figure Studies, 1936
Pen and brown ink on wove paper
38.42 × 25.4 cm (15⅛ × 10 in.)
National Gallery of Art, Washington, DC
Gift of Rufus Zogbaum and Reina Schratter
2016.60.3

Nijinsky, 1940*
Oil on canvas
56.5 × 46.4 cm (22¼ × 18¼ in.)
The Metropolitan Museum of Art, New York
Gift of Theodore J. Edlich Jr., 1986
1986.406.2

Apache Dancer
(Bleecker Street Tavern mural), 1940*
Oil on canvas board
116.84 × 116.84 cm (46 × 46 in.)
National Gallery of Art, Washington, DC
Woodner Collection, Gift of Dian Woodner
2014.145.1

Bubble Dancer
(Bleecker Street Tavern mural), 1940
Oil on canvas board
115.57 × 115.57 cm (45½ × 45½ in.)
National Gallery of Art, Washington, DC
Woodner Collection, Gift of Dian Woodner
2014.145.2

Circus Rider
(Bleecker Street Tavern mural), 1940*
Oil on canvas board
114.3 × 114.3 cm (45 × 45 in.)
National Gallery of Art, Washington, DC
Woodner Collection, Gift of Dian Woodner
2014.145.3

Dancer in a Red Skirt (Fiesta)
(Bleecker Street Tavern mural), 1940*
Oil on canvas board
115.57 × 115.57 cm (45½ × 45½ in.)
National Gallery of Art, Washington, DC
Woodner Collection, Gift of Dian Woodner
2014.145.4

Self Portrait, ca. 1940
Brush and black ink over graphite
on wove paper
25.08 × 22.54 cm (9⅞ × 8⅞ in.)
National Gallery of Art, Washington, DC
Gift of Rufus Zogbaum and Reina Schratter
2016.60.30

Palmerton, Pa., 1941*
Oil on canvas
53.5 × 69 cm (21 × 27⅛ in.)
Smithsonian American Art Museum,
Washington, DC
Museum Purchase
1980.52

Seated Woman, ca. 1942
Pen and black ink on wove paper
22.54 × 30.16 cm (8⅞ × 11⅞ in.)
National Gallery of Art, Washington, DC
Gift of Rufus Zogbaum and Reina Schratter
2016.60.32.a

Woman in a Rocker, 1942
Pen and black ink on laid paper
16.19 × 12.38 cm (6⅜ × 4⅞ in.)
National Gallery of Art, Washington, DC
Gift of Rufus Zogbaum and Reina Schratter
2016.60.2.a

Reclining Nude, 1944
Graphite on laid paper
22.86 × 29.21 cm (9 × 11½ in.)
National Gallery of Art, Washington, DC
Gift of Rufus Zogbaum and Reina Schratter
2016.60.28

Seated Woman Doing Handwork, 1945
Graphite on coated paper mounted to
paperboard
22.86 × 24.13 cm (9 × 9½ in.)
National Gallery of Art, Washington, DC
Gift of Rufus Zogbaum and Reina Schratter
2016.60.8

Woman in a Rocker, ca. 1945*
Oil on canvas
40.6 × 35.6 cm (16 × 14 in.)
The Metropolitan Museum of Art, New York
Gift of Rufus F. Zogbaum, 1998
1998.446.2

Vase of Flowers, ca. 1945*
Oil, whitewash, and charcoal on cardboard
71.8 × 51.4 cm (28¼ × 20¼ in.)
The Metropolitan Museum of Art, New York
Gift of Rufus F. Zogbaum, 1998
1998.446.1

Figure Study, 1945/1948
Brush and black ink and graphite
on wove paper
15.4 × 12.7 cm (6¹⁄₁₆ × 5 in.)
National Gallery of Art, Washington, DC
Gift of Rufus F. Zogbaum
1998.113.19.a

Untitled, 1946*
Oil on canvas
61.3 × 76.2 cm (24⅛ × 30 in.)
Solomon R. Guggenheim Museum,
New York
Gift of Mr. and Mrs. Aron B. Katz, 1981
81.2873

Figure in a Rocker, 1946
Brush and black ink on wove paper
22.86 × 17.78 cm (9 × 7 in.)
National Gallery of Art, Washington, DC
Gift of Rufus Zogbaum and Reina Schratter
2016.60.4

Kitzker, ca. 1946*
Oil on canvas
48.3 × 68.6 cm (19 × 27 in.)
The Metropolitan Museum of Art, New York
Gift of Rufus F. Zogbaum, 1998
1998.446.3

Untitled, 1947
Brush and black ink on wove paper
43.3 × 67 cm (17¹⁄₁₆ × 26⅜ in.)
National Gallery of Art, Washington, DC
Gift of Edward R. Broida
2005.142.24.a

Studio Interior, 1947
Pen and black ink on wove paper
18.42 × 18.1 cm (7¼ × 7⅛ in.)
National Gallery of Art, Washington, DC
Gift of Rufus Zogbaum and Reina Schratter
2016.60.7

Figure at a Table, ca. 1947
Oil paint on paperboard
21.6 × 21.6 cm (8½ × 8½ in.)
National Gallery of Art, Washington, DC
Gift of Rufus F. Zogbaum
1998.113.10

Self Portrait, ca. 1947
Brush and brown ink on wove paper
25.08 × 20.32 cm (9⅞ × 8 in.)
National Gallery of Art, Washington, DC
Gift of Rufus Zogbaum and Reina Schratter
2016.60.6

Untitled, 1947/1950
Brush and black ink (applied recto & verso)
on tracing paper
45.7 × 53 cm (18 × 20⅞ in.)
National Gallery of Art, Washington, DC
Gift of Elisabeth Ross Zogbaum
1998.112.4

Untitled, 1948*
Oil on canvas
93.3 × 171.77 cm (36¾ × 67⅝ in.)
Solomon R. Guggenheim Museum,
New York
Gift of Fred Goldin, 1979
79.2615

Untitled, 1948*
Oil on canvas, mounted on Masonite
97.1 × 75 cm (38³⁄₁₆ × 29½ in.)
Solomon R. Guggenheim Museum,
New York
Gift of Alexander Abraham, 1979
79.2625

Untitled, ca. 1948*
Oil on canvas
96.5 × 80.9 cm (38 × 31⅞ in.)
Solomon R. Guggenheim Museum,
New York
Gift of Alexander Abraham, 1979
79.2624

Painted Newsprint, 1948–50
Oil on newspaper, mounted on gessoed
Masonite
76.2 × 101.6 cm (30 × 40 in.)
The Metropolitan Museum of Art, New York
Gift of Mr. and Mrs. William B. Jaffe, 1964
64.305

Two Studies of Standing Female Nude,
1940s–1950s
Brush and black ink on ledger paper
27.8 × 24 cm (10¹⁵⁄₁₆ × 9⁷⁄₁₆ in.)
National Gallery of Art, Washington, DC
Gift of Rufus F. Zogbaum
1998.113.17.a

Untitled, 1940s–1950s
Brush and brown and black ink
with oil paint on ledger paper
27.8 × 24 cm (10¹⁵⁄₁₆ × 9⁷⁄₁₆ in.)
National Gallery of Art, Washington, DC
Gift of Rufus F. Zogbaum
1998.113.17.b

Seated Female Nude, 1940s–1950s
Pen and black ink on wove paper
22 × 14.3 cm (8¹¹⁄₁₆ × 5⅝ in.)
National Gallery of Art, Washington, DC
Gift of Rufus F. Zogbaum
1998.113.25

Untitled, 1940s–1950s
Brush and black ink on wove paper
24.7 × 15.8 cm (9¾ × 6¼ in.)
National Gallery of Art, Washington, DC
Gift of Elisabeth Ross Zogbaum
1998.112.5

Nijinsky, 1950*
Oil on canvas
115.6 × 88.6 cm (45½ × 34⅞ in.)
The Metropolitan Museum of Art, New York
The Muriel Kallis Steinberg Newman
Collection, Gift of Muriel Kallis Newman,
2006
2006.32.28

Untitled (Study for Wotan), 1950*
Mixed media on paper
13.8 × 21.7 cm (5⁷⁄₁₆ × 8⁹⁄₁₆ in.)
The Museum of Fine Arts, Houston
Museum purchase funded by
the Caroline Wiess Law Accessions
Endowment Fund
96.848

Wotan, 1950*
Oil on canvas mounted on Masonite
139.7 × 201.5 cm (55 × 79⁵⁄₁₆ in.)
The Museum of Fine Arts, Houston
Museum purchase by exchange
80.120

Chief, 1950*
Oil on canvas
148.3 × 186.7 cm (58⅜ × 73½ in.)
Museum of Modern Art, New York
Gift of Mr. and Mrs. David M. Solinger
2.1952

High Street, 1950*
Oil on canvas
147.6 × 196.9 cm (58⅛ × 77½ in.)
Harvard Art Museums/Fogg Museum,
Cambridge, MA
Gift of Lois Orswell
1971.121

Untitled, ca. 1950–52
Ink on cut and pasted papers
12.1 × 9.8 cm (4¾ × 3⅞ in.)
The Metropolitan Museum of Art, New York
Gift of David and Renée McKee, 2002
2002.580

Untitled, 1950s
Oil and graphite on wove paper
58.8 × 67.5 cm (23⅛ × 26⁹⁄₁₆ in.)
National Gallery of Art, Washington, DC
Gift of Elisabeth Ross Zogbaum
2006.67.3

Untitled, 1952*
Oil on paper, mounted on canvas, mounted on aluminum honeycomb panel
81.3 × 111.8 cm (32 × 44 in.)
Solomon R. Guggenheim Museum, New York
Gift of The American Art Foundation, 1980
80.2740

Untitled, 1952
Enamel on canvas
135.6 × 172.7 cm (53⅜ × 68 in.)
The Metropolitan Museum of Art, New York
The Muriel Kallis Steinberg Newman Collection, Gift of Muriel Kallis Newman, 2006
2006.32.29

Painting No. 7, 1952*
Oil on canvas
146.1 × 207.6 cm (57½ × 81¾ in.)
Solomon R. Guggenheim Museum, New York

Painting, 1952*
Oil on canvas
195.6 × 254 cm (77 × 100 in.)
Art Institute of Chicago
Bequest of Sigmund E. Edelstone
1984.521

Untitled, 1955
Brush and black ink on wove paper
27.9 × 37.7 cm (11 × 14¹³⁄₁₆ in.)
National Gallery of Art, Washington, DC
Gift of Edward R. Broida
2005.142.25

Untitled, ca. 1955
Oil with paper collage on wove paper mounted to paperboard
31.3 × 23.1 cm (12⁵⁄₁₆ × 9⅛ in.)
National Gallery of Art, Washington, DC
Gift of Edward R. Broida
2005.142.26

Four Square, 1956*
Oil on canvas
199 × 128.9 cm (78⅜ × 50¾ in.)
National Gallery of Art, Washington, DC
Gift of Mr. and Mrs. Burton Tremaine
1971.87.12

Mahoning, 1956*
Oil and paper on canvas
204.2 × 255.3 cm (80⅜ × 100½ in.)
Whitney Museum of American Art, New York
Purchase with funds from the Friends of the Whitney Museum of American Art
57.10

Untitled, ca. 1956
Oil, ink, cut, torn, and pasted paper on paper
26 × 26 cm (10¼ × 10¼ in.)
The Metropolitan Museum of Art, New York
Gift of Renée and David McKee, 1984
1984.554.1

Untitled, ca. 1959
Oil on paper
61 × 48.3 cm (24 × 19 in.)
Smithsonian American Art Museum, Washington, DC
Museum purchase
1971.259

Red Brass, 1959*
Oil on canvas
173.4 × 99.3 cm (68¼ × 39⅛ in.)
The Museum of Fine Arts, Houston
Bequest of Caroline Wiess Law
2004.28

Orange and Black Wall, 1959*
Oil on canvas
169.5 × 367 cm (66¾ × 144½ in.)
The Museum of Fine Arts, Houston
Bequest of Caroline Wiess Law
2004.27

Black, White, and Gray, 1959
Oil on canvas
266.7 × 198.1 cm (105 × 78 in.)
The Metropolitan Museum of Art, New York
George A. Hearn Fund, 1959
59.165

Blueberry Eyes, 1959–60*
Oil on paperboard
101.9 × 75.6 cm (40⅛ × 29¾ in.)
Smithsonian American Art Museum, Washington, DC
Gift of the Woodward Foundation
1982.57

1960 New Year Wall, Night, 1960
Oil on soft fiberboard
305 × 488 cm (120 × 192 in.)
Pinakothek der Moderne, Munich, Bayerische Staatsgemäldesammlungen
GV 19

Untitled, 1961*
Oil on canvas
184.2 × 269.3 cm (72½ × 106 in.)
Smithsonian American Art Museum, Washington, DC
Museum purchase from the Vincent Melzac Collection through the Smithsonian Institution Collections Acquisition Program
1980.5.1

Merce C, 1961*
Oil on canvas
236.2 × 189.4 cm (93 × 74⅝ in.)
Smithsonian American Art Museum, Washington, DC
Gift of S. C. Johnson & Son, Inc.
1969.47.64

Corinthian II, 1961*
Oil on canvas
202.2 × 272.4 cm (79⅝ × 107¼ in.)
The Museum of Fine Arts, Houston
Bequest of Caroline Wiess Law
2004.26

Untitled, 1961
Oil on canvas
206.1 × 380.4 cm (81⅛ × 149¾ in.)
The Metropolitan Museum of Art, New York
Bequest of Andrea Bollt, 2012
2012.448.8

Study for "Flanders," 1961
Ink and oil on paper
22.9 × 18.1 cm (9 × 7⅛ in.)
The Metropolitan Museum of Art, New York
Gift of Renée and David McKee, 1984
1984.554.2

Notes

Chapter 1

1 See also box 4, folder 17, slide show script partial drafts (1 of 3), ca. 1977–89, image 69, Elisabeth Zogbaum papers regarding Franz Kline, 1892–ca. 2005, bulk 1930–90, Archives of American Art, Smithsonian Institution, Washington, DC [hereafter Zogbaum papers, AAA].

2 Box 4, folder 19, slide show script partial drafts (3 of 3) ca. 1977–ca. 1989, image 61, Zogbaum papers, AAA.

3 A copy of the letter to Witherbee can be found in folder 33, Correspondence 1929, 1935–59, images 1–2, Zogbaum papers, AAA.

4 Box 4, folder 29, notes on Franz Kline (6 of 9), ca. 1970–ca. 1990, image 36, Zogbaum papers, AAA.

5 Franz Kline, *Henry H*, 1959, oil on paper, dimensions and present location unknown, illustrated in Langsner 1962, 5; and *Henry H II*, 1959–60, oil on canvas, 201.9 × 152.4 cm (79½ × 60 in.), private collection.

6 Box 5, folder 4, Clippings, 1–3, Zogbaum papers, AAA.

Chapter 2

1 Box 6, folder 32, Franz Kline art album (2 of 4), ca. 1936–ca. 1946, images 17–18; box 6, folder 33, Franz Kline art album (3 of 4), ca. 1936–ca. 1946, image 3, Zogbaum papers, AAA.

2 See also box 4, folder 18, slide show script partial drafts (2 of 3) ca. 1977–ca. 1989, image 60; box 4, folder 24, notes on Franz Kline ca. 1970–90, image 6, Zogbaum papers, AAA.

3 Franz Kline, *Green Night* (1945), oil on canvas, approx. 51 × 61 cm (20 × 24 in.), private collection.

4 See also box 4, folder 14, slide show script drafts, 1976, p. 11; box 6, folder 33, Franz Kline Art Album (3 of 4), ca. 1936–ca. 1946, image 19, Zogbaum papers, AAA.

5 Box 4, folder 11, notes (1 of 2), ca. 1979–89, image 31, Zogbaum papers, AAA.

6 Box 1, folder 4, biographical outlines, ca. 1956–ca. 1998, image 20, Zogbaum papers, AAA.

7 Gaugh (1985b, 36) says that there were eight or nine paintings; Joselow (2004) and Zogbaum (box 1, folder 4, biographical outlines, ca. 1956–ca. 1998, image 20, Zogbaum papers, AAA) indicate that there were ten.

8 "Apache" (pronounced ah-PASH) was a type of dance associated with Parisian street culture. The name does not refer to the Native American tribe.

9 See also box 1, folder 4, biographical outlines, ca. 1956–ca. 1998, image 20, Zogbaum papers, AAA.

10 As Kline's wife and second partner were named Elizabeth and Elisabeth, respectively, this text refers to his wife using her first name, Elizabeth, and to his second partner using her last name, Zogbaum, in order to prevent confusion.

11 Box 1, folder 4, biographical outlines, ca. 1956–ca. 1998, image 20, Zogbaum papers, AAA.

12 The exhibition was titled *Franz Kline Bar Room Paintings, New York, The Collector's Gallery, February 6–25, 1961*. Box 1, folder 4, biographical outlines, ca. 1956–ca. 1998, image 20, Zogbaum papers, AAA.

13 The term "retail trade paint" refers to paints used in interior or exterior finishes, signs, or furniture. The term "industrial paint" is restricted to paints used in manufacturing, such as automotive paints or stoving enamels. These definitions were first proposed in Barclay 1992.

14 See also box 1, folder 4, biographical outlines, ca. 1956–ca. 1998, image 20, Zogbaum papers, AAA.

15 *Alla prima* (literally, "at first attempt") describes a painting technique in which the artist uses no preparatory drawings or underpainting. The paint is usually applied wet-in-wet, and such paintings are often completed in a single sitting.

16 Samples taken for scientific analysis are very small and barely visible to the naked eye, but as sampling is destructive it is not undertaken lightly. In order to minimize damage to the object, professional ethics mandate that samples be taken from areas of extant damage; therefore, a painting that has no damage will only be analyzed by nondestructive means.

17 Box 4, folder 17, slide show script partial drafts (1 of 3), ca. 1977–ca. 1989, image 25, Zogbaum papers, AAA.

18 E.g., Robert Henri (1865–1929), *Snow in New York* (1902), oil on canvas, 81.3 × 65.5 cm (32 × 25^{13}⁄₁₆ in.), NGA, Washington, DC, Chester Dale Collection, 1954.4.3.

19 The current whereabouts of the El Chico mural cycle are uncertain; Gaugh (1972, 97) suggests it may be owned by Gilbert Di Lucia of New York. *Lehighton* (1945), oil on canvas adhered to plaster, 190.5 × 421.64 cm (75 × 166 in.), Allentown Art Museum, PA, purchased through the Leigh Schadt and Edwin Schadt Art Museum Trust Fund, 2016, 2016.012.000.

20 The name of the institution, initially Manhattan State Hospital for the Insane, changed several times during its existence, first to Central Islip State Hospital and finally to Central Islip Psychiatric Center.

21 Elizabeth Kline was released from the psychiatric hospital in 1960 (Gaugh 1985b, 178). After Kline's death she wrote a letter to the editor of *ARTnews* (61, no. 9 [1963]: 6), in which she commented

on Elaine de Kooning's 1962 article. She also shared her recollections of her husband with interviewers.

22 See box 4, folder 17, slide show script partial drafts (1 of 3), ca. 1977–ca. 1989, image 57, Zogbaum papers, AAA.

23 Box 4, folder 3, excerpts of interview transcripts (1 of 3), ca. 1962–ca. 1979, image 5, Zogbaum papers, AAA.

24 Franz Kline, *Elizabeth* (1946), oil on canvas, 52.1 × 42.9 cm (20½ × 16⅞ in.), private collection.

25 Franz Kline, *The Dancer* (1946), oil on Masonite, 58 × 26 cm (22¾ × 10¼ in.), private collection.

26 Franz Kline, *Untitled* (1946), oil on canvas, 61.3 × 76.2 cm (24⅛ × 30 in.), Solomon R. Guggenheim Museum, New York, Gift of Mr. and Mrs. Aron B. Katz, 1981, 81.2873.

27 Franz Kline, *Self Portrait* (ca. 1945), oil on canvas, 27.3 × 17.9 cm (10¾ × 7 in.), Solomon R. Guggenheim Museum, New York, Gift of Mr. and Mrs. Leon A. Mnuchin, 1962, 62.1612.

Chapter 3

1 Hellstein is quoting from the William Chapin Seitz papers, box 19, folder 3, January 23, 1952, AAA.

2 Box 4, folder 3, excerpts of interview transcripts (1 of 3), ca. 1962–ca. 1979, interview with Joan Mitchell, September 28, 1971, image 30, Zogbaum papers, AAA.

3 Pablo Picasso, *Guernica* (1937), oil on canvas, 349.3 × 776.6 cm (137½ × 305¾ in.), Museo Nacional Centro de Arte Reina Sofía, Madrid, DE00050.

4 Jackson Pollock, *Number 26 A, Black and White* (1948), alkyd on canvas, 205 × 121.7 cm (80¹¹⁄₁₆ × 47¹⁵⁄₁₆ in.), Centre Pompidou, Paris, AM 1984-312.

5 Willem de Kooning, *Black Untitled* (1948), oil and enamel on paper, mounted on wood, 75.9 × 101.6 cm (29⅞ × 40 in.), MMA, from the Collection of Thomas B. Hess, Gift of the heirs of Thomas B. Hess, 1984, 1984.613.7; Willem de Kooning, *Painting* (1948), enamel and oil on canvas, 108.3 × 142.5 cm (42⅝ × 56⅛ in.), MoMA, 238.1948.

6 Cy Twombly, *MIN-OE* (1951), bitumen, oil-based house paint on canvas, 86.4 × 101.6 cm (34 × 40 in.), Robert Rauschenberg Foundation collection; and *Landscape* (1951), industrial paint and collage on wooden panel, 27.9 × 53.3 cm (11 × 21 in.), Collection Paine Webber Group Inc.

7 Willem de Kooning, *Black and White (Rome)* (1959), black enamel and collage on paper, 99.7 × 141.6 cm (39¼ × 55¾ in.), the Menil Collection, 2007-3.

8 Franz Kline, *Meryon* (1960–61), oil on canvas, 235.9 cm × 195.6 cm, Tate, T00926.

9 Franz Kline, *Collage* (1947), oil gouache and collage, 37.6 × 54.8 cm (14⅞ × 21⅝ in.), private collection; and *Untitled* (1947), oil on canvas, 68.6 × 53.3 cm (27⅛ × 21⅛ in.), private collection.

10 Box 4, folder 24, notes, ca. 1970–ca. 1990, image 18, Zogbaum papers, AAA.

11 Box 4, folder 3, excerpts of interview transcripts (1 of 3), ca. 1962–ca. 1979, image 15, interview with Marca-Relli, January 13, 1975, Zogbaum papers, AAA.

Chapter 4

1 See also box 4, folder 15, slide show script drafts, 1977, image 18, Zogbaum papers, AAA.

2 Box 4, folder 15, slide show script drafts, 1977, image 18, Zogbaum papers, AAA.

3 Kingsley (2000, 16) suggests that the exhibited drawing was actually a portrait, citing 1980s interviews with Grace Hartigan and Herman Somberg.

4 The Bell-Opticon experiment may have taken place in 1948 or 1949; de Kooning's accounts vary (Gaugh 1985b, 170).

5 Franz Kline, *Cardinal* (1950), oil on canvas, 203.2 × 147.3 cm (80 × 58 in.), private collection; illustrated in Gaugh 1985b, 92.

6 Franz Kline, *Wild Horses* (1950), oil on canvas, 66 × 95.25 cm (26 × 37½ in.), private collection; *Sketch for a Portrait of Sue Orr* (1950), oil on paper mounted on Masonite, 48.3 × 38.1 cm (19 × 15 in.), Provincetown Art Association and Museum, Gift of the Orr family in memory of Elizabeth Kline, 1375.

7 Franz Kline, *Leda* (1950), oil on canvas, 76.5 × 64 cm (30¼ × 26¾ in.), private collection.

8 Works not illustrated in this book: *Clockface* (1950), oil on canvas, 91.8 × 76.5 cm (36⅛ × 30⅛ in.), private collection; *The Drum* (1950), media and dimensions unknown (illustrated in Kingsley 2000, 401); *Hoboken* (1950), oil on canvas, 158.1 × 204.5 cm (61¼ × 80½ in.), private collection.

9 Franz Kline, *Untitled (Study for High Street)* (1950), ink on paper, 1950, 53.3 × 45.7 cm (21 × 18 in.), private collection; illustrated in Kingsley 2000, 416.

10 Franz Kline, *Sketch for Hoboken*, 1950, oil on board, 66.0 × 81.3 cm (26 × 32 in.), private collection; illustrated in Kingsley 2000, 412.

11 Franz Kline, *Study for Hoboken* (1950), ink on telephone book page, 22.9 × 27.9 cm (9 × 11 in.), private collection; *Study for Clockface* (1950), gouache on telephone book paper, 28.6 × 23.5 cm (11¼ × 9¼ in.), private collection. *Untitled (Study for Wotan)* is the only sketch in a museum collection and available for technical analysis. Photographic reproductions of the other sketches were examined.

12 Franz Kline, *Study for Cardinal*, 1950, ink on paper, 19.7 × 15.2 cm (7¾ × 6 in.), private collection; *Study for The Drum*, 1950, oil on paper, 27.6 × 21.6 cm (10⅞ × 8½ in.), private collection; *Study for Leda*, 1950, ink on paper, 24.8 × 18.4 cm (9¾ × 7¼ in.), private collection.

13 Box 4, folder 11, notes (1 of 2), ca. 1979–ca. 1989, image 16, Zogbaum papers, AAA.

14 *Chief* (1950) and *Nijinsky* (1950) also contain elevated levels of myristic acid, and *Chief* contains odd-numbered fatty acids, but these might arise from the wax-resin infusions present in these paintings, which prevent unambiguous identification of fish oil in the paint by GC-MS.

15 *Wotan* (1950) was never varnished, and although time may have altered the level of gloss, the surface is likely close to what Kline intended. *Nijinsky* (1950) had a nonoriginal overall varnish applied to it at some point in its history before it was acquired by the MMA, and although that varnish is now removed, Kline's matte and gloss areas may have been altered (see chap. 7).

16 "Enamel" is a nonspecific term in the conservation world. Paint makers usually use it to denote a glossy paint (in any binding media: oil, alkyd, latex, etc.), but that gloss can be achieved by different means.

17 Franz Kline, *Giselle* (1950), oil on canvas, 149.2 × 124.5 cm (58¾ × 49 in.), private collection.

18 The fate of *Wyoming* is unknown, and no illustrations of this work are known to exist.

19 Box 4, folder 15, slide show script details, 1977, p. 20, Zogbaum papers, AAA.

20 Franz Kline, *Double Kitzker* (ca. 1946), brush and ink on paper, 21.6 × 27.3 cm (8½ × 10¾ in.), Kline Estate.

21 David Orr helped support the show by giving Kline $300 (Gaugh 1985b, 88).

22 Box 1, folder 31, letters about *Bokubi*, p. 3, Zogbaum papers, AAA. Typewritten translation of the article on Kline by Sabro Hasegawa, *Bokubi* 1 (1951).

23 A photograph of *Wotan* was not included in this issue of *Bokubi*; it is the only painting from the 1950 Charles Egan Gallery show that is not illustrated. This exclusion suggests that the raking damage noted on *Wotan* (see chap. 7) could have occurred during or shortly after the show and that the painting was not restored at the time the works were photographed.

24 Box 4, folder 11, notes (1 of 2), ca. 1979–ca. 1989, image 38, Zogbaum papers, AAA.

25 The paintings were priced at approximately $700 and the sketches and studies at $50 to $100. In comparison, prices for the paintings at Willem de Kooning's first Charles Egan Gallery show in 1948 ranged from $300 to $1,200, suggesting Egan placed less monetary value on Kline's work or was setting low prices to increase sales; nothing from de Kooning's show had sold (Stevens and Swann 2004, 251).

26 Box 4, folder 24, notes, ca. 1979–ca. 1990, image 28, Zogbaum papers, AAA.

Chapter 5

1 Franz Kline, *Ninth Street* (1951), oil on canvas, 152.4 × 198.1 cm, private collection.

2 Franz Kline, *Painting No. 11* (1951), oil on canvas, 156 × 209 cm (61½ × 82¼ in.), private collection; *Ninth Street* (1951), oil on canvas, 152.4 × 198.1 cm (60 × 78 in.), private collection; *Untitled* (1951), oil on canvas, 64.8 × 106.7 cm (25¼ × 42 in.), Montana Historical Society, x1974.04.04.

3 Franz Kline, *Figure 8* (1952), oil on canvas, 205 × 161 cm (80⅞ × 63⅜ in.), Anderson Collection at Stanford University, Gift of Henry W. and Mary Margaret Anderson, and Mary Patricia Anderson Pence, 2014.1.028; *Untitled* (1951), oil on board, 101.6 × 76.2 cm (40 × 30 in.), private collection; *Untitled* (1952), enamel on canvas, 135.6 × 172.7 cm (53⅜ × 68 in.), MMA, The Muriel Kallis Steinberg Newman Collection, Gift of Muriel Kallis Newman, 2006, 2006.32.29; *Painting No. 3* (1952), oil on canvas, 152 × 183 cm (60 × 72 in.), private collection.

4 Franz Kline, *Yellow Square* (ca. 1951), oil on canvas mounted on Masonite, 164.5 × 200 cm (64¾ × 78¾ in.), private collection.

5 Given our findings, Kingsley's use of the term "double-sized" may mean that the canvases had a double ground.

6 Box 4, folder 4, excerpts of interview transcripts (2 of 3), ca. 1962–ca. 1979, image 15, interview with Piero Dorazio, 1972, Zogbaum papers, AAA.

7 Box 4, folder 3, excerpts of interview transcripts (1 of 3), ca. 1962–ca. 1979, image 12, interview with Conrad Marca-Relli, February 13, 1975, Zogbaum papers, AAA.

8 Box 4, folder 4, excerpts of interview transcripts (2 of 3), ca. 1962–ca. 1979, images 24–25, interview with Lutz Sanders, November 18, 1972, Zogbaum papers, AAA.

9 Franz Kline, *Scranton* (1960), oil on canvas, 177 × 124.5 cm (70 × 49 in.), Museum Ludwig Cologne; and *Elizabeth* (1958), oil on canvas, 170.2 × 182.9 cm (67 × 72 in.), private collection.

10 Franz Kline, *Untitled* (1961), oil on canvas, 206.1 × 380.4 cm (81⅛ × 149¾ in.), MMA, Bequest of Andrea Bollt, 2012.448.8.

11 Franz Kline, *Composition* (1953), oil on canvas, 73.5 × 78.6 cm (29¹³⁄₁₆ × 30¹⁵⁄₁₆ in.), Wadsworth Atheneum Museum of Art, Gift of Mr. and Mrs. Walter K. Gutman, 1955.543; *Red Crayon* (1959), oil on canvas, 90.2 × 81.3 cm (35.5 × 32 in.), Kalamazoo Institute of Arts; *Torches Mauve* (1960), oil on canvas, 305.1 × 206.1 cm (120⅛ × 81⅛ in.), Philadelphia Museum of Art, Gift of the artist, 1961, 1961-223-1; *Black, White, and Gray* (1959), oil on canvas, 266.7 × 198.1 cm (105 × 78 in.), MMA, George A. Hearn Fund, 1959, 59.165.

12 Box 4, folder 11, notes (1 of 2), ca. 1977–ca. 1989, image 7, Zogbaum papers, AAA.

13 Box 4, folder 32, notes on FK (9 of 9), ca. 1970–ca. 1990, image 25, Zogbaum papers, AAA.

14 Franz Kline, *Four Square* (1953), oil on canvas, 188 × 122 cm (74 × 48 in.), private collection.

15 Franz Kline, *Third Avenue* (1954), oil on canvas, 96 × 62.8 cm (37¾ × 24¾ in.), private collection; *Thorpe* (1954), oil on canvas, 157.48 × 110.17 cm (62 × 43⅜ in.), Museum of Contemporary Art, Los Angeles, The Panza Collection, 88.8.

16 Franz Kline, *Untitled* (1948), oil and paper collage mounted on canvas, 58.6 × 76.2 cm (23 × 30 in.), Hirshhorn Museum and Sculpture Garden, Smithsonian Institution, Washington, DC, Gift of Joseph H. Hirshhorn, 1966, 66.2752.

17 Franz Kline, *Untitled* (1951), oil on canvas, 76.2 × 61.0 cm (30 × 24 in.), private collection; illustrated as No. 7 in *Bokubi* 5 (Hasegawa 1952); Kingsley 2000, 152.

18 Franz Kline, *Shenandoah* (1956), oil on canvas, 144.8 × 205.7 cm (57 × 81 in.), private collection.

19 Franz Kline, *Buried Reds* (1953), oil on canvas, 53.3 × 38.1 cm (21 × 15 in.), private collection.

20 Pierre Soulages, *Peinture 146 x 97 cm, 17 Fevrier 1950* (1950), oil on canvas, 146 × 97 cm (57½ × 38 in.), Statens Museum for Kunst, Copenhagen.

21 Box 4, folder 29, notes on Franz Kline (6 of 9), ca. 1970–ca. 1990, image 41, Zogbaum papers, AAA.

22 Box 1, folder 13, invoices and receipts, 1954–59, image 6, Zogbaum papers, AAA.

23 Photos, box 7, folder 4, houses and studios, ca. 1954–ca. 1962; receipt, box 1, folder 14, invoices and receipts 1959–60, May, image 43, Zogbaum papers, AAA.

24 Franz Kline, *New York, NY* (1953), oil on canvas, 200.7 × 128.3 cm (79 × 50½ in.), Albright-Knox Art Gallery, Buffalo, New York, Gift of Seymour H. Knox Jr., 1956, K1956.6; *Wanamaker Block* (1955), oil on canvas, 199.4 × 180.3 cm (78½ × 71 in.), Yale University Art Gallery, New Haven, Gift of Richard Brown Baker, B. A., 1935, 1994.91.1; *de Medici* (1956), oil on canvas, 209.6 × 290.8 cm (82½ × 114½ in.), private collection.

25 Box 2, folder 22, "Franz Kline Paintings Sold," 1956–62, Schedule A, 1956 sales, Sidney Janis Gallery, Zogbaum papers, AAA.

Chapter 6

1 Barnett Newman, *Voice of Fire* (1967), acrylic on canvas, 543.6 × 243.8 cm (214 × 96 in.), National Gallery of Canada, Ottawa.

2 Jackson Pollock, *Mural* (1943), oil and casein on canvas, 242.9 × 603.9 cm (95⅝ × 237¾ in.), University of Iowa Stanley Museum of Art, Gift of Peggy Guggenheim, 1959.6.

3 Excluded from the figure are *1960 New Year Wall, Night* (1960) and a backdrop Kline painted for the dancer Merle Marsciano's performance at Hunter College Playhouse (Foster 1994, 173) titled *Queen of Hearts* (1960, oil on canvas, 609.6 × 533.4 cm [240 × 210 in.], private collection), which are the two largest works ever made by Kline.

4 Franz Kline, *Washington Wall* (1959), oil on canvas, 109 × 444 cm (43 × 174 in.), private collection; *1960 New Year Wall, Night* (1960), oil on soft fiberboard, 305 × 488 cm (120 × 192 in.), Pinakothek der Moderne, Munich, Bayerische Staatsgemäldesammlungen, GV 19; *Shenandoah Wall* (1961), oil on canvas, 205 × 434 cm (80¾ × 171 in.), private collection. Some have proposed that *1960 New Year Wall, Night* was actually painted on Kline's studio wall (de Kooning 1962; Gaugh 1985a; Kuh and Berman 2012), but Zogbaum recalls Kline specifically ordering Homosote for the work (box 4, folder

15, slide show script drafts 1977, images 32, 33, Zogbaum papers, AAA).

5 Franz Kline, *Study for Shenandoah Wall* (1960), ink on three sheets of paper mounted on cardboard, 27 × 63 cm (10⅝ × 24¹³⁄₁₆ in.), Sheldon Museum of Art, University of Nebraska—Lincoln, Olga N. Sheldon Acquisition Trust, U-3575.1984.

6 Franz Kline, *Washington Wall Study* (1959), oil, paper collage, and masking tape on paper, 13 × 65.4 cm (5⅛ × 25¾ in.), private collection.

7 Franz Kline, *Red Brass* (1959), oil on canvas, 173.4 × 99.3 cm (68¼ × 39⅛ in.), MFAH, Bequest of Caroline Wiess Law, 2004.28; *Untitled* (ca. 1959), oil on paper, 61.0 × 48.3 cm (24 × 19 in.), SAAM, 1971.259.

8 Franz Kline, *Delaware Gap* (1958), oil on canvas, 198.6 × 269.5 cm (78¼ × 106⅛ in.), Hirshhorn Museum and Sculpture Garden, Smithsonian Institution, Washington, DC, Gift of the Joseph H. Hirshhorn Foundation, 1966, 66.2751.

9 Franz Kline, *Blueberry Eyes* (1959–60), oil on paperboard, 101.9 × 75.6 cm (40⅛ × 29¾ in.), SAAM, Gift of the Woodward Foundation, 1982.57.

10 Box 4, folder 11, notes (1 of 2), ca. 1977–ca. 1989, image 43, Zogbaum papers, AAA.

11 Franz Kline, *Cupola* (1958–60), oil on canvas, 198.1 × 269.9 cm (78 × 106¼ in.), Art Gallery of Ontario, Canada, Gift from the Women's Committee Fund, 1962, 61/55.

12 Franz Kline, *Lehigh* (1956), oil on canvas, 206 × 288.2 cm (81.1 × 113.5 in.), private collection; *Rue* (1959), oil on canvas, 259 × 200.6 cm (102 × 79 in.), private collection.

13 Franz Kline, *Riverbed* (1961), oil on canvas, 200.3 × 277.5 cm (78⅞ × 109¼ in.), private collection.

14 Franz Kline, *Black, White, and Grey* (1959), oil on canvas, 266.7 × 198.1 cm (105 × 78 in.), MMA, George A. Hearn Fund, 1959, 59.165; *Siegfried* (1958), oil on canvas, 261.4 × 206.6 cm (102¹⁵⁄₁₆ × 81⅜ in.), Carnegie Museum of Art, Purchased with funds provided by friends of the museum, 59.21.

15 Franz Kline, *Torches Mauve* (1960), oil on canvas, 305.1 × 206.1 cm (120⅛ × 81⅛ in.), Philadelphia Museum of Art, Gift of the artist, 1961, 1961-223-1; *Dahlia* (1959), oil on canvas, 208.3 × 170.2 cm (82 × 67 in.), Whitney Museum of American Art, New York, Purchase, with funds from an anonymous group of friends of the Whitney Museum of American Art, 66.90.

16 Kingsley (2000, 234) notes a single case where Kline made two nearly compositionally identical paintings, *Probst I* (1960, oil on canvas, 272.4 × 202.5 cm [107¼ × 79¾ in.], Museum of Fine Arts, Boston, Gift of Susan Morse Hilles, 1973.636) and *Spectre* (1956, oil on canvas, 165.1 × 127 cm [65 × 50 in.], Worcester Art Museum, MA, in memory of Carter Chapin Higgins, the gift of his mother, Clara Carter Higgins, 1967.14), and posits that Kline may have forgotten that he had made the smaller one when painting *Probst*.

17 Franz Kline, *Four Square* (1953), oil on canvas, 198.1 × 121.9 cm (78 × 48 in.), private collection; *Black and White No. 2* (1960), oil on canvas, 203.9 × 155 cm (80¼ × 61 in.), Blanton Museum of Art, The University of Texas at Austin, Gift of Mari and James A. Michener, 1991, 1991.248.; *Slate Cross* (1961), oil on canvas, 285.1 × 200.6 cm (112¼ × 79 in.), Dallas Museum of Art, Gift of Mr. and Mrs. Algur H. Meadows and the Meadows Foundation, Inc., 1968.18.

18 Box 4, folder 15, slide show script drafts, 1977, image 28, Zogbaum papers, AAA.

19 Franz Kline, *Study for Corinthian II* (ca. 1958–60), 34.6 × 54.9 cm (13⅝ × 21⅝ in.), Peter Freeman, Inc., New York.

20 Nelson A. Rockefeller Personal Papers, Series C (NAR Art), Subseries 6 (Cancelled Art), box 5, folder 29 (Cancelled Art [K]), Nelson A. Rockefeller Archives, Sleepy Hollow, NY [hereafter Rockefeller Personal Papers].

21 Memo, dated May 3, 1961, from Dorothy Miller to Mrs. Louise Boyer, Rockefeller's secretary, Rockefeller Personal Papers.

22 Franz Kline, *Merce C* (1961), oil on canvas, 236.2 × 189.4 cm (93 × 74⅝ in.), SAAM, Gift of S. C. Johnson & Son, Inc., 1969.47.64.

23 Franz Kline, *Untitled* (1961), oil on canvas, 184.2 × 269.3 cm (72½ in. × 106 in.), SAAM, Museum purchase from the Vincent Melzac Collection through the Smithsonian Institution Collections Acquisition Program, 1980.5.1.

24 Franz Kline, *Untitled* (1960), oil on canvas, 201.9 × 382.3 cm (79½ × 150½ in.), private collection.

25 Franz Kline, *Spagna* (1961), oil on canvas, 200.7 × 149.9 cm (79 × 59 in.), private collection; *Sun Carrier* (1961), oil on canvas, 233.7 × 170.2 cm (92 × 67 in.), private collection; *Zinc Door* (1961), oil on canvas, 233.7 × 172.1 cm (92 × 67¾ in.), private collection.

26 Franz Kline, *Sawyer* (1959), oil on canvas, 208.3 × 170.2 (82 × 67 in.), private collection.

27 Franz Kline, *New York, NY* (1953), oil on canvas, 200.6 × 128.2 cm (79 × 50½ in.), Albright-Knox Art Gallery, Buffalo, New York, Gift of Seymour H. Knox Jr., 1956, K1956:6.

28 Franz Kline, *Andes* (1957), oil on canvas, 204.8 × 261.1 cm (80⅞ × 103⅛ in.), Kunstmuseum Basel, Gift from the Swiss National Insurance Company on the occasion of its 75th anniversary (1958), 1959, 1959.15.

29 Box 1, folder 36, letters and correspondence 1961–62, image 24, letter to Franz Kline from R. Sturgis Ingersoll, December 27, 1961.

30 Box 1, folder 34, correspondence 1959–60, image 31, letter to Franz Kline from Martin Baldwin, director, Art Gallery of Toronto, October 13, 1960, Zogbaum papers, AAA.

31 Franz Kline, *Untitled* (1953), oil on canvas, 88.9 × 57.2 cm (35 × 22½ in.), private collection; *White Forms* (1955), oil on canvas, 188.9 × 127.6 cm (74⅜ × 50¼ in.), MoMA, Gift of Philip Johnson, 413.1977; *Black Star* (1959), oil on canvas, 81.3 × 91.4 cm (32 × 36 in.), private collection; *Initial* (1959), oil on canvas, 255 × 197 cm (100½ × 77½ in.), private collection.

32 From article in *A B C Milano*, June 26, 1960; typescript translation, box 4, folder 40, excerpts of reviews of Franz Kline's art, 1960–68, image 1, Zogbaum papers, AAA.

33 Box 4, folder 5, excerpts of interview transcripts (3 of 3), ca. 1962–79, images 16, 17, 19. Transcript of conversation between Mrs. E. Ross Zogbaum and Kitty Lesser, transcript pp. 7–8, 10, Zogbaum papers, AAA.

34 Box 4, folder 17, slide show scripts partial drafts (1 of 3), ca. 1977–ca. 1989, image 52, Zogbaum papers, AAA.

35 Microfilm reel D206, films 88–90, letter dated May 18, 1961, to Mrs. Breeskin, from "Franz and Betsy"; quote from image 89, Zogbaum papers, AAA.

36 Box 4, folder 30, notes on Franz Kline (7 of 9), ca. 1970–ca. 1990, image 21, Zogbaum papers, AAA.

37 See also box 4, folder 29, notes on Franz Kline (6 of 9), ca. 1970–ca. 1990, image 46, Zogbaum papers, AAA.

38 Box 4, folder 29, notes on Franz Kline (6 of 9), ca. 1970–ca. 1990, image 47, Zogbaum papers, AAA.

39 Box 4, folder 31, notes on Franz Kline (8 of 9), ca. 1970–ca. 1990, image 4, Zogbaum papers, AAA.

40 Box 1, folder 19, Zogbaum papers, AAA.

41 Box 4, folder 13, slide show introduction and project summary, ca. 1977, image 3, Zogbaum papers, AAA.

42 Box 4, folder 13, slide show introduction and project summary, ca. 1977, "Franz Kline: abstract expressionist painter," image 3, Zogbaum papers, AAA.

Chapter 7

1 Receipts in the Archives of American Art for purchases made
 by Kline in the 1960s attest to his buying house paints along with
 other supplies. For example, a handwritten list on the back of
 a receipt dated November 2, 1960, records the purchase of black
 enamel, tar paper, and sandpaper, as well as a pound of ivory
 black pigment. In the absence of other documentary evidence, it
 is unclear if these materials were used to create his paintings
 or to refurbish his home or studio. Box 1, folder 16, images 13–14,
 Zogbaum papers, AAA.

2 Franz Kline, *Mycenae* (1958), oil on canvas, 256.2 × 194.3 cm
 (100.9 × 76½ in.), private collection. Letter dated February 8, 1980,
 from Orrin Riley to Elisabeth Zogbaum, box 2, folder 12,
 Art Examination and condition reports, ca. 1966–85, Zogbaum
 papers, AAA.

3 Box 4, folder 31, notes on Franz Kline (8 of 9), ca. 1970–ca. 1990,
 image 23, Zogbaum papers, AAA.

4 Franz Kline, *Untitled* (1951), oil on canvas, 198.1 × 182.8 cm
 (78 × 72 in.), private collection.

5 *Wotan* does not appear on any of the lists of paintings sold by
 Sidney Janis, Kline's dealer beginning in mid-1956 and for the
 remainder of his life. Box 2, folder 22, "Franz Kline Paintings
 Sold," 1956–62, Zogbaum papers, AAA. *Wotan* was therefore
 likely acquired before 1956 by Scull, in whose collection it
 remained until 1973 (Sotheby Parke Bernet, Inc., New York,
 October 18, 1973, lot 20).

6 The original stretcher or strainer is now lost.

7 The original stretcher or strainer is now lost.

8 BEVA® 371 is a conservation adhesive developed by Gustav A.
 Berger that contains polyethylene vinyl acetate polymers, ketone
 resin, phthalate ester of hydroabietyl alcohol, and paraffin wax
 (Berger 1976).

9 See also box 2, folder 31, Sidney Janis Sales Records, 1955–62,
 Franz Kline: Expenses paid by Sidney Janis Gallery for Account
 of Franz Kline, prepared by Bernard Reis and Co. exhibit C,
 schedule 2, Zogbaum papers, AAA.

10 Box 2, folder 12, Art Examination and condition reports, ca.
 1966–85, O. Riley "Report on Condition of East River Morning";
 and letter dated February 8, 1980, from Orrin Riley to Elisabeth
 Zogbaum, Zogbaum papers, AAA.

11 Box 2, folder 12, (1) David McKee Inc., Invoice for treatment of
 Nijinsky, dated March 3, 1975; and (2) Julius Lowy Frame and
 Restoring Company Inc., Febuary 28, 1985, report on the
 condition and treatment of a painting belonging to Mr. and Mrs.
 Weinberg, "view from artist's studio," Zogbaum papers, AAA.
 The *Nijinsky* painting treated by David McKee Inc. may be
 Nijinsky (1942), oil on canvas, 58.4 × 48.3 cm (23 × 19⅝ in.), Yale
 University Art Gallery, 2021.12.1.

12 Personal communication with Matthew Skopek, 2015.

13 Personal communication with Jim Coddington, 2015.

References

Abbreviations

AAA	Archives of American Art, Smithsonian Institution, Washington, DC
ARTIC	Art Institute of Chicago
MFAH	Museum of Fine Arts, Houston
MMA	Metropolitan Museum of Art, New York
MoMA	Museum of Modern Art, New York
NGA	National Gallery of Art, Washington, DC
SRG	Solomon R. Guggenheim Museum, New York
SAAM	Smithsonian American Art Museum, Washington, DC

"Abstract Art Around the World Today." 1954. Forum held Museum of Modern Art, March 16. Archives of American Art, Smithsonian Institution, Washington, DC.

Amram, David. 2001. "Seeing the Music, Hearing the Pictures." In *The Stamp of Impulse: Abstract Expressionist Prints*, edited by David Acton, David Amram, and David Lehman, 19–25. Exh. cat. New York: Hudson Hills Press.

Anfam, David. 2004. "Franz Kline: Janus of Abstract Expressionism." In *Franz Kline 1910–1962*, edited by Carolyn Christov-Bakargiev, David Anfam, and Dore Ashton, 40–55. Exh. cat. Milan: Skira.

Anfam, David, and Franz Kline. 1994. *Franz Kline: Black & White, 1950–1961*. Exh. cat. Houston, TX: Fine Art Press.

Ashton, Dore. 2004. "Kline as He Was and as He Is." In *Franz Kline 1910–1962*, edited by Carolyn Christov-Bakargiev, David Anfam, and Dore Ashton, 20–39. Exh. cat. Milan: Skira.

Baker, Richard Brown. 1997. "My Dinner with Jasper Johns (and Robert Rauschenberg, Leo Castelli, Robert Scull, Ethel Scull, Willem de Kooning, Franz Kline and Lots More): A Journal." *Paris Review* 143 (Summer): 211–23.

Barclay, Marion. 1992. "Materials Used in Certain Canadian Abstract Paintings of the 1950s." In *The Crisis of Abstraction in Canada: The 1950s*, edited by Denise Le Clerc, 205–32. Exh. cat. Ottawa: National Gallery of Canada.

Barrett, William. 1964. *What Is Existentialism?* New York: Grove Press.

Baur, John I. H. 1955. *The New Decade: 35 American Painters and Sculptors*. Exh. cat. New York: Whitney Museum of American Art.

Behlen, H. 1947. *The Art of Wood Finishing: A Condensed Manual for Furniture, Piano and Hardwood Finishers, Painters, Interior Decorators, and All Allied Craftsmen*. New York: H. Behlen & Bros.

Berger, Gustav A. 1976. "Formulating Adhesives for the Conservation of Paintings." In *Conservation and Restoration of Pictorial Art*, edited by Norman S. Brommelle and Perry Smith, 169–81. London: Butterworths.

Boime, Albert, Franz Kline, and Fred Mitchell. 1977. *Franz Kline: The Early Works as Signals*. Exh. cat. Binghamton: State University of New York Press.

Boon, Jaap J., and Frank G. Hoogland. 2014. "Investigating Fluidizing Dripping Pink Commercial Paint on Van Hemert's Seven-Series Works from 1990–1995." In *Issues in Contemporary Oil Paint*, edited by Klaas Jan van den Berg, Aviva Burnstock, Matthijs De Keijzer, Jay Krueger, Tom Learner, Alberto De Tagle, and Gunnar Heydenreich, 227–46. Cham: Springer.

Boon, Jaap J., Frank Hoogland, Katrien Keune, and Helen Mar Parkin. 2006. "Chemical Processes in Aged Oil Paints Affecting Metal Soap Migration and Aggregation." *AIC Paintings Specialty Group Postprints* 19:16–23. Washington, DC: American Institute for Conservation of Historic and Artistic Works.

Brach, Paul. 1995. "Urban Grit." *Art in America* 83, no. 4 (April): 96–99.

Brannt, William T. 1914. *The Painter, Gilder and Varnisher's Companion*. Philadelphia: Henry Carey Baird & Co.

Breslin, James E. 1988. *Mark Rothko: A Biography*. Chicago: University of Chicago Press.

Brody, Martin, Robert Creeley, and Kevin Power. 2002. *Black Mountain College: Experiment in Art*. Cambridge, MA: MIT Press.

Bruni, Silvia, and Vittoria Guglielmi. 2019. "Raman Spectroscopy for the Identification of Materials in Contemporary Painting." In *Raman Spectroscopy in Archaeology and Art History*, vol. 2, edited by Peter Vandenabeele and Howell Edwards, 157–73. London: Royal Society of Chemistry.

Buckley, Barbara A. 2013. "Stretchers, Tensioning and Attachments." In *Conservation of Easel Paintings*, edited by Joyce Hill Stoner and Rebecca Rushfield, 128–60. London: Routledge.

Campbell, Joseph. 2008. *The Hero with a Thousand Faces*. 3rd ed. Bollinger Series 17. Novato, CA: New World Library.

Campbell, Lawrence. 1954. "Reviews and Previews." *ARTnews* 53, no. 4 (Summer): 54.

Casadio, Francesca, Katrien Keune, Petria Noble, Annelies Van Loon, Ella Hendriks, Silvia A. Centeno, and Gillian Osmond, eds. 2019. *Metal Soaps in Art: Conservation and Research*. Cham: Springer.

Chilvers, Ian, and John Glaves-Smith. 2009. *A Dictionary of Modern and Contemporary Art*. Oxford: Oxford University Press.

Christov-Bakargiev, Carolyn. 2004. "Considering Franz Kline's Paintings: (Dis)Organizing and (De)Centering Emotion." In *Franz Kline 1910–1962*, edited by Carolyn Christov-Bakargiev, David Anfam, and Dore Ashton, 56–85. Exh. cat. Milan: Skira.

Christov-Bakargiev, Carolyn, David Anfam, and Dore Ashton, eds. 2004. *Franz Kline 1910–1962*. Exh. cat. Milan: Skira.

Cockroft, Eva. 1974. "Abstract Expressionism, Weapon of the Cold War." *Artforum* 12, no. 10 (June): 39–41.

Colby, Carl, dir. [1982] 2009. *Franz Kline Remembered*. Santa Monica, CA: Direct Cinema Ltd. DVD.

Cooper, Anna, Aviva Burnstock, Klaas Jan van den Berg, and Bronwyn Ormsby. 2014. "Water-Sensitive Oil Paints in the 20th Century: A Study of the Distribution of Water-Soluble Degradation Products in Modern Oil Paint Films." In *Issues in Contemporary Oil Paint*, edited by Klaas Jan van den Berg, Aviva Burnstock, Matthijs de Deijzer, Jay Krueger, Thomas J. S. Learner, Alberto de Tagle, and Gunnar Heydenreich, 295–310. Cham: Springer.

Corkery, Robert W. 1997. "Langmuir-Blodgett (L-B) Multilayer Films." *Langmuir* 13, no 14: 3591–94.

Creeley, Robert. 1968. "The Art of Poetry X." *Paris Review* 44 (Fall): 155–87.

Crotty, Frank. 1964. "The People Laughed and Were Fascinated." *Worcester Sunday Telegram*, May 24, 9–10.

Dawson, Fielding. 1967. *An Emotional Memoir of Franz Kline*. New York: Pantheon Books.

———. 1989. "On Scudera." *Arts Magazine* 63, no. 7 (March): 56–57.

de Kooning, Elaine. 1951. "Kerkam Paints a Picture." *ARTnews* 49, no. 10 (February): 42–45, 65–67.

———. 1958a. "A Cahier Leaf." *It Is* 1 (Spring): 19.

———. 1958b. "Two Americans in Action: Franz Kline, Mark Rothko." *ARTnews Annual* 27: 86–96, 174–79.

———. 1962. "Franz Kline: Painter of His Own Life." *ARTnews* 61, no. 7 (November): 28–31, 64–69.

DeSesa, Robert. 1959. "Fish Oil in Modern Coatings." *Paint, Oil and Chemical Review* 122: 6–10.

Doerner, Max. 1934. *The Materials of the Artist and Their Use in Painting, with Notes on the Techniques of the Old Masters*. New York: Harcourt, Brace & Co.

Doss, Erika. 2006. "The Visual Arts in Post-1945 America." In *A Companion to Post-1945 America*, edited by Jean-Christophe Agnew and Roy Rosenzweig, 113–33. Oxford: Blackwell.

Dossin, Catherine. 2016. *The Rise and Fall of American Art, 1940s–1980s: A Geopolitics of Western Art Worlds*. New York: Routledge.

Edgar, Natalie, ed. 2007. *Club without Walls: Selections from the Journals of Philip Pavia*. New York: Midmarch Arts Press.

Farber, Manny. 1950. "Art." *The Nation* 171 (November 11): 445.

Fer, Briony. 2005. "Rothko and Repetition." In *Seeing Rothko*, edited by Glenn Phillips and Thomas Crow, 159–75. Los Angeles: Getty Research Institute.

Ferren, John. 1955. "Stable State of Mind." *ARTnews* 54, no. 3 (May): 22–23.

Finsel, Rebecca, and Joel Finsel. 2019. *Franz Kline in Coal Country*. Mt. Pleasant, SC: Fonthill Media.

Fitzsimmons, James. 1950. "Fifty-Seventh Street in Review." *Art Digest* 25 (November 1): 20.

Forder, Caroline. 1994. "Who's Afraid of Red, Yellow and Blue III?" *International Journal of Cultural Property* 3, no. 1: 83–92.

"43rd Washington Square Outdoor Art Exhibit." 1953. American Artist Professional League. www.aaplinc.org/pdf-archive/mag/aapl_1953_washingtonpark.pdf. Accessed June 14, 2019.

Foster, Stephen. 1994. "Franz Kline and the Downtown Community: The Artist's Voice." In *Franz Kline: Art and Structure of Identity*, edited by Stephen Foster, 41–54. Exh. cat. Barcelona: Fundació Antonio Tapies.

Fremout, Wim, and Steven Saverwyns. 2012. "Identification of Synthetic Organic Pigments: The Role of a Comprehensive Digital Raman Spectral Library." *Journal of Raman Spectroscopy* 43, no. 11: 1536–44.

Friedman, Bernard H. 1978. "'The Irascibles': A Split Second in Art History." *Arts Magazine* 53, no. 1 (September): 96–102.

Gabriel, Mary. 2018. *Ninth Street Women: Lee Krasner, Elaine de Kooning, Grace Hartigan, Joan Mitchell, and Helen Frankenthaler: Five Painters and the Movement That Changed Modern Art*. Boston: Little, Brown.

Gaugh, Harry F. 1972. "The Art of Franz Kline, 1930–1950: Figurative to Mature Abstraction." PhD dissertation, Indiana University.

———. 1974. "Kline's Transitional Abstractions, 1946–50." *Art in America* 62, no. 4 (July–August): 43–47.

———. 1985a. "Franz Kline: The Man and the Myths." *ARTnews* 84, no. 10 (December): 61–67.

———. 1985b. *The Vital Gesture: Franz Kline*. Exh. cat. New York: Abbeville Press.

Gaugh, Harry F., and Franz Kline. 1979. *Franz Kline: The Color Abstractions*. Exh. cat. Washington, DC: Phillips Collection.

Gindertael, Roger. 1950. "Young U.S. and French Painters, Part 1." *ARTnews* 49, no. 7 (November): 47.

Giralt-Miracle, Daniel. 1976. *Conrad Marca-Relli*. Barcelona: Ediciones Poligrafa.

Goodnough, Robert. 1952. "Kline Paints a Picture." *ARTnews* 51, no. 8 (December): 36–39, 63–64.

———. 2009. *Artists' Sessions at Studio 35 (1950)*. Chicago: Soberscove Press.

Gordon, John. 1968. *Franz Kline: 1910–1962*. Exh. cat. New York: Whitney Museum of American Art.

Gottsegen, Mark. 2006. *The Painter's Handbook: A Complete Reference*. New York: Watson-Guptill.

Greenberg, Clement. 1952. "Feeling Is All." *Partisan Review* 19, no. 1 (January–February): 92–102.

Gridley, Mary H. 2019. "Ellsworth Kelly: The Studio and Beyond." In *Conservation of Modern Oil Paintings*, edited by Klaas Jan van den Berg, Ilaria Bonaduce, Aviva Burnstock, Bronwyn Ormsby, Mikkel Scharff, Leslie Carlyle, Gunnar Heydenreich, and Katrien Keune, 121–37. Cham: Springer.

Grondahl, Paul. 2011. "And the Governor Fled in His Nightclothes." *Times Union*, March 3, 2011.

Hamill, Pete. 1996. *Piecework: Writings on Men and Women, Fools and Heroes, Lost Cities, Vanished Calamities and How the Weather Was*. Boston: Little, Brown.

Harris, Jonathan. 1993. "Abstract Expressionism and the Politics of Criticism." In *Modernism in Dispute: Art since the Forties*, vol. 4, edited by Paul Wood, Francis Frascina, Jonathan Harris, and Charles Harrison, 42–65. New Haven, CT: Yale University Press.

Harris, Mary E. 1987. *The Arts at Black Mountain College*. Cambridge, MA: MIT Press.

Hasegawa, Saburô. 1951. "The Beauty of Black and White." *Bokubi* 1 (May): 2–8.

———. 1952. "Kline's Recent Works." *Bokubi* 5, no. 12 (May): 4.

Heginbotham, Arlen, and Michael Schilling. 2011. "New Evidence for the Use of Southeast Asian Raw Materials in Seventeenth-Century Japanese Export Lacquer." In *East Asian Lacquer: Material Culture, Science and Conservation*, edited by Shayne Rivers, Rupert Faulkner, and Boris Pretzel, 92–106. London: Archetype.

Heller, Ben. 1963. *Black and White*. Exh. cat. New York: Jewish Museum.

Hellstein, Valerie. 2010. "Grounding the Social Aesthetics of Abstract Expressionism: A New Intellectual History of the Club." PhD dissertation, Stony Brook University.

———. 2014. "The Cage-iness of Abstract Expressionism." *American Art* 28 no. 1 (Spring): 56–77.

Hermans, Joen J., Katrien Keune, Annelies van Loon, Robert W. Corkery, and Piet D. Iedema. 2016. "Ionomer-Like Structure in Mature Oil Paint Binding Media." *RSC Advances* 6, no. 96: 93363–69.

Hermans, Joen, J. Katrien Keune, Annelies van Loon, and Piet D. Iedema. 2015. "An Infrared Spectroscopic Study of the Nature of Zinc Carboxylates in Oil Paintings." *Journal of Analytical Atomic Spectrometry* 30, no. 7: 1600–1608.

Heron, Patrick. 1956. "The Americans at the Tate Gallery." *Arts Magazine* 30, no. 6 (March): 15–17.

Hess, Thomas B. 1950. "Reviews and Previews: 'Black or White.'" *ARTnews* 49, no. 1 (March): 45.

———. 1951. *Abstract Painting: Background and American Phase*. New York: Viking Press.

———. 1956. "Reviews and Previews: Franz Kline." *ARTnews* 55, no. 1 (March): 51.

———. 1958a. "Is Today's Artist with or against the Past? Part II." *ARTnews* 57, no. 5 (September): 38–41, 58–63.

———. 1958b. "Reviews and Previews." *ARTnews* 57, no. 4 (Summer): 14.

———. 1962a. "Exhibitions for 1961–62: Franz Kline." *ARTnews* 60, no. 9 (January): 47, 60–61.

———. 1962b. "Franz Kline, 1910–1962." *ARTnews* 61, no. 4 (Summer): 23, 53.

Hofmann, Hans. 1967. *Search for the Real: And Other Essays*. Cambridge, MA: MIT Press.

Hopkins, Bud. 1979. "Franz Kline's Color Abstractions: Remembering and Looking Afresh." *Artforum* 27, no. 10 (Summer): 37–41.

Hulst, Titia, ed. 2017. *A History of the Western Art Market*. Oakland: University of California Press.

Janis, Sidney. 1967. "Interview with Sidney Janis." Conducted by Helen M. Franc. June. https://www.moma.org/docs/learn/archives/transcript_janis.pdf.

Jewell, Edward Alden. 1943. "National Academy Annual." *New York Times*, February 21, sec. 2, 11.

Joselow, Evie T. 2004. "The Early Work of Franz Kline: The Bleeker Street Tavern Murals, 1940." *PART (on-line Journal of the Graduate Center, City University of New York, PhD Program in Art History)* 9 (Spring–Summer). www.eviejoselow.com/Appraisals/About_files/part_9.pdf. Accessed May 11, 2018.

Joseph, Branden Wayne, and Robert Rauschenberg. 2003. *Random Order: Robert Rauschenberg and the Neo-Avant-Garde*. Cambridge, MA: MIT Press.

Judd, Donald. 1962. "New York Exhibitions: In the Galleries: Franz Kline." *Arts Magazine* 36, no. 5 (February): 44.

———. 1964. "In the Galleries." *Arts Magazine* 39, no. 3 (November): 59.

Karmel, Pepe, ed. 1999. *Jackson Pollock: Interviews, Articles and Reviews*. New York: Museum of Modern Art.

Karp, Ivan C. 1956. "The Unweary Mr. Franz Kline: Artist without Metaphysics." *Village Voice*, March 7, 10.

Kaufman, Jason E. 2008. "Painting: What the Mind's Eye Sees: Action Painters Were Postwar Exemplars of American Individualism." *American Scholar* 77, no. 2: 113–17.

Kingsley, April. 1985. "Franz Kline in Provincetown." *Provincetown Arts* 1 (August): 6–7.

———. 1986. "Franz Kline: Out of Sight, Out of Mind." *Arts Magazine* 60, no. 9 (May): 41–45.

———. 1992. *The Turning Point: The Abstract Expressionists and the Transformation of American Art*. New York: Simon & Schuster.

———. 2000. "Franz Kline: A Critical Study of the Mature Work 1950–1962." PhD dissertation, City University of New York.

———. 2004. "The Turning Point." In *Franz Kline 1910–1962*, edited by Carolyn Christov-Bakargiev, David Anfam, and Dore Ashton, 377–92. Milan: Skira.

Kirsch, Andrea, and Rustin S. Levinson. 2000. *Seeing through Paintings*. New Haven, CT: Yale University Press.

Kline, Franz. 1952. "Letter to the Editor." *Bokubi* 5, no. 12 (May): 4.

Kline, Franz, and Elaine de Kooning. 1962. *Franz Kline: Memorial Exhibition*. Exh. cat. Washington, DC: National Gallery of Art.

Kline, Franz, Marisa del Re, Glenn McMillan, and Claude R. Logan. 1984. *Kline: May 2–June 9, 1984*. Exh. cat. New York: Marisa del Re Gallery.

Kline, Franz, and Stephen C. Foster. 1994. *Franz Kline: Art and Structure of Identity*. Exh. cat. Barcelona: Fundació Antoni Tàpies.

Kozloff, Max. 1973. "American Painting during the Cold War." *Artforum* 11, no. 9 (May): 43–54.

Krez, Anna, Mark D. Mitchell, and Anikó Bezur. 2017. "Art of Darkness: Ralph Albert Blakelock's *Moonlight*." *Yale University Art Gallery Bulletin*: 42–48.

Kuh, Katherine. 1962. *The Artist's Voice: Talks with Seventeen Artists*. New York: Harper and Row.

Kuh, Katharine, and Avis Berman. 2012. *My Love Affair with Modern Art: Behind the Scenes with a Legendary Curator*. New York: Skyhorse Publishing.

Lake, Susan. 1999. "The Relationship between Style and Technical Procedure: Willem de Kooning's Paintings of the Late 1940s and 1960s." PhD dissertation, University of Delaware.

La Nasa, Jacopo, Joy Mazurek, Ilaria Degano, and Corina E. Rogge. 2021. "The Identification of Fish Oils in 20th Century Paints and Paintings." *Journal of Cultural Heritage* 50(11):49–60.

Lane, Mervin, ed. 1990. *Black Mountain College: Sprouted Seeds, an Anthology of Personal Accounts*. Knoxville: University of Tennessee Press.

Langsner, Jules. 1962. "Franz Kline." *Artforum* 1, no 2 (July): 4–5.

Läuchli, Mathias, Nathalie Bäschlin, Anita Hoess, Thomas Frankhauser, Cornelius Palmbach, and Marcel Ryser. 2014. "Packing Systems for Paintings: Damping Capacity in Relation to Transport-Induced Shock and Vibration." In *ICOM-CC 17th Triennial Conference Preprints, Melbourne, 15–19 September 2014*, ed. Janet Bridgland, art. 1307. Paris: International Council of Museums.

Learner, Tom. 2000. "A Review of Synthetic Binding Media in Twentieth-Century Paints." *Conservator* 24, no. 1: 96–103.

Lee, Yvette Y. 2002. "'Beyond Life and Death': Joan Mitchell's *Grand Vallée*." In *The Paintings of Joan Mitchell*, edited by Jane Livingston, Joan Mitchell, Linda Nochlin, Yvette Y. Lee, and Jane Livingston, 61–74. New York: Whitney Museum of Art.

Levison, Henry W. 1985. "Yellowing and Bleaching of Paint Films." *Journal of the American Institute for Conservation* 24, no. 2: 69–76.

MacDonald, Dwight. 1960. "Massachusetts vs. Mailer." *New Yorker*, October 8, 154, 156, 158, 160–66.

Mallégol, Jacky, Jacques Lemaire, and Jean-Luc Gardette. 2001. "Yellowing of Oil-Based Paints." *Studies in Conservation* 46, no. 4: 121–31.

Marcon, Paul J. 1991. "Shock, Vibration and Protective Package Design." In *Art in Transit: Studies in the Transport of Paintings*, edited by Marion. F. Mecklenburg, 107–20. Washington, DC: National Gallery of Art.

Mattison, Robert S. 2012. *Franz Kline: Coal and Steel*. Exh. cat. Allentown, PA: Allentown Art Museum of the Lehigh Valley.

McDarrah, Fred. 1961. *The Artist's World in Pictures: The New York School*. New York: E. P. Dutton.

McGonigle, Frank, and Peter A. Ciullo. 1996. "Paints and Coatings." In *Industrial Minerals and Their Uses: A Handbook and Formulary*, edited by Peter A. Cuillo, 99–159. New York: William Andrew.

Mecklenburg, Marion F., ed. 1991. *Art in Transit: Studies in the Transport of Paintings*. Washington, DC: National Gallery of Art.

Merryman, John Henry, and Albert E. Elsen. 1987. *Law, Ethics and the Visual Arts*. Vol. 2. Philadelphia: University of Pennsylvania Press.

Metropolitan Museum of Art (MMA). 1950. *American Painting Today, 1950: A National Competitive Exhibition*. Exh. cat. New York: The Metropolitan Museum of Art.

Metzger, Robert P. 2006. *9th St.: Nine Artists from the Ninth Street Show*. Exh. cat. New York: David Findlay Jr. Fine Art.

Metzger, Robert P., and Franz Kline. 1989. *Franz Kline: The Jazz Murals*. Exh. cat. Lewisburg, PA: Bucknell University Press.

Molesworth, Helen, and Ruth Erickson. 2015. *Leap Before You Look: Black Mountain College, 1933–1957*. New Haven, CT: Yale University Press.

Morita, Shiryû. 1952. "Impression of Kline's Recent Works." *Bokubi* 5, no. 12 (May): 5.

Morris, George L. K., Willem de Kooning, Alexander Calder, Fritz Glarner, Robert Motherwell, and Stuart Davis. 1951. "What Abstract Art Means to Me." *Bulletin of the Museum of Modern Art* 18, no. 3 (Spring): 2 15.

Newman, Barnett. 1992. *Barnett Newman: Selected Writings and Interviews*. Edited by John P. O'Neill. New York: Knopf.

New York Tribune. 1881. "Art on the Stage." *Scientific American*, suppl. no. 290, July 23, 4622.

O'Brian, John, ed. 1993. *Clement Greenberg: The Collected Essays and Criticism*. Vol. 3: *Affirmations and Refusals 1950–1956*. Chicago: University of Chicago Press.

O'Hara, Frank. 1958. "Franz Kline Talking." *Evergreen Review* 2, no. 6 (Autumn): 58–64.

———. 1964. *Franz Kline: A Retrospective Exhibition*. Exh. cat. London: Whitechapel Gallery.

Ordonez, Eugena, and John Twilley. 1997. "Clarifying the Haze: Efflorescence on Works of Art." *Analytical Chemistry* 69, no. 13: 416A–422A.

Osmond, Gillian. 2019. "Zinc Soaps: An Overview of Zinc Oxide Reactivity and Consequences of Soap Formation in Oil-Based Paintings." In *Metal Soaps in Art: Conservation and Research*, edited by Francesca Casadio, Katrien Keune, Petria Noble, Annelies Van Loon, and Ella Hendriks, 25–46. Cham: Springer.

Perilli, Achille. 1957. "Segni e immagini di Franz Kline." *Civiltà delle Macchine* 5, no. 3 (May–June): 33.

Perl, AnnMarie. 2017. "A Belated 'Breakthrough' to Abstraction." In *In Focus: Meryon 1960–1 by Franz Kline*, edited by AnnMarie Perl. Tate Research Publication. www.tate.org.uk/research/publications/in-focus/meryon/abstraction. Accessed January 25, 2018.

Perls, Frederick S., Ralph Hefferline, and Paul Goodman. 1951. *Gestalt Therapy: Excitement and Growth in Human Personality*. Goldsboro, ME: Gestalt Journal Press.

Phenix, Alan, Alexia Soldano, Klaas Jan van den Berg, and Birgit van Driel. 2017. "'The Might of White': Formulations of Titanium Dioxide–Based Oil Paints as Evidenced in Archives of Two Artists' Colourmen, Mid-20th Century." In *ICOM-CC 18th Triennial Conference Preprints, Copenhagen, 4–8 September 2017*, ed. Janet Bridgland. Paris: International Council of Museums.

Pranther, Marla. 1994. "Catalogue." In *Willem de Kooning: Paintings*, edited by Marla Prather, Anthony David Bernard Sylvester, David Sylvester, and Richard Shiff, 75–224. Exh. cat. Washington, DC: National Gallery of Art.

Raven, Laura E., Madeleine Bisschoff, Margje Leeuwestein, Muriel Geldof, Joen J. Hermans, Maartje Stols-Witlox, and Katrien Keune. 2019. "Delamination Due to Zinc Soap Formation in an Oil Painting by Piet Mondrian (1872–1944)." In *Metal Soaps in Art: Conservation and Research*, edited by Francesca Casadio, Katrien Keune, Petria Noble, Annelies Van Loon, Ella Hendriks, Silvia A. Centeno, and Gillian Osmond, 343–58. Cham: Springer.

Read, Sir Herbert, and H. Harvard Arnason. 1960. "A Dialogue on Modern U.S. Painting." *ARTnews* 59, no. 3: 32–26.

Robichaux, John W. 1997. *Hensche on Painting: A Student's Notebook*. Kearney, NE: Morris Publishing.

Robinet, Laurianne, and Marie-Claude Corbeil. 2003. "The Characterization of Metal Soaps." *Studies in Conservation*, 48, no 1: 23–40.

Robson, Anne Diedre. 1988. "The Market for Modern Art in New York in the 1940s and 1950s." PhD dissertation, University College London.

———. 1995. *Prestige, Profit, and Pleasure: The Market for Modern Art in New York in the 1940s and 1950s*. New York: Garland.

Rodman, Selden. 1957. *Conversations with Artists*. New York: Delvin-Adair.

Rogala, Dawn V. 2016. *Hans Hofmann: The Artist's Materials*. Los Angeles: Getty Conservation Institute.

Rogala, Dawn, Susan Lake, Christopher Maines, and Marion Mecklenburg. 2010. "Condition Problems Related to Zinc Oxide Underlayers: Examination of Selected Abstract Expressionist Paintings from the Collection of the Hirshhorn Museum and Sculpture Garden, Smithsonian Institution." *Journal of the American Institute for Conservation* 49, no. 2: 96–113.

Rogge, Corina E., and Julie Arslanoglu. 2019. "Luminescence of Coprecipitated Titanium White Pigments: Implications for Dating Modern Art." *Science Advances* 5, no. 5 (May).

Rogge, Corina E., Zahira Véliz Bomford, and Maite Leal. 2019. "Seldom Black and White: The Works of Franz Kline." In *Metal Soaps in Art: Conservation and Research*, edited by Francesca Casadio, Katrien Keune, Petria Noble, Annelies Van Loon, Ella Hendriks, Silvia A. Centeno, and Gillian Osmond, 413–24. Cham: Springer.

Rogge, Corina E., and Bradford A. Epley. 2017. "Behind the Bocour Label: Identification of Pigments and Binders in Historic Bocour Oil and Acrylic Paints." *Journal of the American Institute for Conservation* 56, no. 1: 15–42.

Rosati, James. 1968. "Oral History Interview with James Rosati." Interview by Sevim Fesci. Archives of American Art, Smithsonian Institution.

Rose, Barbara. 1980. *Pollock Painting*. New York: Agrinde Publications.

Rosenberg, Harold. 1952. "The American Action Painters." *ARTnews* 51, no. 8 (December). 22 23, 48 50.

———. 1961. "The Search for Jackson Pollock." *ARTnews* 59, no. 10 (February): 35, 58–60.

Rothko, Mark. 1951. "I paint very large pictures." Excerpt from Symposium, "How to Combine Architecture, Painting, and Sculpture." *Interiors* 110, no. 10 (May): 100–105.

Roueché, Berton. 1950. "Unframed Space." *New Yorker* 26, no. 24 (August): 16.

Russell, John. 1979. "Gallery View: Kline's 'Effulgent Abstractions.'" *New York Times*, March 18, sec. D, 31.

Salisbury, Stephan. 1986. "An Innovator Who Painted Pennsylvania." *Philadelphia Inquirer*, June 22, K01.

Sandler, Irving. 1957. "Conversation with Jack Tworkov on August 11, 1957, at His Summer Home in Provincetown." https://jacktworkov.org/news/2018/06/rip-irving-sandler-1925-2018.

———. 1961. "Reviews and Previews." *ARTnews* 59, no. 10 (February): 10.

———. 1970. *The Triumph of American Painting: A History of Abstract Expressionism*. New York: Praeger.

———. 2003. *A Sweeper-Up after Artists: A Memoir*. New York: Thames & Hudson.

Sawyer, Kenneth B. 1960. *Quattro artisti americani, XXX Biennale Venezia, 1960, Stati Uniti d'America*. Exh. cat. Baltimore: Baltimore Museum of Art.

Schilling, Michael R., Joy Keeney, and Tom Learner. 2004. "Characterization of Alkyd Paint Media by Gas Chromatography-Mass Spectrometry." In *Modern Art, New Museums: Contributions to the Bilbao Congress, 13–17 September 2004*, edited by Ashok Roy and Perry Smith, 197–201. London: International Institute for Conservation.

Schilling, Michael R., Joy Mazurek, and Tom J. S. Learner. 2007. "Studies of Modern Oil-Based Artists' Paint Media by Gas Chromatography/Mass Spectrometry." In *Modern Paints Uncovered: Proceedings from the Modern Paints Uncovered Symposium, Tate Modern, London, May 16–19, 2006*, edited by Thomas J. S. Learner, Patricia Smithen, Jay W. Kreuger, and Michael R. Schilling, 129–39. Los Angeles: Getty Conservation Institute.

Shearer, Benjamin F. 2007. *Home Front Heroes: A Biographical Dictionary of Americans during Wartime*. Vol. 2. Westport, CT: Greenwood Press.

Singer, Elias. 1957. *Fundamentals of Paint, Varnish, and Lacquer Technology*. St. Louis: American Paint Journal Company.

Smith, Anne Chesky and Heather South. 2014. *Black Mountain College*. Charleston, SC: Arcadia Publishing.

Stallsmith, T. G. 1911. "Value of Certain Paint Oils, Linseed Oil, China Wood Oil and Other Oils." *Spokesman and Harness World* 27 (June 1): 272.

Standeven, Harriet A. L. 2013. "Oil-Based House Paints from 1900 to 1960: An Examination of Their History and Development, with Particular Reference to Ripolin Enamels." *Journal of the American Institute for Conservation* 52, no. 3: 127–39.

Steinberg, Leo. 1956. "Month in Review." *Arts Magazine* 30, no. 7 (April): 42.

Stern, Bert, and Dorothy Seiberling. 1959. "The Varied Art of Four Pioneers." *LIFE* 47, no. 20 (November 16): 74–86.

Stevens, Mark, and Annalyn Swan. 2004. *de Kooning: An American Master*. New York: Knopf.

Still, Clyfford. 1962. "An Open Letter to an Art Critic." *Artforum* 2, no 6 (December): 32.

Svoboda, Shelley A., and Camilla J. Van Vooren. 1989. "An Investigation of Albert Pinkham Ryder's Painting Materials and Techniques with Additional Research on Forgeries." In *Postprints, American Institute for Conservation of Historic and Artistic Works, Paintings Specialty Group*, 36–50. Washington, DC: American Institute for Conservation of Historic and Artistic Works.

Sylvester, David. 1963. "Franz Kline 1910–1962: An Interview with David Sylvester." *Living Arts* 1: 2–13.

Taubes, Frederic. 1944. *Oil Painting for the Beginner*. New York: Watson-Guptill Publications.

Temkin, Ann. 2010. *Abstract Expressionism at MoMA: Selections from the Collection*. Exh. cat. New York: Museum of Modern Art.

Tillim, Sidney. 1960. "Report on the Venice Biennale." *Arts Magazine* 35, no. 1 (October): 28–35.

Titanium Pigment Corporation. 1955. *The Handbook*. New York: Titanium Pigment Corporation.

Tworkov, Jack. 1957. *Exhibition of Paintings: April 15 through May 4*. Exh. cat. New York: Stable Gallery.

Vasari, Giorgio. 1907. *Vasari on Technique*. Translated by Louisa S. Maclehose. London: J. M. Dent & Co.

Vincent, Christine J. 2010. *The Artist as Philanthropist: Strengthening the Next Generation of Artist-Endowed Foundations: A Study of the Emerging Artist-Endowed Foundation Field in the US*. Washington, DC: Aspen Institute. https://assets.aspeninstitute.org/content/uploads/2016/07/AEF-Study-Report-Supplement-2013.pdf. Accessed September 18, 2019.

Whitney Museum of American Art. 2014. "Whitney Story: Conserving Mahoning." https://whitney.org/WhitneyStories/ConservingMahoning. Accessed November 23, 2015.

Wilentz, Sean. 2018. *Fred W. McDarrah: New York Scenes*. New York: Harry N. Abrams.

Zimmer, Nina, Markus Klammer, Michael Leja, Stefan Neuner, Stephanie Straine, Anne-Christine Strobel, and Tetsuya Oshima. 2016. *The Figurative Pollock*. New York: Prestel.

Illustration Credits

Figs. 1.1, 1.5, 2.1, 3.5, 5.2: Elisabeth Zogbaum papers relating to Franz Kline, 1892–ca. 2005, bulk 1930–1990 / Archives of American Art, Smithsonian Institution

Fig. 1.2: Image from Matthew J. and Arlyn Bruccoli Collection of F. Scott Fitzgerald, Irvin Department of Rare Books, University of South Carolina Libraries, Columbia, S.C.

Fig. 1.3: Photo Courtesy Charlene Graver and Larry Graver

Fig. 1.4: By kind permission of Nick Spurrier / Collection of Panter & Hall

Figs. 1.6, 2.3, 2.9, 2.10, 2.21, 5.7: National Gallery of Art, Washington, DC

Fig. 2.2: Image courtesy Minneapolis Institute of Art

Figs. 2.4, 5.8: Courtesy of the National Gallery of Art Painting Conservation Department

Fig. 2.5: Jerome Robbins Dance Division, The New York Public Library for the Performing Arts

Figs. 2.6, 2.11–2.13, 4.2, 5.9: Image © The Metropolitan Museum of Art

Figs. 2.7, 2.15, 2.18, 4.15, 4.16: The Metropolitan Museum of Art, Departments of Scientific Research and Painting Conservation

Fig. 2.8: Smithsonian American Art Museum, Washington, DC / Art Resource, NY

Figs. 2.14, 2.17: Images by Evan Read, Paintings Conservation, The Metropolitan Museum of Art

Figs. 2.16, 2.23, 4.8, 4.9, 4.11–4.14, 4.18, 4.19, 5.4, 6.1, 6.4–6.8: Images and graph by C. Rogge, © MFAH

Figs. 2.19, 2.20, 2.22, 5.3, 5.11: Solomon R. Guggenheim Museum

Fig. 3.1: © Estate of Arthur Swoger / Courtesy of the RISD Museum, Providence, RI

Fig. 3.2: Jackson Pollock © 2022 The Pollock-Krasner Foundation / Artists Rights Society (ARS), New York / Photo © Tate

Fig. 3.3: Willem de Kooning © 2022 The Willem de Kooning Foundation / Artists Rights Society (ARS), New York / The Art Institute of Chicago / Art Resource, NY

Fig. 3.4: Willem de Kooning © 2022 The Willem de Kooning Foundation / Artists Rights Society (ARS), New York / The Museum of Fine Arts, Houston, Bequest of Caroline Wiess Law, 2004.12.A–.B

Figs. 4.1, 4.6, 6.12: Digital Image © The Museum of Modern Art / Licensed by SCALA / Art Resource, NY

Fig. 4.3: The Museum of Fine Arts, Houston, Museum purchase funded by the Caroline Wiess Law Accessions Endowment Fund, 96.848

Fig. 4.4: The Museum of Fine Arts, Houston, Museum purchase, by exchange, 80.120

Fig. 4.5: Photo: © President and Fellows of Harvard College

Figs. 4.7, 4.10: Images by M. Golden, © MFAH

Fig. 4.17: Photo by Fritz Goro / The LIFE Picture Collection / Shutterstock

Fig. 5.1: The Art Institute of Chicago / Art Resource, NY

Figs. 5.5, 5.6: Digital image © Whitney Museum of American Art / Licensed by Scala / Art Resource, NY

Fig. 5.10: Munson-Williams-Proctor Arts Institute / Art Resource, NY

Fig. 5.12: J. Warda / Solomon R. Guggenheim Museum Conservation Department

Fig. 5.13: © Sidney Janis Gallery / Elisabeth Zogbaum papers relating to Franz Kline, 1892–ca. 2005, bulk 1930–1990. Archives of American Art, Smithsonian Institution

Fig. 6.2: The Museum of Fine Arts, Houston, Bequest of Caroline Wiess Law, 2004.27 / Image by J. D. Craven

Fig. 6.3: Peter Stackpole / The LIFE Picture Collection / Shutterstock

Figs. 6.9, 6.15: Allan Stone Gallery

Fig. 6.10: Photo by Biff Henrich for Albright-Knox Art Gallery, Buffalo, New York

Fig. 6.11: Courtesy of Rockefeller Archive Center

Fig. 6.13: The Museum of Fine Arts, Houston, Bequest of Caroline Wiess Law, 2004.26

Fig. 6.14: Photo by Fred W. McDarrah / MUUS Collection via Getty Images

Figs. 7.1–7.3, 7.7: Image by J. D. Craven, © MFAH

Fig. 7.4: Photo The Museum of Fine Arts, Houston, Gift of P / K Associates, 84.1003 © Andrea Frank Foundation

Fig. 7.5: Image by M. Golden and B. Samples, © MFAH

Fig. 7.6: Image created by Z. Bomford, © MFAH

Index

Acknowledgments

We thank the contributors to this book, Julie Arslanoglu, Silvia A. Centeno, Isabelle Duvernois, and Maite Leal, for their expertise and patience throughout this process. It has been a sincere pleasure to work with them.

We came too late to know and interview Kline and his contemporaries and so have relied heavily on those who did. In particular, we have to thank Elisabeth Ross Zogbaum, Kline's second partner and executor of his estate. In her writings housed at the Archives of American Art, she claimed to not be gifted with words and expressed dismay that while she had researched the chronology of Kline's life, she could not put into words what a unique artist he was. We hope that our efforts, which have leaned so much on hers, may help others to see Kline and his work more clearly. We thank her son, Rufus Zogbaum, who is continuing to shepherd the Kline estate, for keeping alive the memory of Kline, both as an artist and as a kind and loving person. We also owe a debt of gratitude to the art historians who did have the opportunity to interview Kline's contemporaries, in particular, Harry Gaugh. The sheer number of citations of his work is an indication of our reliance on his scholarly legacy. We thank the Archives of American Art, especially Marisa Bourgoin, head of reference services, for access to the Elisabeth Zogbaum files relating to Franz Kline and for helping preserve invaluable archival material for generations to come.

Research is a collaborative endeavor, and we have been extremely fortunate in having kind and generous colleagues who made this work possible. In particular, we thank our colleagues and friends at the MFAH, including Gary Tinterow, director; Alison de Lima Greene, Isabel Brown Wilson Curator of Modern and Contemporary Art; and David Bomford, chair of conservation emeritus, for wholeheartedly supporting this project. We are grateful to Lynne Wexler, reference librarian emerita; Rebekah Scoggins, public service and instruction librarian; and Jason Valdez, collections strategy librarian, for their research support; to James D. Craven, imaging specialist, for tech-nical imaging; and to Melissa Gardner, associate paintings conservator, Bertram Samples, senior paintings technician, and Per Knutås, chair of conservation, for their insights and support. The MFAH was in a unique position to undertake this project thanks to the profound generosity of Caroline Wiess Law, who donated two paintings by Kline to the museum, and whose accession endowment supported the acquisition of another. These works, which spanned Kline's mature career, formed the nucleus of our project.

Our work would not have been possible without the support of the Getty Conservation Institute. We thank Tom Learner, head of science, for his interest in this project and for permitting GC-MS analysis to be performed at the GCI; and Joy Mazurek, assistant scientist, and Michael Schilling, senior scientist, for running the samples on our behalf. We thank Cynthia Godlewski, publications manager, for her invaluable assistance. Thanks to the team at Getty Publications: Rachel Barth, our book editor; Jeffrey Cohen, our wonderful designer; Molly McGeehan, production coordinator; and Kelly Peyton, who handled images and rights. We are grateful to Sheila Berg, Pamela Morgan, and Theresa Duran for their contributions to our manuscript.

There are many other institutions and individuals without whom we would have been unable to complete this work, in particular, those who permitted us to visit and study their works by Kline. We greatly appreciate their generosity in sharing their time and expertise. At the Art Institute of Chicago we thank Francesca Casadio, Grainger Executive Director of Conservation and Science; Kelly Keegan, associate paintings conservator; and the late Frank Zuccari, Grainger Executive Director of Conservation Emeritus. At Harvard Art Museums, we thank Narayan Khandekar, director of the Straus Center for Conservation and Technical Studies and senior conservation scientist; Anne Schaffer, paintings conservation fellow; and Kate Smith, conservator of paintings and head of paintings lab at the Straus Center. At the Metropolitan Museum of Art, we thank Michael Gallagher, Sherman Fairchild

Chairman of Paintings Conservation; Evan Reed, manager of technical documentation in the paintings conservation department; and Rachel Mustalish, conservator, Sherman Fairchild Center for Works of Art on Paper Conservation. At the Museum of Modern Art, we thank Jim Coddington, chief conservator emeritus; Emily Cushman, collection specialist, department of drawings and prints; Ellen Davis, assistant projects conservator, now assistant paintings conservator at the Straus Center for Conservation and Technical Studies; Federico Carò, research scientist; Michael Duffy, paintings conservator; and Christopher McGlinchey, conservation scientist emeritus. At the National Gallery of Art, we extend our gratitude to Barbara Berrie, head of the scientific research department; Judith Brodie, curator and head of American and modern prints and drawings emerita; Jay Krueger, head of paintings conservation; Douglas Lachance, painting conservation technician; Suzanne Lomax, senior conservator scientist; Charlie Ritchie, associate curator of American and modern prints and drawings; and Kimberly Schenck, head of paper conservation. At the Smithsonian American Art Museum, we thank Tiarna Doherty, chief conservator emerita, and Amber Kerr, chief conservator and senior paintings conservator; at the Whitney Museum of American Art, Carol Mancusi-Ungaro, Melva Bucksbaum Associate Director for Conservation and Research, and Matthew Skopek, associate conservator. At the Solomon R. Guggenheim Museum, New York, we are grateful to Julie Barten, senior painting conservator and associate director of conservation affairs; Susan Davidson, senior curator, collections and exhibitions; Gillian McMillan, associate chief conservator for the collection; Lena Stringari, deputy director and chief conservator; Hillary Torrence, conservation associate; and Jeffrey Warda, senior conservator, paper and photographs.

We thank Nicholas Barbi, president of nSyngeries Inc., for his loan of a Bruker M6 Jetstream unit for analysis of *Orange and Black Wall*; Dan Kirby, conservation scientist, for performing time of flight mass spectroscopic identification of the animal glue sizing on *Wotan*; Ilaria Degano, associate professor of analytical chemistry at the Università di Pisa, and Jacopo La Nasa, postdoctoral fellow at the Università di Pisa, for performing liquid chromatography mass spectroscopy on samples from *Wotan*; Amy Fitch, archivist at the Rockefeller Archive Center, for providing archival materials relating to *Corinthian I*; and Liza Barkley, archival associate emerita at the Menil Collection, for permitting access to archival files relating to the exhibition *Franz Kline: Black and White, 1950–1961*.

C. E. Rogge owes an enormous debt of gratitude to Kevin MacKenzie, who endured the ghost of another man haunting my life for the past five years. He graciously provided editing, acted as a sounding board, and always helped me believe that there was a light at the end of this tunnel.

And finally, thank you, Franz Kline. We hope we caught it.

About the Authors

CORINA E. ROGGE is the Andrew W. Mellon Research Scientist at the Museum of Fine Arts, Houston (MFAH), and the Menil Collection. She is currently serving as vice president for the American Institute for Conservation and as an associate editor for the *Journal of the American Institute for Conservation*. She earned a BA in chemistry from Bryn Mawr College and a PhD in inorganic chemistry from Yale University. She has held postdoctoral appointments at the University of Wisconsin–Madison and the University of Texas Health Sciences Center (Houston). Before joining the MFAH, she held positions as the Wiess Instructor of Chemistry at Rice University and the Andrew W. Mellon Assistant Professor in Conservation Science in the Department of Art Conservation at State University of New York Buffalo State College. Rogge has published on the materials and techniques of other twentieth-century artists such as Barnett Newman and Giorgio de Chirico, and on a variety of topics, including titanium white pigments, the identification of fish oil in paints, tintypes, and ancient Egyptian artifacts.

ZAHIRA VÉLIZ BOMFORD is an independent art historian and art conservator based in London. After undergraduate study at the University of Florida, she completed an MA in art history and diploma in art conservation from Oberlin College. She held conservation fellowships at the Metropolitan Museum of Art, the Smithsonian Institution, and the Cleveland Museum of Art. She practiced as an art conservator in Spain, where she directed in situ conservation projects under the auspices of the Getty Foundation, the World Monuments Fund, and the Royal Foundation of Toledo. Between 1987 and 1992 she assisted John Brealey when he was guest chief conservator at the Prado Museum. After 1990 she began her practice as a private conservator in London and completed her PhD in the history of art at the Courtauld Institute in 1998. Bomford has published numerous books and articles, including catalogues of Alonso Cano's drawings and Spanish drawings in the Courtauld Gallery, London, and on the history of restoration, technical art history, and conservation. Most recently she was senior conservator of paintings at the Museum of Fine Arts, Houston, retiring in 2019.

JULIE ARSLANOGLU is a research scientist at the Metropolitan Museum of Art. She joined the museum in 2006 and has focused her research on the chemistry and chemical interactions of organic polymeric materials found in artworks. She is also the co-founder of the Art Bio Matters conference series and co-founder of ARt and Cultural HEritage: Natural Organic Polymers by Mass Spectrometry (ARCHE) with her collaborator, Caroline Tokarski (University of Bordeaux). This program was awarded CNRS-LIA status in 2019.

SILVIA A. CENTENO is a research scientist at the Metropolitan Museum of Art, where her main responsibilities include the investigation of artists' materials and techniques and deterioration processes in paintings, photographs, and works of art on paper. She received a PhD in chemistry from the Universidad Nacional de La Plata, Argentina. She has published and lectured on a number of topics: paintings dating from medieval times to the twentieth century, pigment- and platinum-based photographs, daguerreotypes, inks, and deterioration processes in oil paintings.

ISABELLE DUVERNOIS is conservator of modern and contemporary paintings at the Metropolitan Museum of Art. She is a graduate of New York University's Conservation Center and Institute of Fine Arts. She has contributed to numerous exhibition catalogues, including *Picasso in the Metropolitan Museum of Art* (2010), *Marsden Hartley's Maine* (2017), and *Matisse: In Search of True Painting* (2012). Most recently she has published technical research on Pollock (2017), Horace Pippin (2017), and Modigliani (March–May 2018).

MAITE MARTINEZ LEAL is a paintings conservator at the Museum of Fine Arts, Houston. She has treated paintings dating from the early fifteenth century to the contemporary period, including Latin American collections, the Brillembourg and Adolpho Leirner collections, and the collected works of Hélio Oiticica and Carlos Cruz-Diez. She has participated in a number of Getty Foundation–funded projects including the PST: LA/LA initiative (2016), Conserving Canvas (2019–21), Tear Mending (2019–21), and Wax Lining Reversal (2019–21).